IMPRESSIONISM ABROAD

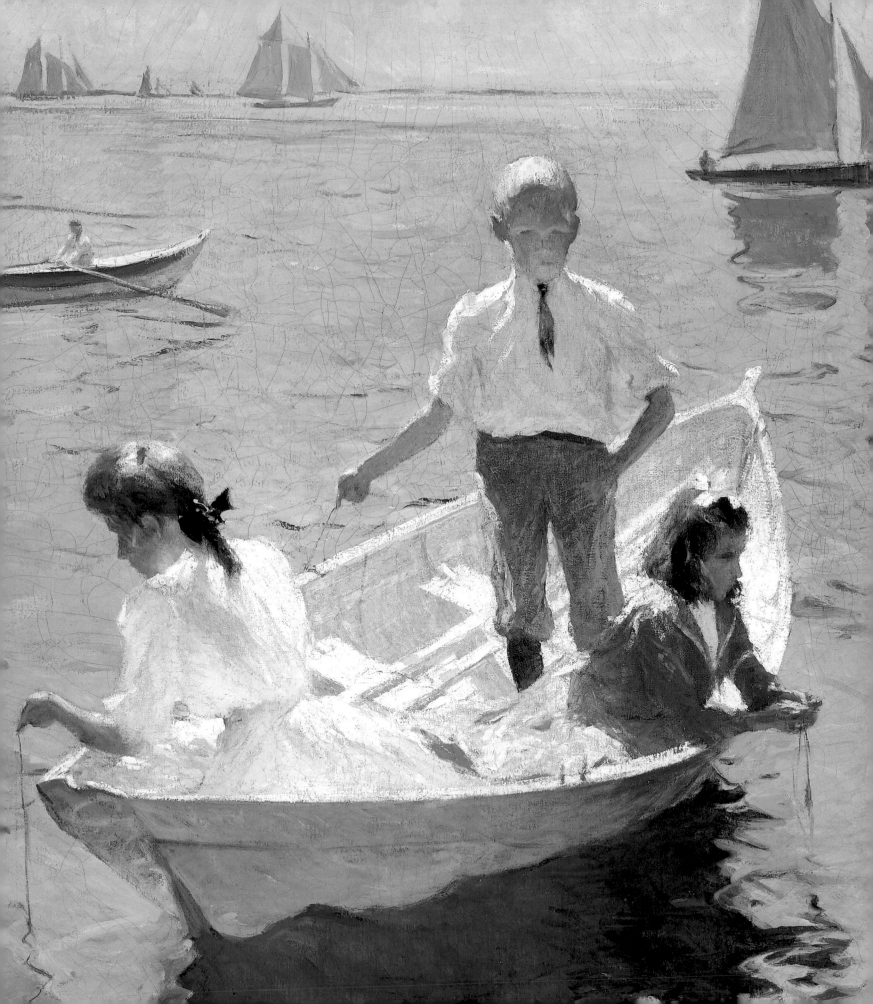

IMPRESSIONISM ABROAD

Boston and French Painting

ROYAL ACADEMY OF ARTS

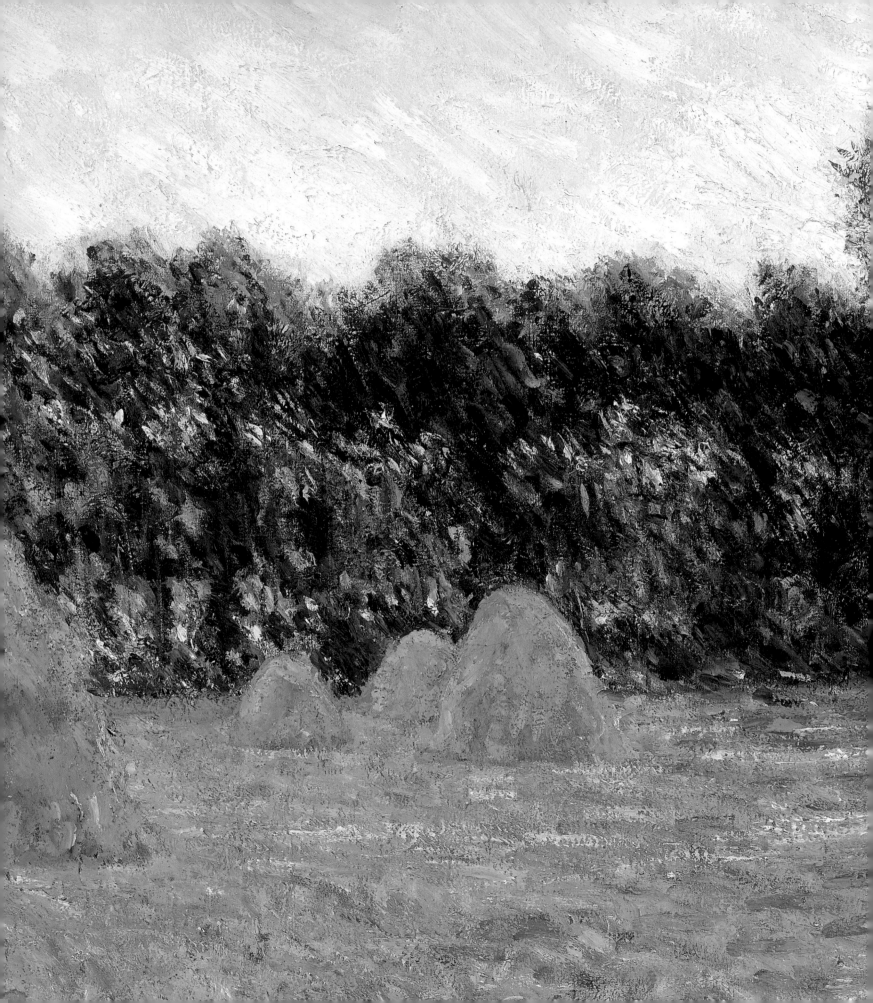

First published on the occasion of the exhibition
'Impressionism Abroad: Boston and French Painting'

Royal Academy of Arts, London
2 July – 11 September 2005
Supported by Fidelity Investments through the Fidelity Foundation

Norton Museum of Art, West Palm Beach, Florida
19 November 2005 – 5 March 2006

This exhibition was first shown, with some variations, at the Nagoya/Boston Museum of Fine Arts, Nagoya, from 26 April to 9 November 2003.

The Royal Academy of Arts is grateful to Her Majesty's Government for agreeing to indemnify this exhibition under the National Heritage Act 1980, and to The Museums Libraries and Archives Council for its help in arranging the indemnity.

EXHIBITION CURATORS
Erica E. Hirshler
MaryAnne Stevens

CATALOGUE CONTRIBUTORS
Janet L. Comey (JC)
Erica E. Hirshler (EH)
Lisa R. Leavitt (LL)
Kathleen Mrachek (KM)
Ellen E. Roberts (ER)

EXHIBITION ORGANISATION
Lucy Hunt
Kathleen Mrachek
Emeline Winston

PHOTOGRAPHIC AND COPYRIGHT CO-ORDINATION
Andreja Brulc

CATALOGUE
Royal Academy Publications
David Breuer
Harry Burden
Claire Callow
Carola Krueger
Peter Sawbridge
Nick Tite

Copy-editor: Sarah Derry
Design: Maggi Smith
Colour origination: DawkinsColour
Printed in Belgium by Die Keure

British Library Cataloguing-in-Publication Data

A catalogue record for this book is available from the British Library

ISBN 1-903-97360-0 (paperback)

ISBN 1-90397-77-5 (hardback)

Distributed outside the United States and Canada by Thames & Hudson Ltd, London
Distributed in the United States and Canada by Harry N. Abrams, Inc., New York

EDITORIAL NOTE
Measurements are given in centimetres, height before width.

ACKNOWLEDGEMENTS
Kathy Adler, Elliot Bostwick Davis, Katherine Getchell, Andrew Haines, Tsugumi Maki Joiner, Patricia Loiko, Rhona Macbeth, Michael Maegraith, Maureen Melton, Toni Pullman, Gary Rattigan, Victoria Reed, Brooks Rich, Martha Richardson, Jennifer C. Riley, Malcolm Rogers, George T. M. Shackelford, Kate Silverman, David Sturtevant, Jean Woodward

Frontispiece: Detail of cat. 1
Pages 4–5: Detail of cat. 36
Pages 8–9: Detail of cat. 5
Pages 10–11: Detail of cat. 16

CONTENTS

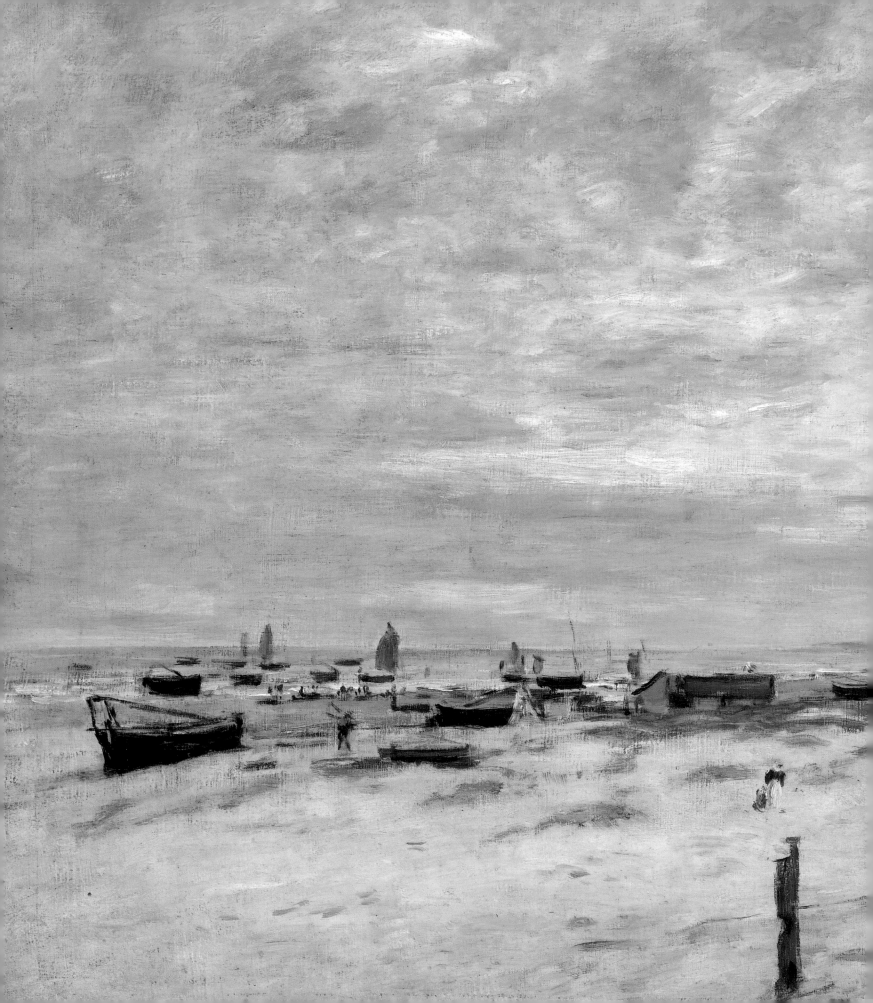

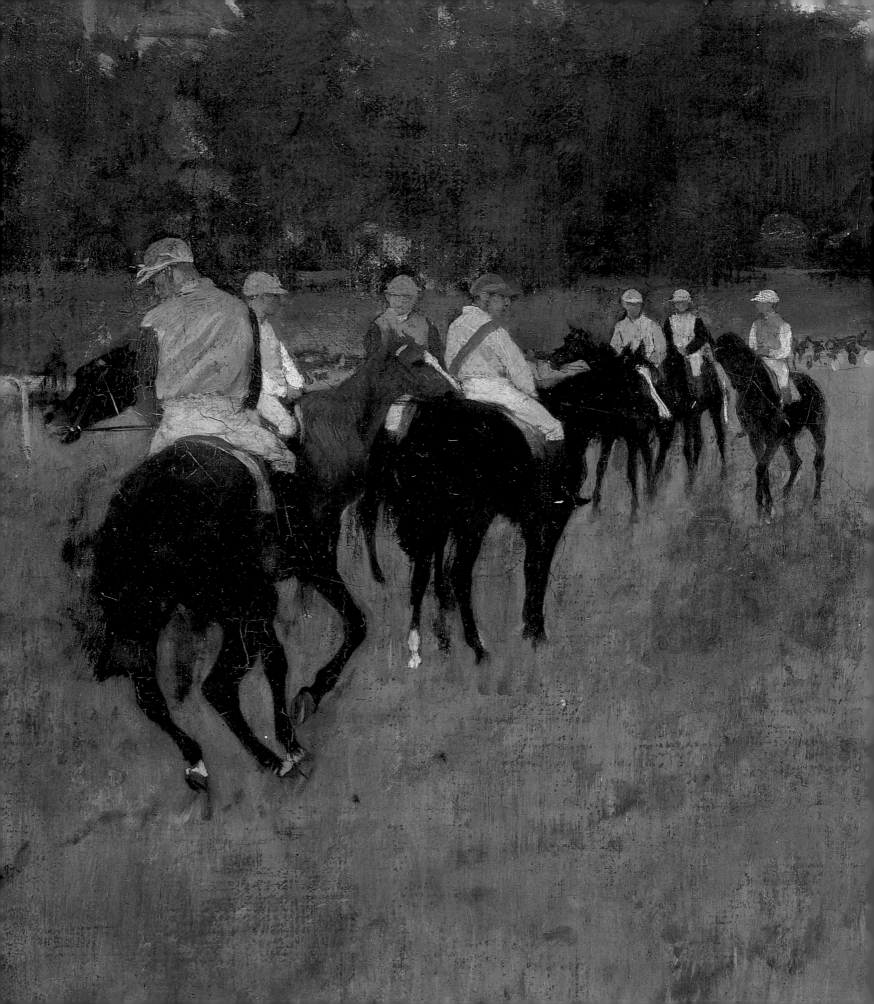

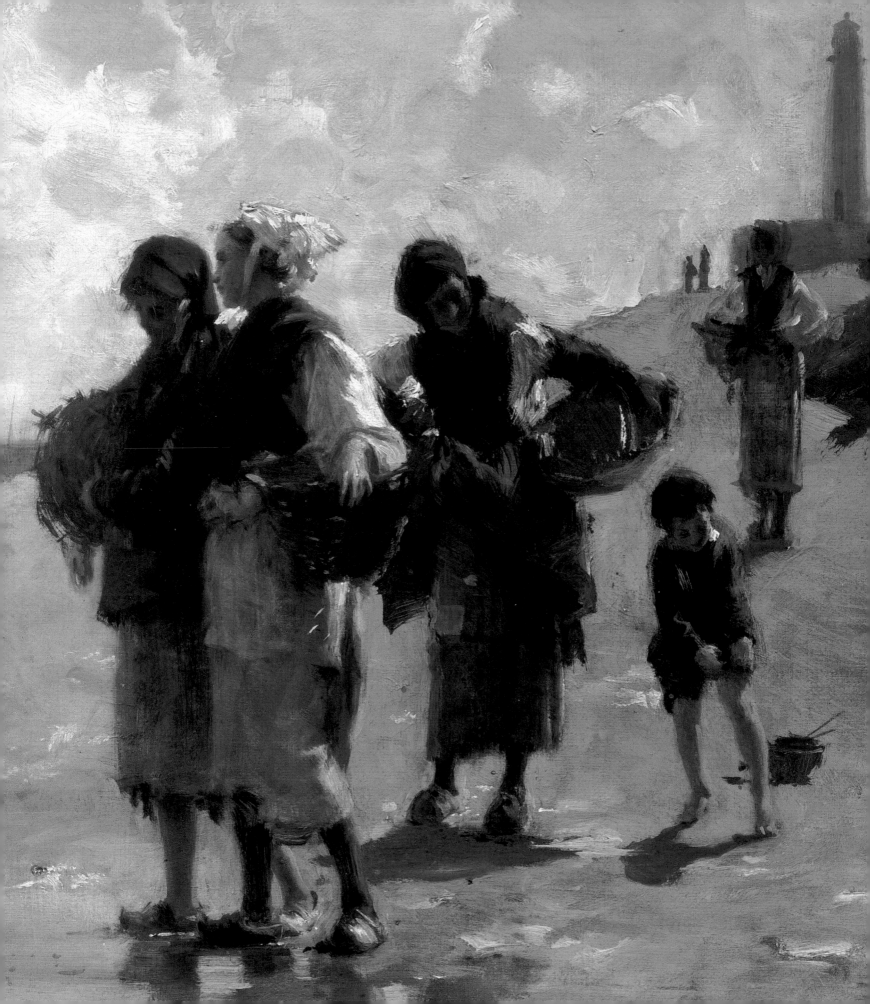

PRESIDENT'S FOREWORD

During the second half of the nineteenth century and the opening decades of the twentieth, Boston was exceptional among American cities for its enthusiastic collecting of modern French and American painting. Open minded, curious, quietly sophisticated, well travelled and well heeled, Bostonians acquired work from galleries and exhibitions in Paris, New York and their home town. Over the period they amassed major collections in which French art, from Corot and Millet to Renoir and Monet, hung beside their American counterparts represented in the paintings of, for example, John Singer Sargent, Childe Hassam, William Morris Hunt and J. Foxcroft Cole. By 1892, such was the discerning appreciation for Impressionism in Boston that it was possible to hold the first one-man exhibition in the United States devoted to Monet with all the paintings drawn from local collections.

The Bostonians' private enthusiasm for French and American modern art in no small way shaped the early character of the Museum of Fine Arts in Boston. Founded in 1870, it boasted works by members of the Barbizon School on its walls by 1881. By 1925, it could number over twenty Monets, as well as works by Pissarro and Renoir, holdings which were complemented by paintings by their American admirers. This exhibition, with the exception of a few additional loans, has drawn on the collections of the Museum of Fine Arts.

Impressionism Abroad: Boston and French Painting is the fourth collaboration between the Royal Academy and the Museum of Fine Arts, Boston. We acknowledge with gratitude the generous engagement of the Museum, and in particular, wish to thank its Director, Dr Malcolm Rogers; Dr George T. M. Shackelford, Chair, Art of Europe and Arthur K. Solomon Curator of Modern Art; and Dr Elliot Bostwick Davis, John Moors Cabot Chair, Art of the Americas, for their unstinting enthusiasm and support. The exhibition has been expertly curated by Dr Erica E. Hirshler, Croll Senior Curator of American Paintings at the Museum of Fine Arts, who has worked with MaryAnne Stevens, Acting Secretary of the Royal Academy. Erica Hirshler has been ably assisted by Kathleen Mrachek, and the exhibition has been organised by Lucy Hunt. A small number of important additional loans have come from both public and private collections. We thank these lenders for their generosity. Finally, we are delighted to be able to thank once again the Fidelity Trust for their support of a further exhibition project shared between the Royal Academy and the Museum of Fine Arts, Boston.

Opposite: Detail of cat. 51
Overleaf: Detail of cat. 52

Sir Nicholas Grimshaw
President, Royal Academy of Arts

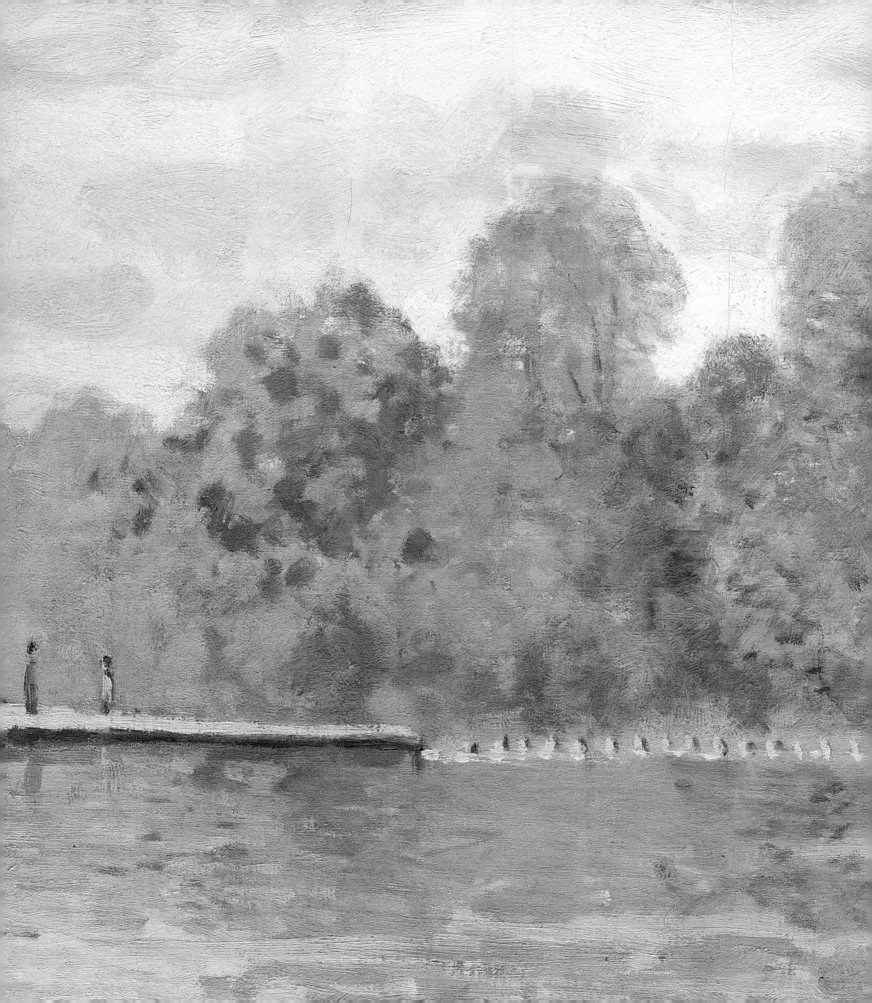

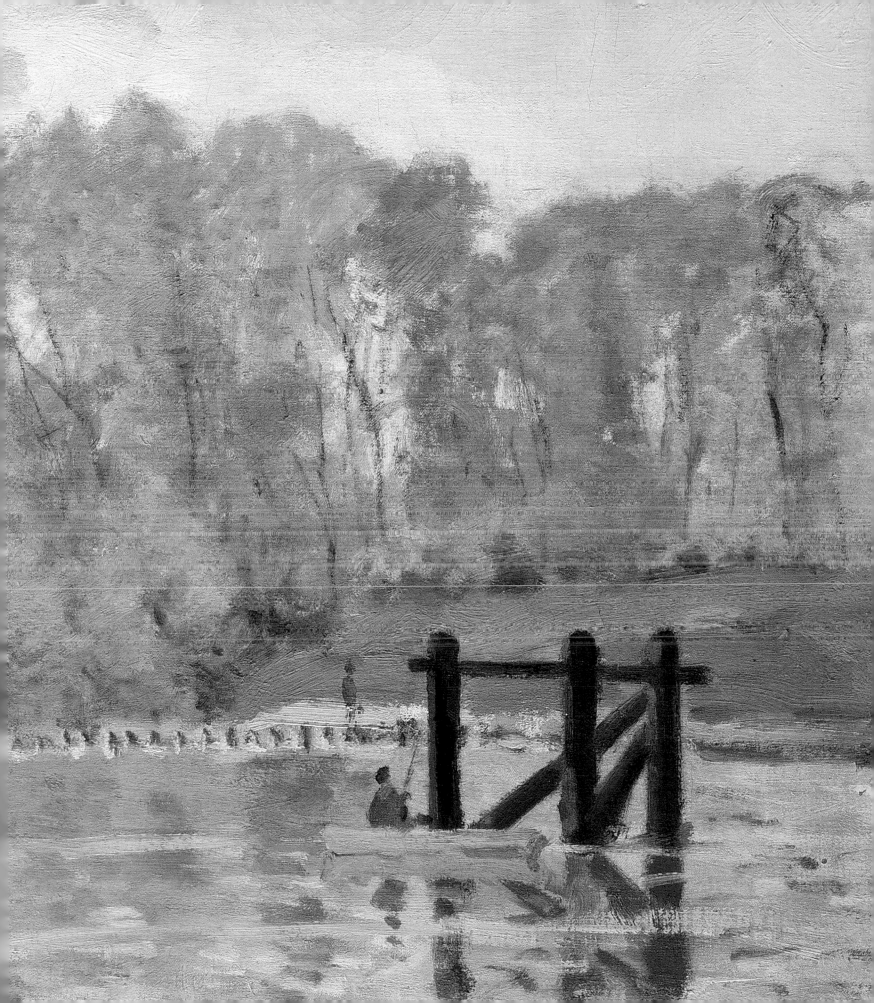

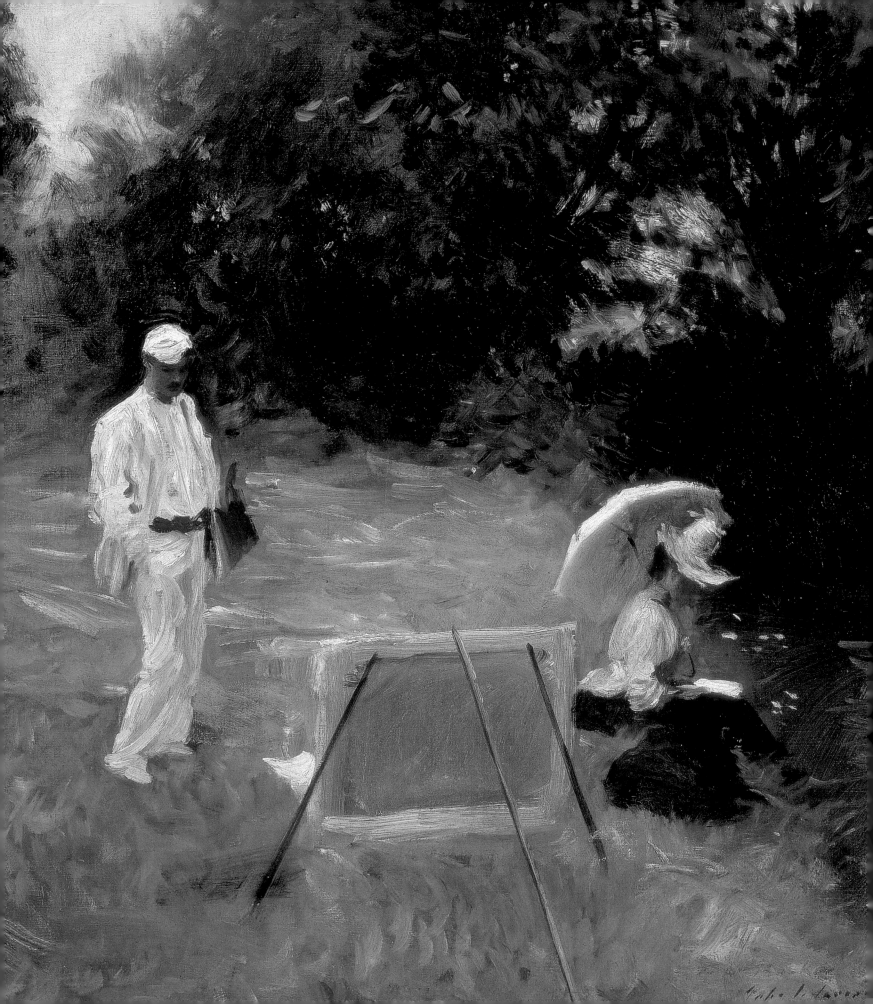

IMPRESSIONISM IN BOSTON

Erica E. Hirshler

Fig. 1 William Morris Hunt
Self-Portrait, 1866
Oil on canvas, 77.2 x 64.8 cm.
Museum of Fine Arts, Boston.
Warren Collection,
William Wilkins Warren Fund

Opposite: Detail of cat. 48

In 1905 a young Boston painter wrote to her father-in-law about two events that had captivated her husband, also an artist:

> The Monet exhibition is in full swing at present. All the street cars have a great placard on in front that you see before anything else – even the car. 'Monet Exhibition at Copley Hall!' Later the sign will be replaced by another: 'Baseball! Boston and New York This Afternoon, 3:30!' I hardly know which interests Phil the more!

These twin passions of Boston culture – viewing Impressionist paintings (especially by Claude Monet) and besting New York on the baseball diamond – are still characteristic of the city. At the time Lilian Westcott Hale wrote her letter, the team now called the Boston Red Sox was less than five years old. The local infatuation with Impressionism, however, had much deeper roots.[1]

The Monet exhibition that Hale mentioned was the fourth in Boston devoted to the French master's paintings since 1892. Almost half of the ninety-five canvases displayed were drawn from local collections, testifying to Boston connoisseurs' commitment to Monet's modern art. Monet's work had first been shown in the city in April 1866, when an unidentified seascape was displayed at the Allston Club, a local painters' association devoted to showing new, and often European, art. It won little notice, but the foundations of Boston's subsequent love affair with Monet's brand of Impressionism had been laid with the local enthusiasm for the French Barbizon style, just as aspects of Impressionism itself sprang from the broadly painted pastoral subjects of Barbizon. Practitioners of both styles employed commonplace motifs rather than heroic sites for landscapes, explored the atmospheric effects of light and weather, and eschewed a tightly painted surface in favour of an individualised finish that maintained the immediacy of a sketch.

By the time the Allston Club was organised in 1866, the charismatic painter William Morris Hunt was Boston's leading tastemaker (fig. 1 and p. 135). Hunt was born in Vermont, attended Harvard in the 1840s, and then travelled to Europe with his family, studying sculpture in Italy. There he came to know Thomas Gold Appleton, an important Boston collector and amateur artist. Appleton was acquainted with the Barbizon painter Constant Troyon and owned several of his pictures, as well as works by Troyon's contemporaries Théodore Rousseau and Narcisse-Virgile Diaz de la Peña (cat. 18). When Hunt and his colleagues later founded the Allston Club,

Fig. 2 Gustave Courbet
The Quarry, 1856
Oil on canvas, 210.2 x 183.5 cm.
Museum of Fine Arts, Boston.
Henry Lillie Pierce Fund

Fig. 3 Thomas Couture
Two Soldiers (study for *Enrollment
of the Volunteers*), c. 1848
Oil on canvas, 81.9 x 65.4 cm.
Museum of Fine Arts, Boston.
Gift by Contribution

they devoted their efforts towards promoting this type of French art. Among the very first things they did was to purchase Gustave Courbet's *The Quarry* (fig. 2), thereby demonstrating the members' dedication to modern French painting that found nobility and spiritual power in everyday subjects, a quality they saw most particularly in works of the Barbizon School.

After his Italian sojourn, Hunt travelled to France and began to study with Thomas Couture, whose figurative work provided a link between traditional heroic painting and the new exaltation of realism. To capture his themes, Couture advocated sketching in oil directly on the canvas and working up broadly painted compositions in large areas of light and shadow (fig. 3). While he emphasised drawing, he favoured colour and tone over clarity of line and preferred to leave his pigments unblended on the canvas. Unlike his popular contemporaries Jean-Léon Gérôme and William Bouguereau, who crafted enamel-like surfaces polished with detail (fig. 4), Couture advocated a rougher finish that clearly revealed the artist's hand. Hunt admired the way that Couture's completed work retained the freshness and vitality of a sketch, finding the method helpful in overcoming the fussiness that he felt diverted the painter (and

Fig. 4 Jean Léon Gérôme
L'Eminence grise, 1873
Oil on canvas, 68.6 x 101 cm.
Museum of Fine Arts, Boston.
Bequest of Susan Cornelia Warren

the viewer) from the generalised atmospheric effects he sought to capture. 'Beauty of outline, beauty of masses, as beauty of colour, require an incessant sacrifice of detail', Couture proclaimed.[2] Hunt always promoted that message, and throughout his own long career as a teacher he sent his best students to France to study with Couture.

 In 1850, while still Couture's pupil, Hunt visited the Paris Salon, the international exhibition of contemporary art. He was captivated by two paintings he saw there by Jean-François Millet, a French artist ten years his senior who had recently settled in the village of Barbizon. Hunt was so impressed with Millet's canvas *The Sower* (1850, Museum of Fine Arts, Boston) that he bought it, reportedly for sixty dollars.[3] He also asked William Perkins Babcock, with whom he had worked in Couture's studio, to introduce him to Millet. Babcock was one of a small group of Boston painters who had already discovered Millet and Barbizon, and Hunt soon joined their community. Hunt and Babcock became especially close to the French artist, even serving as witnesses to his second marriage in 1853, and both would place Millet's work in Boston collections.

Hunt stayed in Paris until 1855, making frequent trips to Barbizon. He not only bought Millet's work but also studied his technique. He was present in the artist's studio when Millet was painting *Shearing Sheep*, a picture that Hunt purchased even before it was finished and that would earn Millet acclaim at the Salon of 1853 (fig. 5). The subject had caught Millet's attention soon after he moved to Barbizon. He first experimented on a small canvas with a frieze-like depiction of men shearing sheep in the shadowy interior of a barn (cat. 29). Millet ultimately abandoned this composition, but the progress of the French artist's work fascinated Hunt. He copied Millet's preliminary sketch (cat. 25) and he acquired the original, keeping it in his studio for the rest of his life.

Hunt became one of the chief proselytisers of Millet's work in the United States. His ability to shape local taste was enhanced significantly after he returned to Boston and married Louisa Dumaresq Perkins, whose father Thomas Handasyd Perkins was one of the city's wealthiest merchants, most important philanthropists, and strongest supporters of the arts. Hunt thus joined Boston's intellectual aristocracy, and his influence on artistic taste was profound. His efforts as an advisor to local collectors equalled his activities as a painter. Many American artists served collectors who were anxious to have their potential purchases evaluated by someone whose aesthetic judgment they trusted. With the serious scholarly study of art history at its very beginning and the curatorial profession many years away, painters like Hunt were the experts. Among the Bostonians whom Hunt advised was Quincy Adams Shaw (p. 130), a wealthy businessman and benefactor who, along with his wife, the educator Pauline Agassiz Shaw, assembled the largest group of Millets in the United States, a collection only surpassed in number (although not in importance) by Britain's James Staats Forbes.

The outstanding treasure of Millets assembled with Hunt's encouragement in Boston is well known.[4] Other French masters also found great favour with local patrons, and a variety of different artists helped to obtain their work. Hunt's fellow painters Thomas Robinson and Joseph Foxcroft Cole (p. 134) were particularly active. Robinson, best known for his Barbizon-inspired landscapes with cows, was a purchasing agent for the Providence, Rhode Island, commercial art gallery of Seth Vose, one of the major suppliers of Barbizon paintings in America. In the 1880s Vose also ran a gallery in Boston's Studio Building on Tremont Street, the headquarters for most of the city's painters and also a place of pilgrimage for admirers of Hunt, who had worked there until his death in 1879. Cole, also a landscapist, bought paintings in France for a number of Boston collectors.

Aside from Millet, the French painter who most inspired Bostonians was Jean-Baptiste-Camille Corot, whose poetic landscapes seemed tailor-made for a community deeply associated with the naturalist writings of the New Englanders Ralph Waldo Emerson and Henry David Thoreau. Corot was much admired throughout the United States, but affection for him in Boston was strong enough to inspire local devotees to credit him with a particular weather condition: a 'Corot day' was misty and grey.[5] His paintings were exhibited at the Allston Club, several of them borrowed from the club's members. Art correspondents often quipped that of the one thousand canvases Corot painted, ten thousand were in America, but despite these intimations concerning the marketing of forgeries after the French master, Bostonians assembled a remarkably fine cache of his work.[6] Corots could be found in the collections of Appleton, James Davis (cat. 13), Robinson, and the great Millet collector Shaw, among many others. Susan Cornelia Clarke Warren (p. 131), one of several important women collectors in the city, bought

Forest of Fontainebleau (cat. 12), a painting that had earned the artist the *Légion d'honneur* when it was exhibited at the Paris Salon of 1846. Warren purchased it through Seth Vose in 1886; she eventually owned at least six Corots. Overshadowing all of these collectors was Henry Clay Angell (p. 126), a friend of Hunt, Robinson and Cole, who owned thirty-four paintings by Corot, ranging from sketches to large finished compositions (cat. 14).

Corot and his younger colleagues Antoine Chintreuil (cat. 10) and Charles-François Daubigny (cat. 15), like Millet and the painters in Barbizon, crafted simple rural landscapes that celebrated the effects of light. In America, Hunt also became increasingly concerned with capturing atmosphere in his work. *Gloucester Harbor*, made during the summer of 1877, is the culmination of his efforts (cat. 24). Though he had studied the scene before, Hunt completed *Gloucester Harbor* in only three hours, proudly announcing to his student and biographer Helen Knowlton that he had 'painted a picture with *light* in it'.[7] Its rough, scumbled sky, with its active clouds and diffuse sunlight, recalls Millet's handling of atmospheric effects in such compositions as *End of the Hamlet at Gruchy* (cat. 30), which Hunt particularly admired. Some critics dismissed Hunt's painting as an unfinished sketch, but the canvas was highly admired in Boston and brought a notably high price when the collector Isabella Stewart Gardner and her husband bought it at the studio sale following Hunt's death.

Bostonians had distinct tastes in both French and American art. They favoured pastoral scenes of modest scale and often expressed enthusiasm for paintings that others dismissed as unfinished. As the critic William Howe Downes noted in 1888, Bostonians 'have never made such extensive, costly, and showy collections as those … in New York', but any American dealer 'who had a good Corot or Courbet [was] obliged to send it to Boston in order to sell it.' Their clear preferences supported with equal fervour a younger generation of artists who painted in a loosely finished style that would become known as Impressionism. 'It is not altogether impossible', reported Downes jovially of his fellow Bostonians, 'to find extremists who already avow openly their admiration for those mad outlaws, the Impressionists!' He added: 'there is such a thing as fashion in art', and in recognition of the lucrative potential of the American market, he remarked that 'the Parisian merchant who foresaw the fame of the men of 1830 is now staking his fortune upon the next turn of the tide.'[8]

Hunt, Robinson and Cole had encouraged Boston's taste for French landscapes, for rural subjects painted with attention to nuances of light and atmosphere using loose and individualised brushwork. These preferences were easily transferred from Millet's Barbizon to Monet's Giverny. As one art columnist noted, 'at last the news is circulated that leading Boston buyers of paintings – the first buyers, in other days of Millets, Corots, Diazes, and Daubignys – are now sending to Paris for this sort of thing, and Impressionism becomes the fashion.'[9]

Many of the devotees of the Barbizon School in Boston began to favour the new style, adding Impressionist canvases to their holdings. Henry Sayles's great nephew described his uncle, one of the city's great collectors of Barbizon paintings, and characterised his evolving taste:

He was a very austere old Victorian gentleman … [who lived in] a large, regular city house [on Commonwealth Avenue] with lots of room. The place was paved with pictures from top to bottom. It was rather gloomy and dark … the big Courbet [*The Quarry*, bought

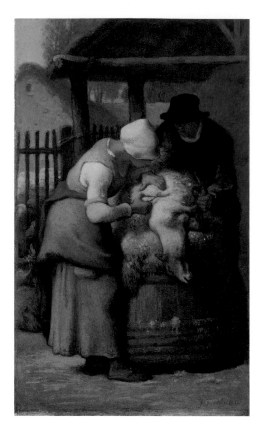

Fig. 5 Jean-François Millet,
Shearing Sheep, 1852–3.
Oil on canvas, 40.7 x 24.8 cm.
Museum of Fine Arts, Boston.
Gift of Quincy Adams Shaw through
Quincy Adams Shaw, Jr, and
Mrs Marian Shaw Haughton

from the then defunct Allston Club] was over the sideboard in the dining room … he had other Courbets and he had Barbizon pictures. And then later he bought Impressionist pictures, Monet and Renoir. And … then, of course, there were a lot of American pictures by people whom he knew … William Morris Hunt and his associates.[10]

One of those 'associates' was J. Foxcroft Cole, a painter who became a good friend and counsellor to Sayles and to other Boston collectors. Cole progressed from a preference for the Barbizon style towards Impressionism with particular ease.

Cole had studied in France, first with Emile Charles Lambinet (see cat. 26) – whose paintings he had already seen and admired in Boston – and later with Charles Jacque, another popular figure in Barbizon. Like Hunt, whose studio was next door to his own, Cole developed a soft and opalescent variation of the Barbizon style, frequently depicting the rural landscape of Normandy and later of Winchester, Massachusetts, just north of Boston, where he settled with his family (cat. 11). In 1872 the American novelist and art critic Henry James characterised Cole's work as both singularly French in style and distinctly sketchy and unfinished in appearance, qualities that allied it with the emerging Impressionist aesthetic. James described Cole's paintings as depicting 'rather less than we would desire but … nothing that we would wish away.' Hunt supported and encouraged Cole, buying four of his paintings and hanging them amidst his Barbizon pictures.[11]

Like Hunt, Cole advised a number of local connoisseurs. Artist Frederic Porter Vinton (see cat. 56) recalled that Cole 'was trusted by collectors to expend large sums, both abroad and at home, for valuable paintings, which are now regarded as priceless possessions by the owners.' Sayles, who owned at least six Coles, commissioned the artist to buy for him in Paris. 'I got about twenty fine examples of the greatest French masters', Cole later recalled.[12] While he continued to suggest Barbizon-style pictures to those who preferred them, Cole increasingly advocated Impressionist paintings. In Paris in 1874 he bought Camille Pissarro's *View of Pontoise* (1873, private collection) for Angell. Pissarro's geometrically arranged view of the village with a screen of trees and reflecting water marked a new direction for both artist and collector. Cole probably also recommended Monet to Angell, who owned *Springtime at Argenteuil* (1872, Portland Museum of Art, Maine) perhaps as early as 1890. In 1891 Cole was described in the press as an importer 'of Monets for collectors of authority'.[13] The writer was no doubt referring to Cole's activities in Paris the September before, when he purchased four paintings for Peter Chardon Brooks (p. 126): Cazin's *Riverbank with Bathers* (cat. 8) and (for almost the same price) three paintings by Monet – *Boulevard Saint-Denis, Argenteuil, in Winter* (cat. 34); *The Fort of Antibes* (cat. 37); and *The Seine at Lavacourt* (1880, Harvard University Art Museums). 'I have spent nearly all your money', Cole wrote to Brooks, adding that he had chosen the Monets from about fifty available at the dealer Durand-Ruel, who represented many of the Impressionists.[14] Cole's conviction was strong enough that he acquired a Monet for himself that year. From the Boston gallery Doll and Richards, where he also displayed his own paintings, Cole bought *Antibes Seen from the Plateau Notre-Dame*, one of Monet's most recent, starkly arranged and vividly coloured images of the Mediterranean (cat. 38).

Among the other associates of Hunt's who shared Cole's embrace of Impressionism were Elizabeth Howard Bartol (p. 126) and Anna Perkins Rogers (p. 130), both of whom had been

Hunt's students in the innovative painting classes he had established for women in the late 1860s. The two artists lived around the corner from one another on Beacon Hill and both came from distinguished Boston families. Bartol, a figure painter and outspoken supporter of women's professional development, owned a typical accumulation of works by Corot (now reattributed), Johan Frederik (Frits) Thaulow (a friend of Monet's who was popular in Boston, see cat. 55), Hunt, and John La Farge. She also bought Eugène Boudin's luminous *Port of Le Havre* (cat. 4). Boudin, whose interest in atmospheric effects had attracted Monet to his studio, had been included in the first Impressionist exhibition in Paris in 1874. Although he never followed his younger brethren into the realm of brilliant colour, broken brushwork and two-dimensional arrangement that marked the height of their achievement, Boudin was described in the Boston press as 'one of the strongest of the Impressionist school'.[15] He had been popular among Boston collectors since the 1870s, and his first solo exhibition in America was held at Chase's Gallery in Boston in May 1890.

Bartol's friend Rogers, whose family tree included the famous colonial portraitist John Singleton Copley and several of his important sitters, specialised in opalescent landscapes and floral compositions. She also became a significant collector, owning tonal pastoral and figurative works by Hunt, George Fuller (a Massachusetts painter then renowned as the American Millet) and Sarah Wyman Whitman, with whom she had studied in Hunt's class. In June 1890 Rogers travelled to Paris, where she purchased a freely brushed rural landscape by Jean Charles Cazin (cat. 9). With its russet tones and fluid paint, the Cazin was similar to the American paintings Rogers owned. About ten days later, however, and three months before Cole's purchases for Brooks, she bought two much more adventurous pictures, both by Monet.

One of the Monets that Rogers chose, *Snow at Argenteuil* (cat. 33), depicts the same kind of tranquil village scene she would have enjoyed in works by the Barbizon painters in Boston collections. The silvery grey Corot-like palette of *Snow at Argenteuil* also allowed an easy transition. The path toward Impressionism was familiar to them, and most Boston collectors ignored the lively dialogue in the American press about the unfinished and bizarre smears that dealers were attempting to foist upon an unsuspecting public. As one perceptive writer on the Paris art scene for an American magazine noted, the Impressionists were 'a product of a natural evolution in modern French art, the lineal descendants of Corot, Théodore Rousseau, Courbet and Millet.'[16]

A simultaneous interest in Asian art among Bostonians also helped them negotiate the more abstract compositional aspects of Impressionist painting. Monet's *Snow at Argenteuil* for example, with its dappled surface, recalls a variety of Ukiyo-e prints that are patterned with falling snow (fig. 6); similarly, Rogers's *Fisherman's Cottage on the Cliffs at Varengeville* (cat. 35), a striking arrangement of bright complementary colours and flat shapes, experiments with Japanese conceptions of design. With the characteristic local fervour for a noble cause, Bostonians Edward Sylvester Morse, Ernest Fenollosa and William Sturgis Bigelow began to work in Japan in the 1870s and 1880s to preserve traditional art and culture before modernisation and contact with the West adulterated it. Boston collectors started to acquire great masterpieces of Japanese art, scholarship was encouraged, and a series of lessons that Westerners could learn from Japanese design were disseminated, most notably by Arthur Wesley Dow, who later codified his lectures in his 1899 book *Composition*.

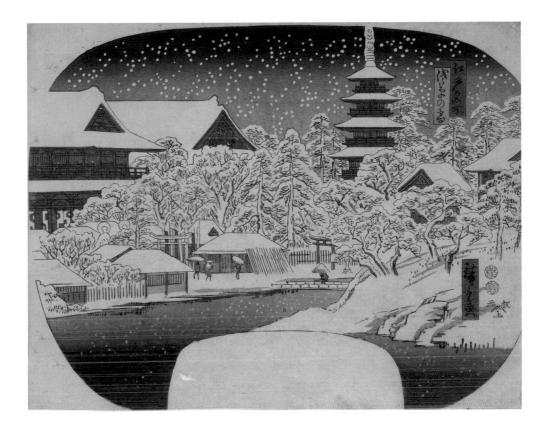

Fig. 6 Utagawa Hiroshige
Asakusa Kannon Temple in Snow, from
the series *Famous Places in Edo*, c. 1850–2
Woodblock print; ink and colour on paper,
23.4 x 29 cm.
Museum of Fine Arts, Boston.
William S. and John T. Spaulding Collection

The flat designs and bold colour juxtapositions of Japanese woodblock prints affected both Impressionist painters and the collectors who bought their work. The confluence between Japanese art and Impressionism was described in the popular American magazine *Lippincott's* in 1879:

> It was not till after the appearance of Japanese albums among us that any one dared to sit down on a river-bank and transfer to canvas a distinctly red roof in juxtaposition with a white wall, a really green poplar, a yellow road and blue water. Before we had the authority of Japanese art for doing it the thing could not be done. But with their art before us … we begin to understand that certain effects which had hitherto been neglected or looked on as eluding imitation can be reproduced in a way we had not thought of.[17]

The tremendous enthusiasm for Japanese art in Boston allowed an innate understanding of many Impressionist compositional strategies, and several major Boston collectors of Asian art also bought Impressionist paintings.

Among the most notable figures to combine a passion for Japan and Impressionism was the artist, collector and advisor Lilla Cabot Perry (p. 137), who included Japanese prints in the backgrounds of several of her figurative compositions. With her husband, who taught English at Keiogijiku University, Perry spent three years in Tokyo in the late 1890s. There she was reintroduced to the educator and connoisseur Okakura Kakuzo, whom she had first met in London ten years earlier, through mutual Boston friends. Okakura helped to arrange an exhibition of Perry's work in Tokyo in 1898.

Lilla Cabot had grown up in the midst of Boston's artistic and literary community. Acquainted with Henry James since she was a schoolgirl, she married one of his closest childhood friends, Thomas Sargeant Perry, in 1874. Thomas Perry taught intermittently and wrote literary criticism; in the mid-1880s, Lilla, mother of three children, began to study painting in Boston. In 1887 the Perrys moved to Paris, where she continued her training. In June 1889 she attended the large exhibition of works by Monet and the sculptor Auguste Rodin at the Galerie Georges Petit. Perry was electrified by Monet's approach to art and became one of his most zealous advocates in the United States.

The Perrys travelled to Giverny, leased a house there, and befriended Monet and his companion Alice Hoschedé (fig. 7). Perry's own work was affected profoundly and, clearly indebted to Monet, she immersed herself in painting the local landscape with an Impressionist eye (cat. 44). She also began to buy Monet's paintings and recommend them to friends. Although her later claim that she introduced Monet to Boston was extravagant, she promoted both the French master and the growing coterie of his American followers. Her vision is represented in the collection of her brother, Arthur Tracy Cabot (p. 126). Cabot bought several Monets in the 1890s, including *Meadow with Haystacks Near Giverny* (cat. 36), as well as the American artist Dennis Miller Bunker's Impressionist painting *The Pool, Medfield* (cat. 7), a scintillating view of the Charles River near Boston.

Perry's interest in both French and American Impressionist paintings was shared by Sarah Choate Sears (p. 130), another woman collector in Boston. Sears, also an artist, had begun her career with watercolour and pastel portraits. In the 1890s she took up the camera, becoming an accomplished art photographer. Eager to embrace innovation in her own work, she was enthusiastic about avant-garde art, and her collection was one of the most adventurous in Boston. Most likely with the encouragement of her friend Mary Stevenson Cassatt, Sears bought Edouard Manet's *Street Singer* in 1895 – a painting that the New York collector Horace Havemeyer had rejected for the unconventional way the model's hand disguised her features (cat. 28). That same year, Sears commissioned John Singer Sargent to paint her daughter Helen (cat. 50). Many Bostonians asked Sargent to record their families, but Sears befriended him, took his portrait with her camera (fig. 8), and owned several of his paintings, including an unusually abstract Alpine landscape (c. 1911, Springfield Museum of Fine Arts, Mass.) In 1909, during the exhibition of Monet's water lily series in Paris, Sears purchased one of his shimmering fusions of vista and reflection (1905, private collection), a painting from the same sequence as the *Water Lilies* bought by Alexander Cochrane (cat. 42 and p. 127). Sears also owned works by Bunker, Cassatt, Paul Cézanne, Edgar Degas, Edmund Charles Tarbell (p. 138), and Pierre-Auguste Renoir.[18]

Boston artists played a significant role in shaping the collections of many of the city's most adventurous patrons. Their aesthetic interests helped to make Boston a vital centre in the nineteenth century for two of the most modern kinds of French art. With riches from both French and American artists readily available, Boston also became an important locus for public display.

——

Various Impressionist paintings had been shown in Boston throughout the 1870s, but the first significant exhibition was held in 1883 at an international trade fair in Mechanics' Hall on Huntington Avenue. Paul Durand-Ruel sent fifteen paintings from Paris by Manet, Monet,

Fig. 7 Lilla Cabot Perry
Claude Monet and Mr Perry at Giverny, 1890–5
Gelatin silver print, 29.3 x 23.5 cm.
Museum of Fine Arts, Boston.
Gift of Mrs Henry Lyman

Fig. 8 John Singer Sargent drawing Ethel Barrymore in 1903. Photograph taken by Sarah Choate Sears. Isabella Stewart Gardner Museum, Boston.

Pissarro, Renoir and Alfred Sisley. It was the first time such work had been shown in quantity in the United States. While few critics noticed these modern pictures, local painters paid attention – in fact, the young Tarbell reproduced Manet's *Dead Christ with Angels* as an engraving for the catalogue. This relatively modest Boston debut was followed by a large show of Impressionism in New York in 1886, and Americans began to respond so positively to the new style that Durand-Ruel opened a branch in New York in 1888. By the end of the decade, several Boston painters had adapted the French style to their own work and Boston collectors had begun a spree of Impressionist purchases.

In a single three-year period between 1889 and 1892, an astonishing number of Impressionist paintings came to Boston. Angell and Brooks bought four Monets between them; cotton buyer Samuel Dacre Bush acquired Monet's *Antibes, Afternoon Effect* (1888, Museum of Fine Arts, Boston); Cabot got Monet's *Cap d'Antibes, Mistral* (cat. 39); industrial chemist Cochrane bought Renoir's *Grand Canal, Venice* (cat. 47); Cole obtained his Monet, *Antibes Seen from the Plateau Notre-Dame* (cat. 38); Mr and Mrs Charles Fairchild, friends of Sargent's, purchased Monet's *Road at La Cavée, Pourville* (1882, Museum of Fine Arts, Boston); engineer Desmond Fitzgerald (p. 128) bought a Sisley, Pissarro's *Peasants in the Fields, Eragny* (1890, Albright-Knox Art Gallery, Buffalo), and about five of the nine Monets he would ultimately own; Clara Millet Bertram Kimball (p. 128), who already owned an early Monet, bought *Valley of the Petite Creuse* (cat. 40); Horatio Appleton Lamb (p. 129) acquired one of Monet's haystacks (1891, Museum of Fine Arts, Boston); another cotton merchant, James Prendergast, procured *Entrance to the Village at Vétheuil* (1879, Museum of Fine Arts, Boston); Rogers bought her two Monets; artist, theorist and teacher Denman Ross purchased *Valley of the Creuse (Grey Day)* (1889, Museum of Fine Arts, Boston); and Sayles acquired four Monets. There were now enough paintings in local collections to organise several exhibitions.

One of the first of these was a group show devoted to Monet, Pissarro and Sisley organised by Durand-Ruel. Held at Chase's Gallery, it opened in March 1891. Each painter was described in a separate essay. Frederic Porter Vinton (p. 138), an established portraitist and supporter of the new style, wrote about his visit to Sisley the summer before at Moret, praising the artist for his response to the 'gaiety of nature'. Fitzgerald passionately applauded Monet, noting: 'there is not living to-day another artist devoted to landscape art who is turning out work which is destined to have such an influence as that of Monet.'[19]

Vinton gave a number of lectures about Impressionism to Boston audiences, and Fitzgerald turned his attention to organising a Monet exhibition. Like Perry, Fitzgerald had been converted to Monet's paintings in Paris at Galerie Georges Petit in 1889. He started buying them immediately and advised others to do the same. In March 1892 Fitzgerald gathered together twenty-one Monets from collections in Boston and Providence and arranged for their display at the St Botolph Club, a local fraternity of art lovers that had hosted exhibitions since its founding in 1880. In his foreword to the catalogue, Fitzgerald explained that he could have amassed twice as many Monets from Bostonians had there been room to show them.

The exhibition was greeted with enthusiasm in several local newspapers, and some writers equated Monet's immediate visions of the landscape with Emerson's much-loved transcendentalist meditations. 'The great secret of all Impressionism', wrote Cecilia Waern in the *Atlantic Monthly*, 'lies in aiming to reproduce, as nearly as possible, the same kind of physical impression

on the spectator's eye that was produced on the eye of the artist by the object seen in nature; to make an immediate impression upon our retina.' Emerson had proclaimed that art should be creative, not merely imitative, and that the painter should omit landscape's prose details in favour of its poetic 'spirit and splendor'. 'Art should exhilarate,' he wrote, 'awakening in the beholder the same sense of universal relation and power which the work evinced in the artist.'[20] In Boston, Monet's paintings could be read as manifestations of Emerson's 'transparent eyeball', a concept of a direct experience of nature in which the observer excludes personal interpretation – or as Emerson suggested, 'all mean egotism vanishes … I am nothing; I see all.'[21] For Emerson this act led to spiritual grace, and perhaps his faithful Boston readers found that quality in Monet's work as well.

The city's enthusiastic response to Monet encouraged other exhibitions of the artist's paintings, including two more at the St Botolph Club in February 1895 and February 1899. Many of the Impressionists were included in group shows throughout the 1890s, and in 1905 another large Monet retrospective was held, this time organised by the Copley Society, a local artists' organisation. For that effort, paintings were borrowed from private collections across the country and Durand-Ruel provided additional canvases. The Monets were shown in Copley Hall together with sculpture by Rodin (fig. 9), the display most likely inspired by the 1889 exhibition in Paris so admired by Perry and Fitzgerald. Fitzgerald again contributed the text, noting that Boston had 'done very well in its steady devotion to Monet's work.'[22]

Many of these paintings reappeared on the walls of the Museum of Fine Arts in 1911 for the first Monet retrospective ever held at an American museum. Boston's collectors would continue to buy Impressionist canvases during the early twentieth century, sometimes even selecting new works – Sears and Cochrane, for example, purchased their Monet water lilies soon after they were painted. Cochrane also bought one of Monet's recent pictures of Venice, a fitting

Fig. 9 Installation of the *Monet–Rodin* exhibition, Copley Society, Boston, March 1905

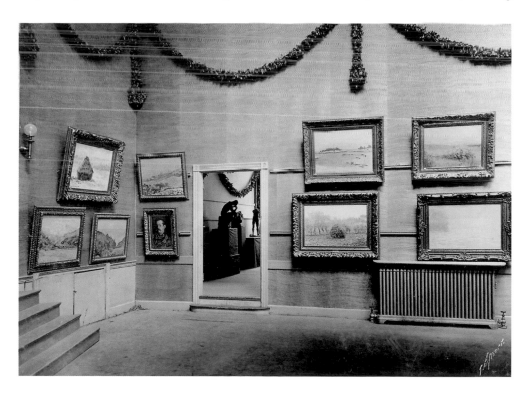

companion to the Venetian oil by Renoir he had acquired in 1889 (cats 41 and 47). Engineer and lawyer Arthur Brewster Emmons (p. 127) bought several images of London and Venice dating from the early 1900s; he acquired twenty-six Monets between 1906 and 1915, all from Durand-Ruel, and the dealers introduced him to the painter in Giverny in 1907. Most often, however, Bostonians continued to purchase landscapes from the 1880s and 1890s. The Edwards family bought eight Monets in the 1920s and 1930s, as well as paintings by Renoir, Pissarro and Sisley (p. 137, cat. 53). John Pickering Lyman (p. 130), a Boston banker who lived in nearby Portsmouth, New Hampshire, amassed a sizeable collection of works by both French and American Impressionist painters, including Sisley, Pissarro (cat. 45), Monet and Frederick Childe Hassam. John Taylor Spaulding (p. 131), heir to a sugar fortune who started his collecting with an astonishing group of Japanese prints, had a more modern eye than many of his colleagues and preferred strong brushwork to evanescent impressions. He bought an early, dark and broadly painted Monet titled *Rue de la Bavolle, Honfleur* (*c.* 1864, Museum of Fine Arts, Boston), as well as Degas's *Ballet Dancer with Arms Crossed*, a boldly rendered sketch (cat. 17).

Fig. 10 Childe Hassam
Boston Common at Twilight, 1885–6
Oil on canvas, 106.7 x 152.4 cm.
Museum of Fine Arts, Boston,
Gift of Miss Maud E. Appleton

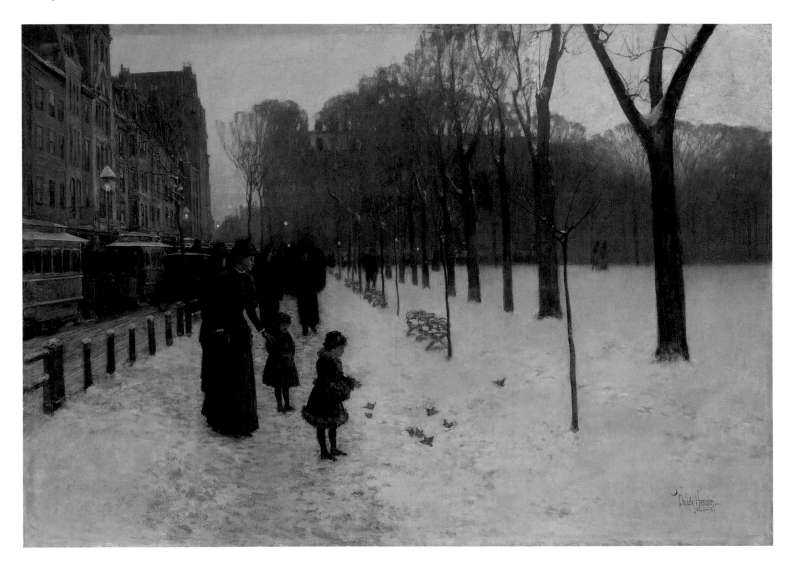

By this time, most of Boston's artists had also embraced Impressionism, transforming American painting 'from the school of mud', as one critic described it, 'to the school of the open air'.[23] Once young advocates of a radical new technique, artists from Boston soon began to dominate the artistic establishment in the United States, teaching at art schools, leading exhibition juries and earning praise as America's most popular painters. Their own brilliant explorations of sunlight were bought by the same patrons who acquired French examples, including Cabot, Cochrane, Fitzgerald, Kimball, Lyman and Sears. In these ways, they established Impressionism as the primary style for both American collections and American art.

—

Impressionist pictures came to Boston in such quantity and through so many different channels that the adoption of the style by local artists seems inevitable. Even if they did not travel to France, the city's painters could see these modern canvases in exhibitions at home, in the collections of their own patrons and as adapted in the work of their American colleagues. Boston artists were among the earliest American painters to embrace Impressionism, revising it to fulfil their own needs and helping to popularise the style throughout the United States.

Hassam was one of the first Boston artists to employ Impressionist themes. His early pastoral landscapes developed from the legacy of Hunt and the example of his friends Robinson and Cole. But after only one brief trip to Europe, Hassam embarked on a series of Boston streetscapes, exploring the newly built boulevards of the Back Bay in rain and snow (fig. 10). Hassam returned to France in 1886 with his wife and lived in Paris until 1889, befriending Couture's daughter and painting the streets and parks of the French capital with increasingly bright tones and divided brushwork. Hassam described one of these pictures, *Grand Prix Day* (cat. 21), in a letter to his friend and former Hunt student Rose Lamb, noting that he had sold it immediately to the Boston dealer Williams and Everett. He praised the Impressionists to critic William Howe Downes, writing that 'an artist should paint his own time and treat nature as he feels it … even Claude Monet, Sisley, Pissaro [*sic*] and the school of extreme impressionists do some things that are charming and will live.'[24]

When he returned to Boston, Hassam depicted his native city in much the same way that he had documented Paris, as an impartial observer painting modern life (cat. 22). Although he settled in New York in 1889, he continued to exhibit in Boston galleries throughout the 1890s. Hassam also kept painting the New England countryside, particularly the rocky island of Appledore off the New Hampshire coast, where he had first travelled in the 1880s. There he found continued inspiration in the sun, sea and rocks, crafting varied compositions from them well into the twentieth century (cat. 23).

In Paris, Hassam had admired the talented American expatriate John Singer Sargent. In the autumn of 1887 Sargent made his first working visit to the United States, seeking new markets for his inventive portraits, which were praised by Henry James in the popular magazine *Harper's Weekly* even before he disembarked. Sargent was a catalyst for the espousal of Impressionism by Bostonians. Although he evidently met Monet in Paris in 1876, Sargent was committed to establishing his reputation in more conventional circles. Some of his more informal sketches, however, including *Fishing for Oysters at Cancale* (cat. 51), demonstrate an affinity with the new style. During the early 1880s, he had begun an intense exploration of Impressionism. In 1881 and again in

May 1885, Sargent exhibited with Monet, Renoir, Degas and other French painters in Paris. He visited Monet at Giverny during the summer of 1885 and painted the French artist at work (cat. 49). Depicted on Monet's easel in the painting is *Meadow with Haystacks Near Giverny* (cat. 36). Sargent returned to Giverny in the summer of 1887 and bought at least one Monet in August (he eventually owned four), just a few weeks before setting sail for America.[25] His excitement about Impressionism found a receptive audience in Boston. He may, for instance, have influenced his close Boston friends the Fairchilds to buy Monet's *Road at La Cavée, Pourville* in 1888 (although they kept it for only a year).

Sargent's interest in Impressionism had a still larger effect upon the city's painters. He befriended several artists in Boston in 1887 and 1888, including Vinton and Bunker, both of whom adopted Impressionism shortly after his visit. Vinton, who had been encouraged early in his career by Hunt and had taken over Hunt's studio in the 1880s, became particularly admired for his dark, dashing portraits of men. He and Sargent worked together in Vinton's new Exeter Street studio, and Vinton, a founding member of the St Botolph Club, played a key role in organising and installing Sargent's first solo exhibition there in January 1888. The two artists maintained their friendship for many years, and in 1903, during one of Sargent's increasingly frequent trips to Boston, he painted Vinton's portrait and gave it to him as a gift (fig. 11).

From 1889 to 1890 Vinton travelled to Europe for an extended visit, stopping in Grèz-sur-Loing and visiting Sisley in nearby Moret. In France, Vinton 'embraced the new gospel of sunlight and open air'; the shimmering paintings he made, including *La Blanchisseuse* (cat. 56), mark his enthusiasm.[26] Vinton further demonstrated his commitment to Impressionism in the lectures he gave to a variety of Boston audiences, including the Boston Art Students' Association. He also bought the contents of the 1890 Boudin exhibition at Chase's Gallery, prompting the French artist to give him three paintings inscribed in his honour.[27]

Sargent had an even stronger influence on Bunker, a young painter just establishing his career. The two artists, both Francophiles and music lovers, became good friends in the fall of 1887, and early the next summer Bunker travelled to England to join Sargent for the season. There he may even have met Monet, who had plans to visit Sargent in England in July 1888. Bunker and Sargent painted together in Calcot Mill, Gloucestershire, a small village with a meandering stream and overhanging willows that provided the setting for many of Sargent's most Impressionist works (cat. 48). Bunker struggled with his own art and likely destroyed the results from this trip, but in the fall, back in Boston, he painted his first entirely Impressionist picture, *Chrysanthemums*, in Isabella Stewart Gardner's greenhouse (fig. 12). With its tipped-up perspective, flattened composition and divided brushwork, it was the most modern picture he had ever made.

Bunker continued his experiments the next summer in Medfield, Massachusetts, painting a series of images of the marshy fields at the source of the Charles River. *The Pool, Medfield* (cat. 7) is a fully realised Impressionist painting, with vibrant colour and an elevated vantage point that creates tension between the surface design and the illusion of recession into space. Bunker used long, sinuous strokes of paint, defining the direction of grasses and water with the flow of his brush. When his Medfield views were first shown at the St Botolph Club in January 1890, critics realised that Bunker was in the vanguard of a new style in American art. Others understood the connection too, and Monet collector Arthur Tracy Cabot bought Bunker's canvas.

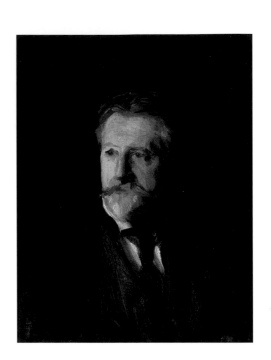

Fig. 11 John Singer Sargent
Frederic Porter Vinton, 1903
Oil on canvas, 64.8 x 48.9 cm.
Museum of Art, Rhode Island
School of Design

Although the press singled out the vivid canvases of Sargent and Bunker on display at the club, one writer noted, 'there are others, but not so intense, by Messrs. Major and Tarbell – and the whole group proves … that certain young men have agreed to look at nature for a while through a blue glass.'[28] Ernest Lee Major (p. 136) had recently replaced Bunker as an instructor at the Cowles Art School in Boston. He had spent the summer of 1888 at Montigny-sur-Loing, not far from Grèz, where a colony of American painters rendered the countryside with fresh attention to light and colour (cat. 27). Tarbell, newly appointed to teach at the School of the Museum of Fine Arts, showed three canvases that January: two figurative works and an unidentified picture entitled *Annisquam*, painted the preceding summer on the coast north of Boston.

Tarbell was a friend of Bunker's; they had met at least by 1888, when Bunker incised Tarbell's name onto one of his paintings and gave it to him. Bunker and Sargent encouraged Tarbell to experiment with Impressionism, and by 1890 he was painting his wife outdoors. Tarbell earned his early reputation with such sunlit images and painted them throughout his career, developing a distinctly American version of Impressionism. In *Mother and Child in a Boat* (cat. 54), for example, Tarbell united his dual allegiance to tradition and to the avant-garde, carefully modelling his figures and inserting their solid forms into a scintillating landscape of light and colour. Kimball, who by this time owned two Monets, immediately purchased Tarbell's painting.

Tarbell not only studied Impressionism in Boston and was inspired to experiment with it by Sargent and Bunker, but also saw new works on display in the city by local artists active in Giverny. As early as 1887, a columnist reported that at least four young Boston painters had gathered the summer before at 'the home of Claude Monet'. 'A few pictures just received from these young men', he added, 'show that they have got the blue-green colour of Monet's impressionism and "got it

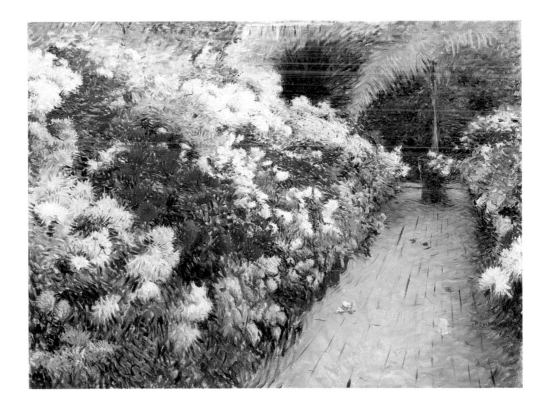

Fig. 11 Dennis Miller Bunker
Chrysanthemums, 1888
Oil on canvas, 90.2 x 121.9 cm.
Isabella Stewart Gardner Museum, Boston

bad"', referring playfully to their enthusiasm for Monet's brilliant palette.[29] One of them, Willard Metcalf, who started his career in Boston but later established himself in New York, was painting in Giverny by 1886 along with Theodore M. Wendel (p. 138) and Louis Ritter, two artists trained in Munich who settled in Boston. The next year they were joined by John Leslie Breck, another Bostonian (p. 133, cat. 6), and a colony of American artists began to develop. Philip Leslie Hale (p. 135), whose wife Lilian later recorded his passion for Monet, spent the summers of 1888–9 and 1890–3 there (see cats 19 and 20). Lilla Cabot Perry arrived in 1889. Eight years later Monet confessed, 'so many artists, students, flock here I have often thought of moving away.'[30]

Metcalf came home to Boston in late December 1888, and Wendel, Ritter and Perry all returned in the next year. Metcalf's Giverny paintings were displayed at the St Botolph Club in March 1889, and Perry showed Breck's work in her studio that autumn. Breck had a large solo exhibition in 1890 at the St Botolph Club; among the lenders was Quincy Adams Shaw, who had added many Brecks to his collection of Barbizon paintings. A number of these so-called 'Givernyites' began to paint Impressionist works in the United States. Perry, for example, posed her daughters in the sunlit garden of the house in Milton, Massachusetts, where she spent the summer of 1890 (cat. 43), and Philip Hale created a series of figural compositions of girls in sunlight at Matunuck, Rhode Island (fig. 13). Dwight Blaney, a friend of Hassam and Breck, bought Monet's *Haystacks at Giverny* (1893, private collection) in 1895 and painted Impressionist landscapes of the Maine coast. The new style had become ubiquitous.

Boston artists, so quick to embrace Impressionism, devoted themselves to it for a long time. Unlike their French exemplars, most of the Americans who adopted Impressionism became integral members of the artistic establishment. By the time Benson made his first Impressionist

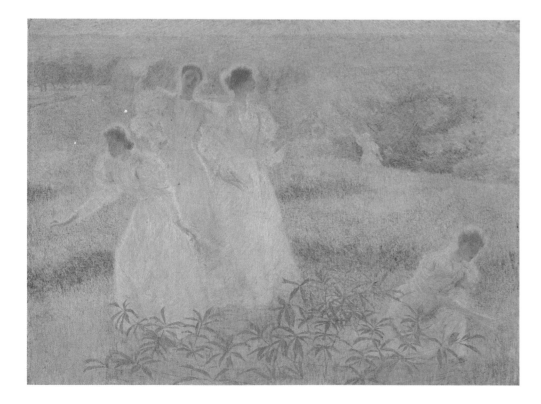

Fig. 13 Philip Leslie Hale
Girls in Sunlight, 1895
Oil on canvas, 73.7 x 99.1 cm.
Museum of Fine Arts, Boston.
Gift of Lilian Westcott Hale
(Mrs Philip Leslie Hale)

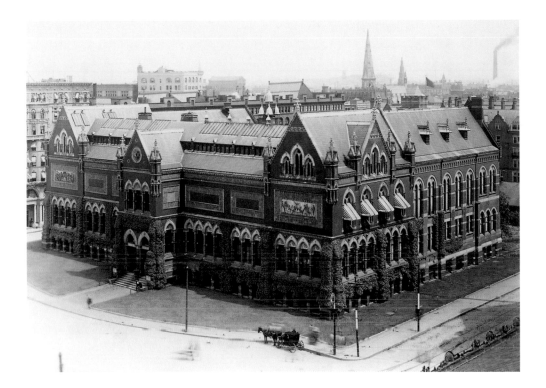

Fig. 14 First building for the Museum of Fine Arts, Copley Square, Boston, 1876, designed by Sturgis and Brigham

picture he had already started to teach at the School of the Museum of Fine Arts. Like his good friend Tarbell, Benson believed in the academy and in established methods of art instruction. His interest in the traditional craft of painting is evident in his own method of working up his preliminary sketches into carefully arranged compositions. *Calm Morning*, for example, is one of several similar images of his children in a dory silhouetted against the sparkling water of Benson's summer home in Maine (cat. 1). Its informal, contemporary subject, fluid brushwork and bright colours are hallmarks of Impressionism, but the underpinning of design and the solid modelling of the figures demonstrate an equal commitment to academic convention.

Calm Morning was included in three exhibitions and sold to a Boston collector almost immediately. When it was reproduced in a magazine for children in 1909, the accompanying text merrily declared that 'hidden somewhere about Mr. Benson's studio … there is a little jar marked "Sunshine" into which he dips his brush.'[31] Both Benson and Tarbell, like their artistic predecessors, became leading tastemakers in Boston. They also earned national recognition and won popular prizes for their art. Downes described their images as 'visions of the free life of the open air, with figures of gracious women and lovely children, in a landscape drenched in sweet sunlight … a holiday world [in which] … all the elements combine to produce an impression of natural joy of living.'[32] Impressionist paintings had been transformed – no longer classified as 'interesting freaks',[33] they became, like baseball, representations of the American dream.

———

The Boston artists who transformed Impressionism into a popular American style were active advisors to local collectors, just as their Barbizon predecessors had been. They also became

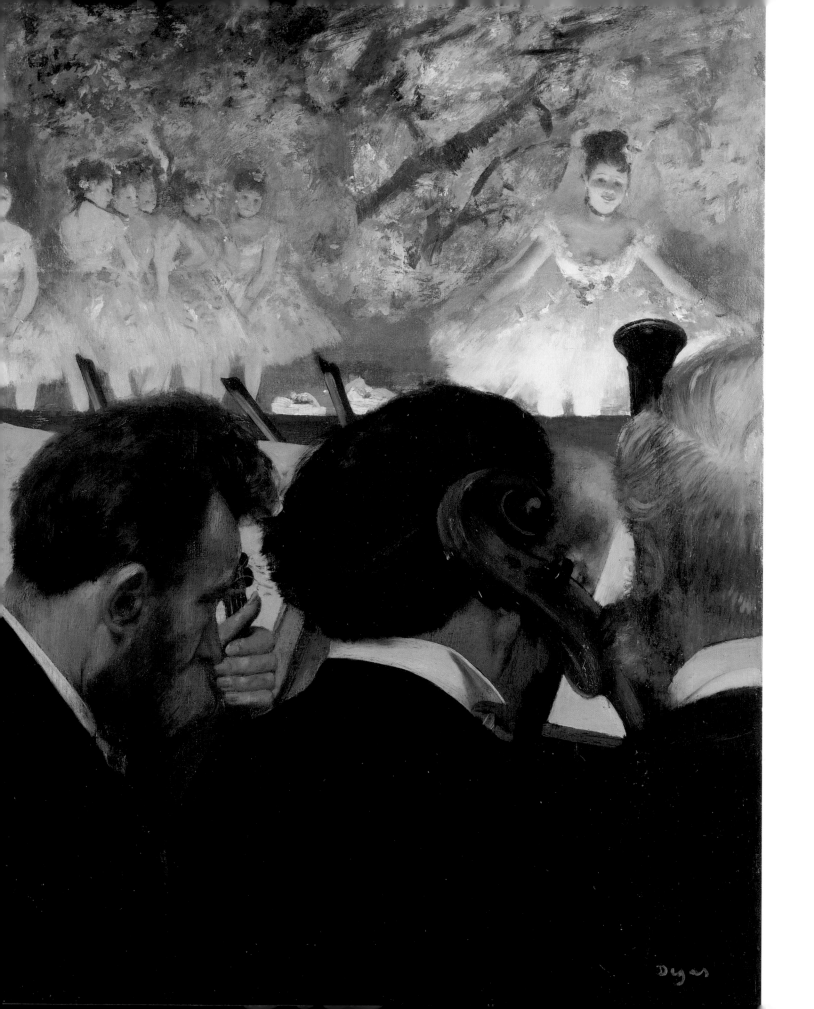

integral players in the formation of institutional collections, most particularly at the new Museum of Fine Arts, founded in 1870 (fig. 14). Unlike many of its sister institutions in the US and abroad, the Boston museum never imposed a restriction against the acquisition of works by living artists for its permanent collection. In consequence, both the Barbizon painters and the Impressionists were quick to find a home there.

Five years after the museum first opened its doors in Copley Square, when its building was still incomplete, the institution was described for visitors in the 1881 *King's Handbook of Boston*. The writer confidently reported that Millet's pastels and watercolours were hanging there, along with paintings by Corot, Troyon and Courbet from the museum's and other collections.[34] Quincy Adams Shaw had given his large Corot, *Dante and Virgil* (*c*. 1859), to the museum in 1875; the painting was on display when the galleries opened on 4 July 1876. Corot's *Bathers in a Clearing* (*c*. 1870–5), a late work, came the year after the artist's death in 1875, along with Millet's *Sewing Lesson* (1874) and twenty Millet drawings (all purchased at the artist's studio sale). These recent pictures were soon followed by other such gifts, among them Millet's *Young Shepherdess* (*c*. 1870–3) and canvases by Diaz and Couture. There never seems to have been a question among the museum's trustees that these paintings, so greatly admired in Boston for over twenty-five years, deserved a prominent place in the city's art museum.

Impressionist paintings were also quickly accepted for display in the galleries of the Museum of Fine Arts, at first as loans from local collectors. In 1891, Anna Rogers lent the institution her two Monets; the next year Desmond Fitzgerald provided his Pissarro and two Monets. In 1894, Adelaide Cole Chase made a loan of Monet's *Antibes Seen from the Plateau Notre-Dame*, which she had inherited from her father, J. Foxcroft Cole, while Mrs Horatio Lamb and Denman Ross lent another three Monets: *Grainstack (Snow Effect), Cliffs of the Petites Dalles* and *Ravine of the Creuse* (1891, 1880 and 1889, all Museum of Fine Arts, Boston). These were new and adventurous canvases, yet they took their places on the gallery walls with apparently no fanfare or fuss, belying Boston's reputation for conservative taste.

By the turn of the century, the museum, despite its chronic lack of acquisition funds, started to consider adding Impressionism to its permanent collection. In April 1903, the dealer Durand-Ruel shipped two paintings by Degas from its New York gallery to the museum for consideration, *Race Horses at Longchamp* (cat. 16) and *Orchestra Musicians* (fig. 15). Museum President Samuel Warren, the son of Barbizon collector Susan Warren, asked the director, Edward Robinson, a classical scholar and future head of the Metropolitan Museum of Art, to garner the opinions of local experts to determine which one of the two canvases to buy. The authorities Robinson solicited were mostly Boston artists, many of them associated with the museum's school. Vinton, Tarbell, Perry and Benson all shared their ideas, expressing unanimous enthusiasm for Degas and discussing the strengths and weaknesses they perceived in the two pictures. Vinton preferred *Race Horses*, which he felt was one of the artist's best jockey subjects, although he recognised the superb quality of *Orchestra Musicians* despite the 'big dark heads', which he found 'ugly in the composition'. Tarbell voted for the musicians, which he thought would most benefit art students, but he confessed that the image of race horses was the best drawing of horses he had ever seen. Perry said that *Orchestra Musicians* would be a better purchase, as it was a more characteristic composition. Although he liked both paintings, Benson preferred the race horses and felt it was the correct choice for the museum.[35]

The Museum of Fine Arts, Boston bought *Race Horses at Longchamp* the next month for $9,000, and it became the first painting by Degas to enter the collection of any American museum. Three years later, in 1906, Denman Ross gave the MFA three Monets. Other gifts soon followed, as well as several bequests from some of Boston's earliest patrons of Impressionism. By 1925, the Museum's holdings already included five Degases, over twenty Monets, three Renoirs and four Pissarros. Paintings by American artists in the new style were also acquired, among them four Bensons, two Bunkers, eight Sargents, five Tarbells and four Vintons.

Once 'mad outlaws', Monet and his French colleagues, along with their American counterparts, were now displayed in dignified installations among the old masters in the museum's galleries. They hung, as local critic Dorothy Adlow described them, 'serenely, placidly, undisturbing', adding 'how quickly the eye becomes adapted' to seeing them there.[36] Boston's French paintings became the cornerstone of one of the richest collections of Impressionism in the United States. They also became an integral part of American culture, revealing the ideals of the city's collectors and providing inspiration to its painters.

NOTES

1 Lilian Westcott Hale to Edward Everett Hale, n.d. (March or April 1905), Hale Family Papers, Sophia Smith Collection, Smith College, Northampton, Mass. There had been a variety of baseball teams in Boston since 1871, but the first Monet was shown in the city in 1866.

2 Thomas Couture, *Conversations on Art Methods*, Paris 1879, quoted in *American Pupils of Thomas Couture*, Marchal E. Landgren, exh. cat., University of Maryland Art Gallery, College Park, 1970, p. 13.

3 Martha A. S. Shannon, *Boston Days of William Morris Hunt*, Boston, 1923, p. 34. For Hunt, see also Martha Hoppin, 'William Morris Hunt and His Critics', *American Art Review*, 2 (1975), pp. 79–91; and Sally Webster, *William Morris Hunt*, Cambridge, 1991.

4 See Alexandra R. Murphy, 'French Paintings in Boston: 1800–1900', in *Corot to Braque: French Paintings from the Museum of Fine Arts, Boston*, Alexandra R. Murphy, exh. cat., Museum of Fine Arts, Boston, 1979; and *Jean-François Millet*, Alexandra R. Murphy, exh. cat., Museum of Fine Arts, Boston, 1984.

5 See Michael Pantazzi, 'Corot and His Collectors', in *Corot*, Gary Tinterow et al., exh. cat., Metropolitan Museum of Art, New York, 1996, p. 398.

6 Vincent Pomarède, 'Corot Forgeries: Is the Artist Responsible?' in New York 1996, p. 383.

7 Helen Knowlton, *The Art-Life of William Morris Hunt*, Boston 1899, p. 119. See also *William Morris Hunt: A Memorial Exhibition*, Martha Hoppin and Henry Adams, exh. cat., Museum of Fine Arts, Boston, 1979, p. 75.

8 William Howe Downes, 'Boston Painters and Paintings, no. 6, Private Collections', *Atlantic Monthly*, 62 (December 1888), pp. 781–2.

9 Greta, 'Art in Boston: The Wave of Impressionism', *Art Amateur*, 24 (May 1891), p. 141.

10 Oral history interview with Henry Sayles Francis at Walpole, New Hampshire, 28 March 1974, Archives of American Art, Smithsonian Institution, Washington, DC, http://artarchives.si.edu/oralhist/franci74.htm.

11 Henry James, 'Art in Boston', *Atlantic Monthly*, 29 (March 1872), p. 372; Wayne Craven, 'J. Foxcroft Cole (1837–1892): His Art, and the Introduction of French Painting to America', *American Art Journal*, 13 (Spring 1981), pp. 51–71.

12 Frederic P. Vinton, 'Joseph Foxcroft Cole', in *Memorial Exhibition of the Works of J. Foxcroft Cole*, exh. cat., Museum of Fine Arts, Boston, 1893, p. 8; J. Foxcroft Cole to William Howe Downes, 1 December 1885, quoted in Craven 1981, p. 62.

13 Greta 1891, p. 141.

14 Cole to Peter Chardon Brooks, 26 September 1890, Brooks Papers, Massachusetts Historical Society, Boston, Mass., quoted in Eric Zafran, 'Monet in Boston', in *Monet and his Contemporaries: Masterpieces from the Museum of Fine Arts*, Eric Zafran (ed.), exh. cat., Bunkamura Museum of Art, Tokyo, 1992, pp. 25–76.

15 Franklin T. Robinson, *Boston Daily Traveler*, 3 (7 June 1890), quoted in *Boudin: Impressionist Marine Paintings*, Peter C. Sutton, exh. cat., Peabody Museum of Salem, Salem, Mass., 1991, p. 15.

16 L. Lejeune, 'The Impressionist School of Painting', *Lippincott's Magazine*, 24 (December 1879), p. 725.

17 Ibid., p. 724.

18 For Sears, see Erica E. Hirshler, 'The Fine Art of Sarah Choate Sears', *Antiques*, 160 (September 2001), p. 320–9.

19 *Catalogue of Paintings by the Impressionists of Paris*, exh. cat., Chase's Gallery, Boston, 1891, p. 4. The writer on Pissarro is not identified.

20 Cecilia Waern, 'Some Notes on French Impressionism', *Atlantic Monthly*, 69 (April 1892), p. 537; Ralph Waldo Emerson, 'Art', *Essays: First Series* (1841), in *The Complete Essays and Other Writings of Ralph Waldo Emerson*, Brooks Atkinson (ed.), New York, 1940, pp. 305, 312.

21 Ralph Waldo Emerson, *Nature* (1836), in *The Collected Works of Ralph Waldo Emerson*, vol. 1, Introduction and notes by Robert E. Spiller, text established by Alfred R. Ferguson, Cambridge, Mass., 1971, p. 10.

22 Desmond Fitzgerald, 'Claude Monet', in *Loan Collection of Paintings by Claude Monet*, exh. cat., Copley Society, Boston, 1905, p. 3.

23 Hamlin Garland, *Roadside Meetings*, New York, 1930, p. 31.

24 Hassam to Rose Lamb, 29 November 1887, and Hassam to William Howe Downes, 28 May 1889, both reprinted in Ulrich W. Hiesinger, *Childe Hassam: American Impressionist*, Munich, 1994, pp. 178–9.

25 Richard Ormond and Elaine Kilmurray, *John Singer Sargent: The Early Portraits*, New Haven and London, 1998, pp. xiii–xvii, 155–60.

26 *Memorial Exhibition of the Works of Frederic Porter Vinton*, Arlo Bates, exh. cat., Museum of Fine Arts, Boston, 1911, p. 14.

27 See L. E. Rowe, 'Boudin, Vinton, and Sargent', *Bulletin of the Rhode Island School of Design*, 25 (January 1937), pp. 2–5; and *European Painting and Sculpture, c. 1770–1937*, Daniel Rosenfield (ed.), Museum of Art, Rhode Island School of Design, Providence, 1991, pp. 121–2.

28 'Fine Arts', *Boston Herald*, 2 February 1890, p. 12. For Bunker, see *Dennis Miller Bunker: American Impressionist*, Erica E. Hirshler, exh. cat., Museum of Fine Arts, Boston, 1994.

29 Greta, 'Boston Art and Artists', *Art Amateur*, 17 (17 October 1887), p. 93. See also William H. Gerdts, *Monet's Giverny: An Impressionist Colony*, New York, 1993.

30 Anna Seaton-Schmidt, 'An Afternoon with Claude Monet', *Modern Art*, 5 (1 January 1897), p. 33, as quoted in Gerdts 1993, p. 35.

31 *St. Nicholas Magazine*, 36 (August 1909), p. 883.

32 William Howe Downes, 'The Spontaneous Gaiety of Frank W. Benson's Work', *Arts and Decoration*, 1 (March 1911), p. 195.

33 'The Midwinter Exhibition at the St. Botolph Club', *Boston Evening Transcript*, 28 January 1890, p. 6.

34 Moses King, *King's Hand-Book of Boston*, Cambridge, Mass., 1881, p. 116. The author of this section was most likely art critic William Howe Downes.

35 Frederic P. Vinton to Samuel D. Warren, 5 April 1903. Vinton also suggested soliciting Sargent's opinion on the matter; Sargent was in Boston that spring and was painting a portrait of Edward Robinson, but no account of his opinion on the Degas paintings survives. The Vinton, Tarbell, Perry and Benson letters are in the Archives of the Museum of Fine Arts, Boston.

36 Dorothy Adlow, 'The Monet Memorial Exhibition', [1927], unidentified clipping, Boston Public Library vertical files.

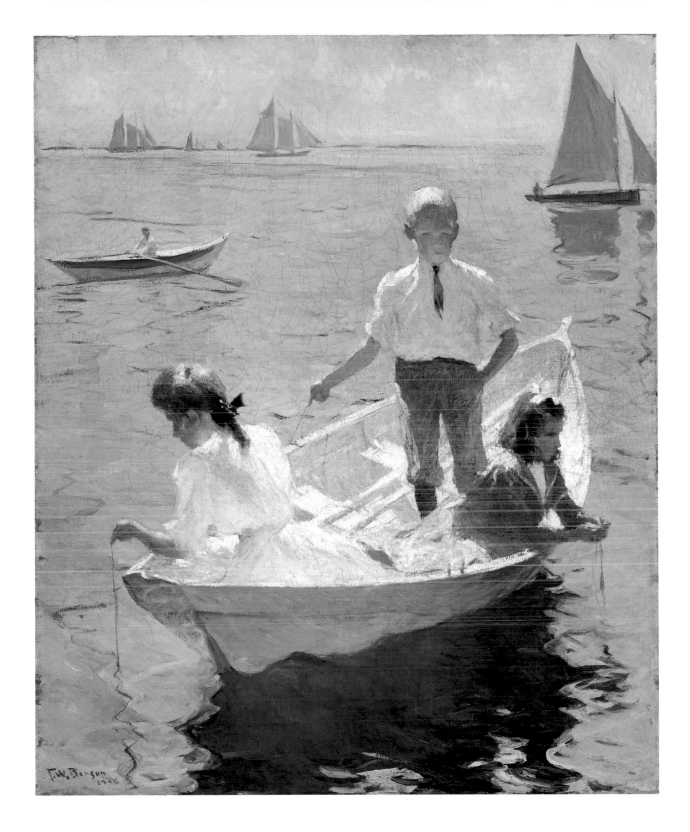

1 FRANK WESTON BENSON
American, 1862–1951
Calm Morning, 1904
Oil on canvas, 112.7 x 91.8 cm
Museum of Fine Arts, Boston. Gift of the Charles A. Coolidge Family

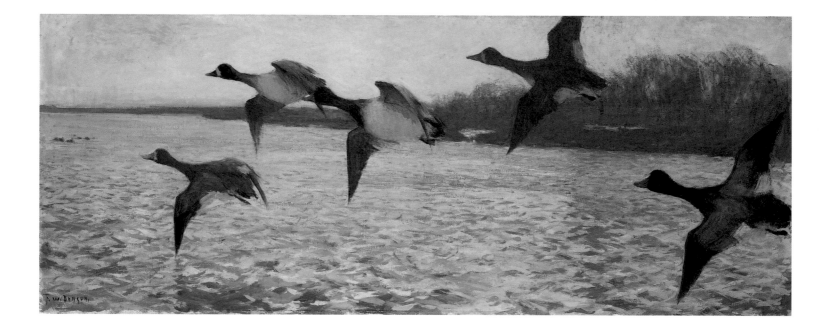

2 FRANK WESTON BENSON
American, 1862–1951
Early Morning, c. 1899
Oil on canvas, 61.3 x 152.7 cm
Museum of Fine Arts, Boston. Bequest of Dr Arthur Tracy Cabot

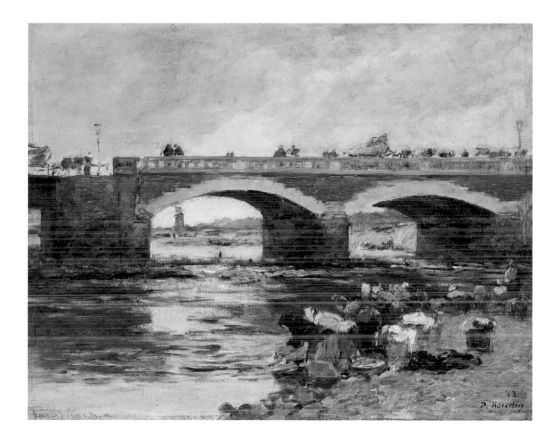

3 EUGENE BOUDIN
French, 1824–1898
Washerwomen Near a Bridge, 1883
Oil on panel, 32 x 41 cm
Museum of Fine Arts, Boston. Bequest of David P. Kimball in memory of his wife Clara Bertram Kimball

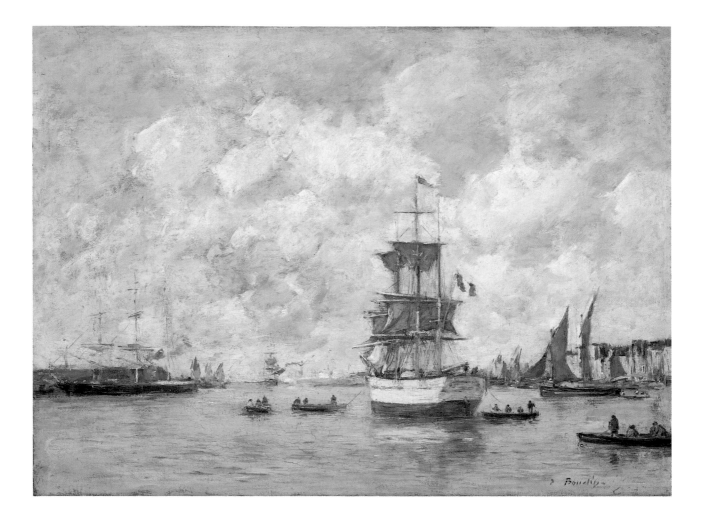

4 EUGENE BOUDIN
French, 1824–1898
Port of Le Havre, c. 1886
Oil on canvas, 39.7 x 54.3 cm
Museum of Fine Arts, Boston. Bequest of Miss Elizabeth Howard Bartol

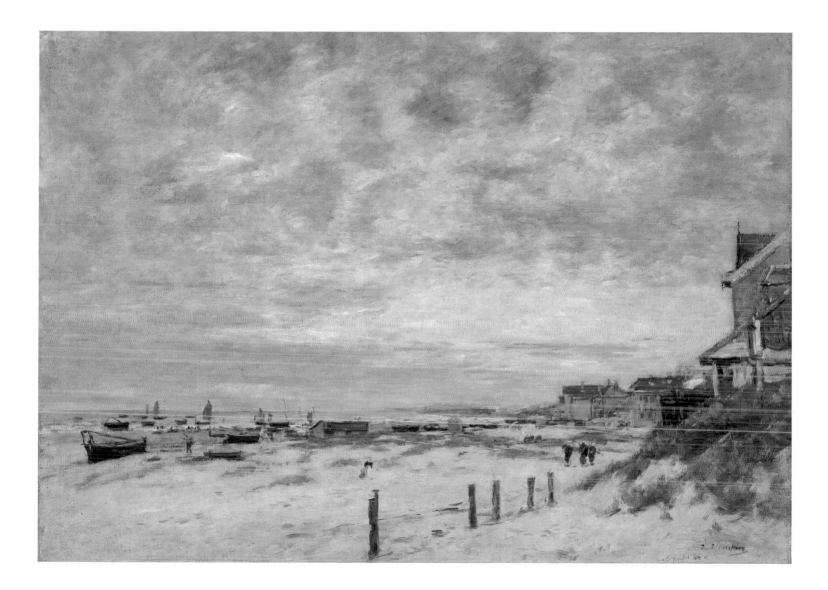

5 EUGENE BOUDIN
French, 1824–1898
The Inlet at Berck (Pas-de-Calais), 1882
Oil on canvas, 54.6 x 75 cm
Museum of Fine Arts, Boston. Bequest of Mrs Stephen S. FitzGerald

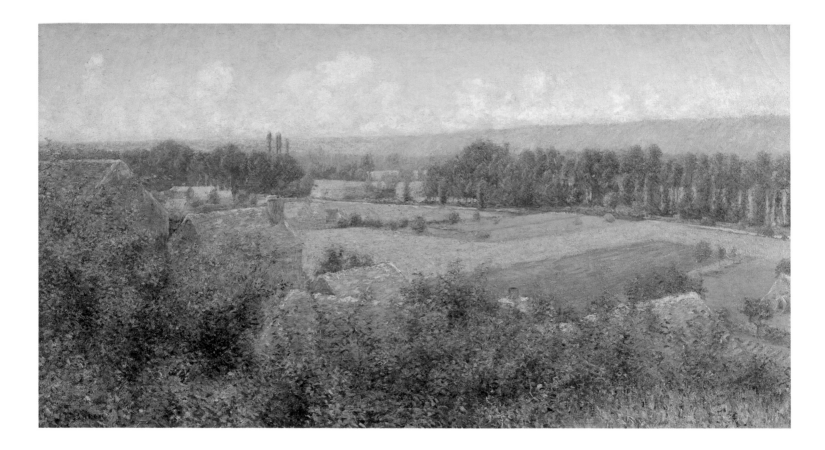

6 JOHN LESLIE BRECK
American, 1860–1899
In the Seine Valley (Giverny Landscape), c. 1890
Oil on canvas, 69.9 x 130.8 cm
Private collection

7 DENNIS MILLER BUNKER
American, 1861–1890
The Pool, Medfield, 1889
Oil on canvas, 47 x 62 cm
Museum of Fine Arts, Boston. Emily L. Ainsley Fund

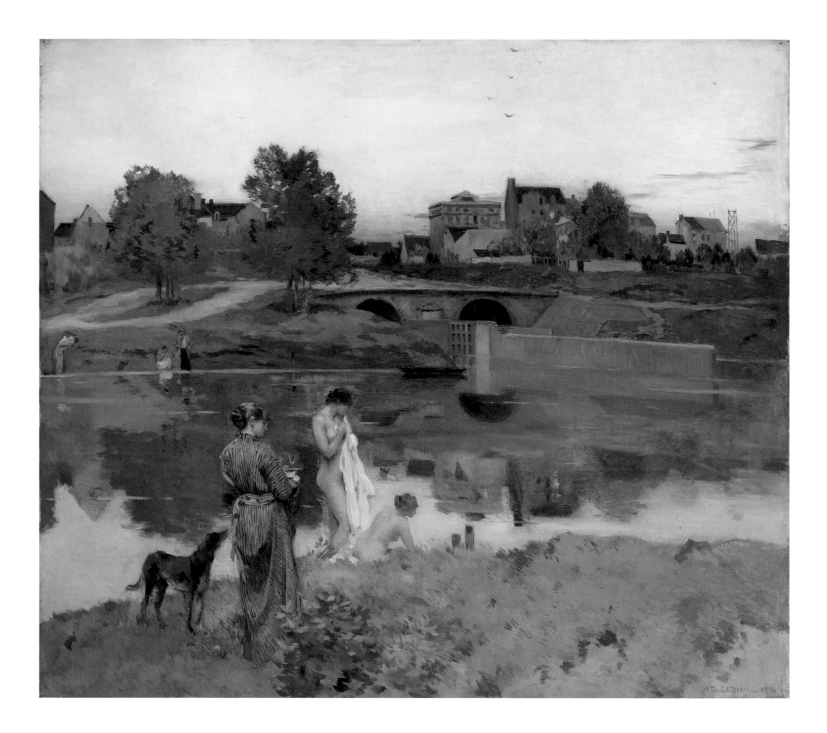

8 STANISLAS HENRI JEAN-CHARLES CAZIN
French, 1841–1901
Riverbank with Bathers, c. 1882
Oil on canvas, 131.2 x 147 cm
Museum of Fine Arts, Boston. Peter Chardon Brooks Memorial Collection; Gift of Mrs Richard M. Saltonstall

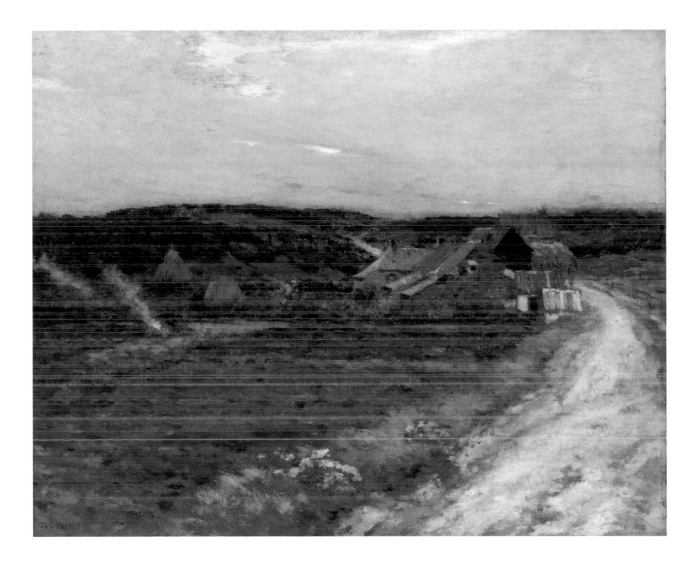

9 STANISLAS HENRI JEAN-CHARLES CAZIN
French, 1841–1901
Farm Beside an Old Road, late 1880s
Oil on canvas, 65.1 x 81.6 cm
Museum of Fine Arts, Boston. Bequest of Anna Perkins Rogers

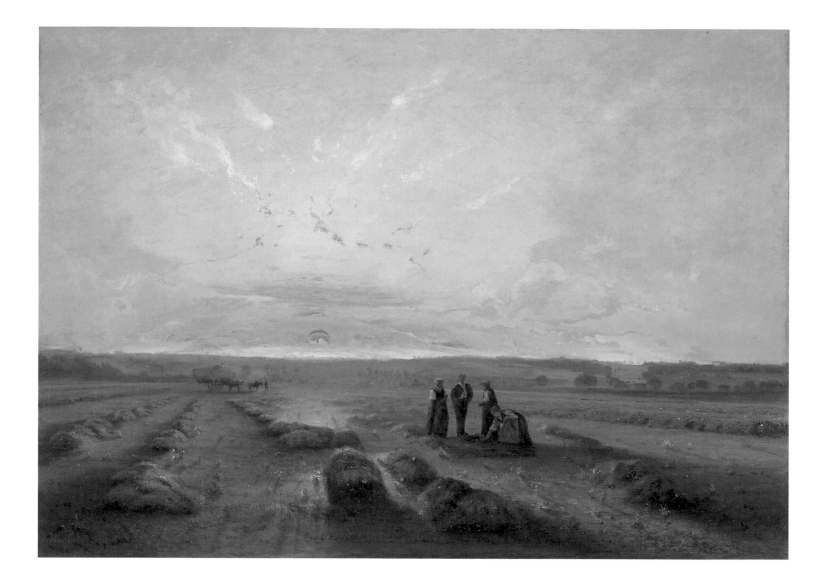

10 ANTOINE CHINTREUIL
French, 1814–1873
Last Rays of Sun on a Field of Sainfoin, c. 1870
Oil on canvas, 95.9 x 134 cm
Museum of Fine Arts, Boston. Gift of Mrs Charles Goddard Weld

11 JOSEPH FOXCROFT COLE
American, 1837–1892
The Aberjona River, Winchester, c. 1880
Oil on canvas, 46 x 66.4 cm
Museum of Fine Arts, Boston. Gift of Alexander Cochrane

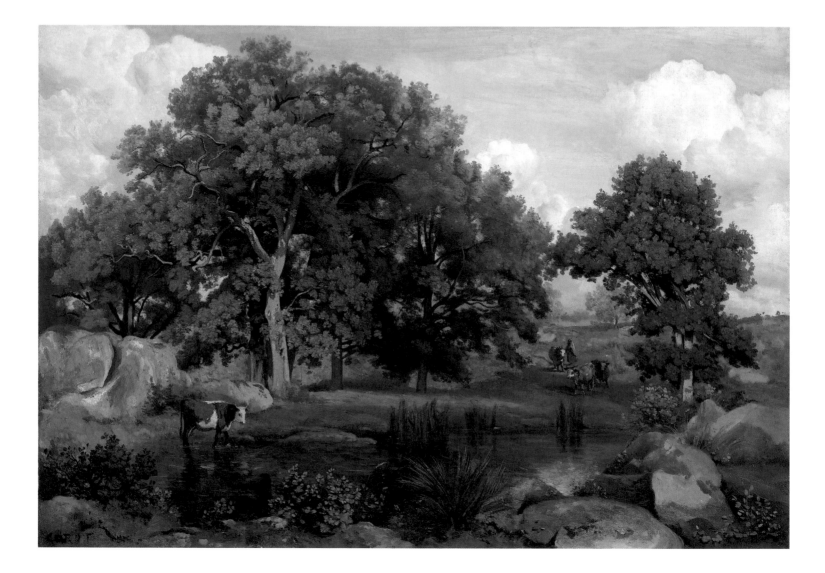

12 JEAN-BAPTISTE-CAMILLE COROT
French, 1796–1875
Forest of Fontainebleau, 1846
Oil on canvas, 90.2 x 128.8 cm
Museum of Fine Arts, Boston. Gift of Mrs Samuel Dennis Warren

13 JEAN-BAPTISTE-CAMILLE COROT
French, 1796–1875
Bathers in a Clearing, c. 1870–5
Oil on canvas, 92 x 73.2 cm
Museum of Fine Arts, Boston. Gift of James Davis

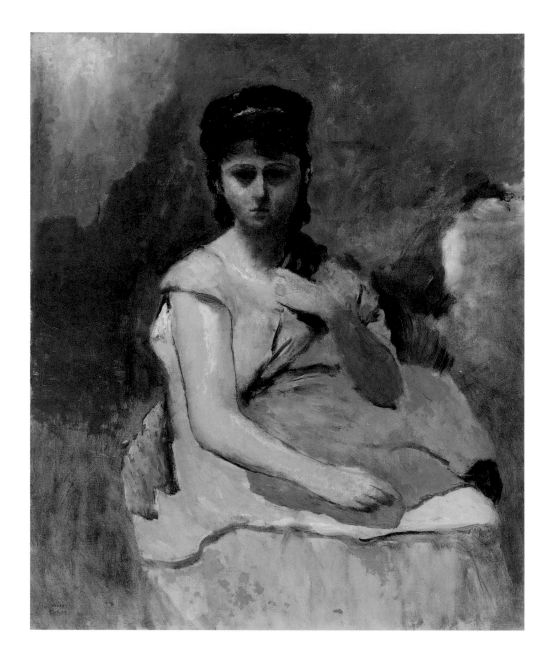

14 JEAN-BAPTISTE-CAMILLE COROT
French, 1796–1875
Woman with a Pink Shawl, c. 1865–70
Oil on canvas, 66.7 x 55.2 cm
Museum of Fine Arts, Boston. The Henry C. and Martha B. Angell Collection

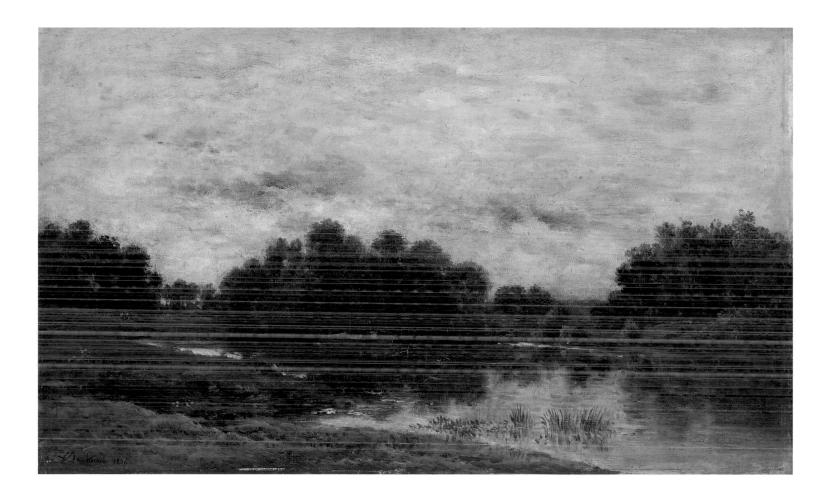

15 CHARLES-FRANÇOIS DAUBIGNY
French, 1817–1878
Ile-de-Vaux on the Oise near Auvers, 1876
Oil on panel, 40.6 x 68.6 cm
Museum of Fine Arts, Boston. Bequest of Mrs David P. Kimball

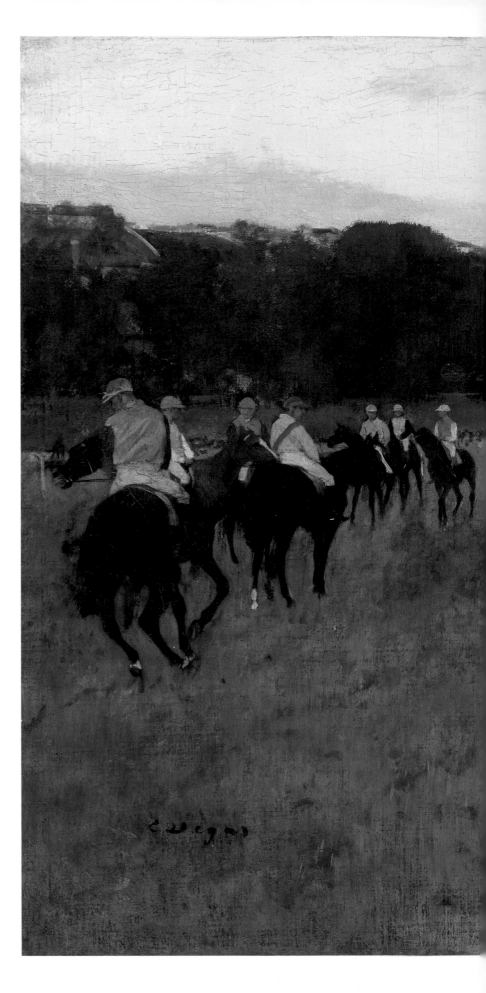

16 EDGAR DEGAS
French, 1834–1917
Race Horses at Longchamp, 1871
possibly reworked in 1874
Oil on canvas, 34 x 41.9 cm
Museum of Fine Arts, Boston. S. A. Denio Collection

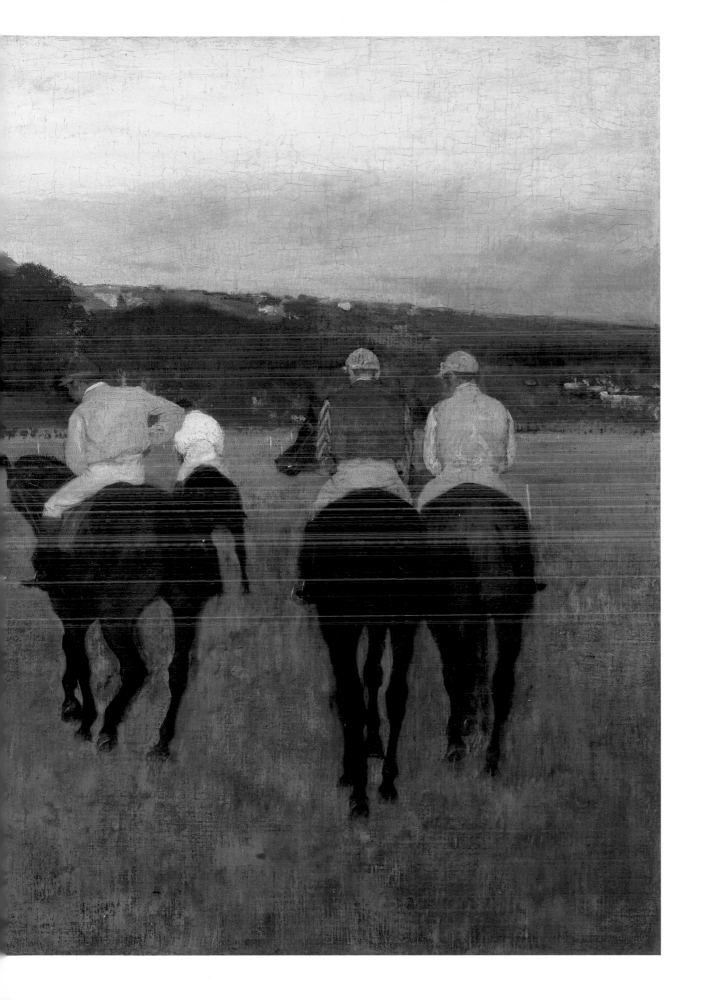

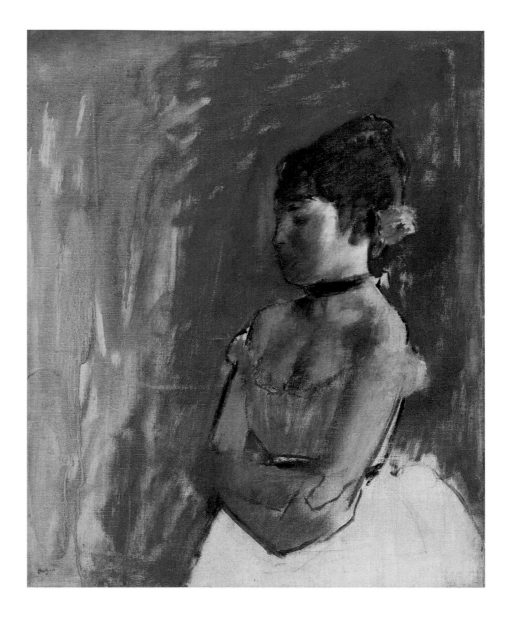

17 EDGAR DEGAS
French, 1834–1917
Ballet Dancer with Arms Crossed, c. 1872
Oil on canvas, 61.3 x 50.5 cm
Museum of Fine Arts, Boston. Bequest of John T. Spaulding

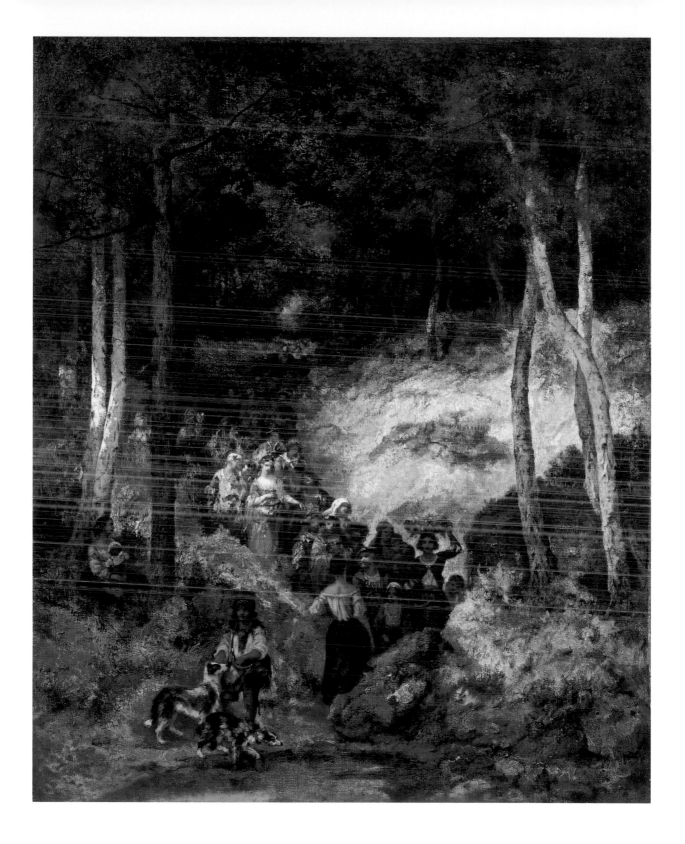

18 NARCISSE-VIRGILE DIAZ DE LA PEÑA
French, 1808–1876
Bohemians Going to a Fête, c. 1844
Oil on canvas, 101 x 81.3 cm
Museum of Fine Arts, Boston. Bequest of Susan Cornelia Warren

19 PHILIP LESLIE HALE
American, 1865–1931
Landscape, c. 1890
Oil on canvas, 46 x 55.9 cm
Museum of Fine Arts, Boston. Gift of Nancy Hale Bowers

20 PHILIP LESLIE HALE
American, 1865–1931
French Farmhouse, c. 1893
Oil on canvas, 64.8 x 81.3 cm
Museum of Fine Arts, Boston. Gift of Nancy Hale Bowers

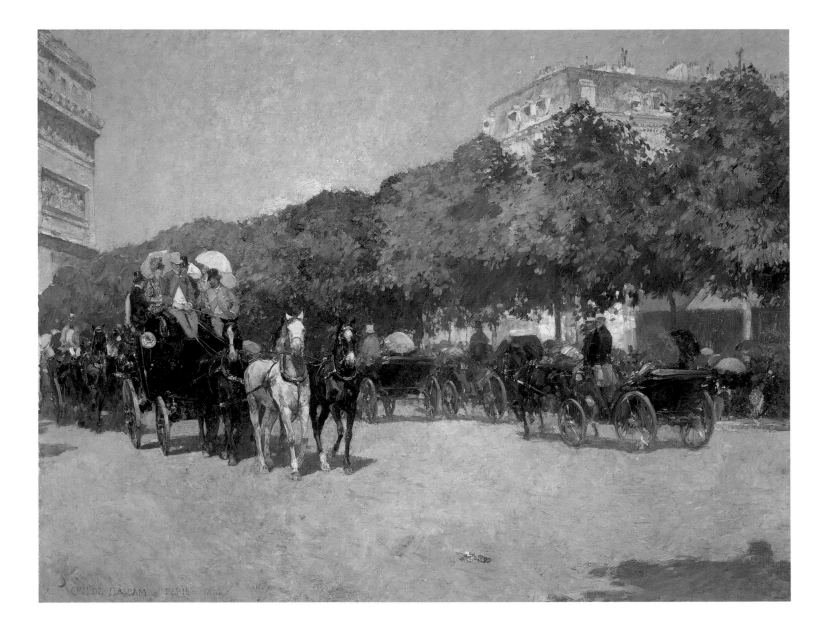

21 CHILDE HASSAM
American, 1859–1935
Grand Prix Day, 1887
Oil on canvas, 61.3 x 78.7 cm
Museum of Fine Arts, Boston. Ernest Wadsworth Longfellow Fund

64

22 CHILDE HASSAM
American, 1859–1935
Charles River and Beacon Hill, c. 1892
Oil on canvas, 41 x 45.7 cm
Museum of Fine Arts, Boston. Tompkins Collection

23 CHILDE HASSAM
American, 1859–1935
Bathing Pool, Appledore, 1907
Oil on canvas, 63.2 x 75.6 cm
Museum of Fine Arts, Boston. Ernest Wadsworth Longfellow Fund

24　WILLIAM MORRIS HUNT
American, 1824–1879
Gloucester Harbor, c. 1877
Oil on canvas, 53.7 x 79.1 cm
Museum of Fine Arts, Boston. Gift of H. Nelson Slater, Mrs Esther Slater Kerrigan
and Mrs Ray Slater Murphy in memory of their mother Mabel Hunt Slater

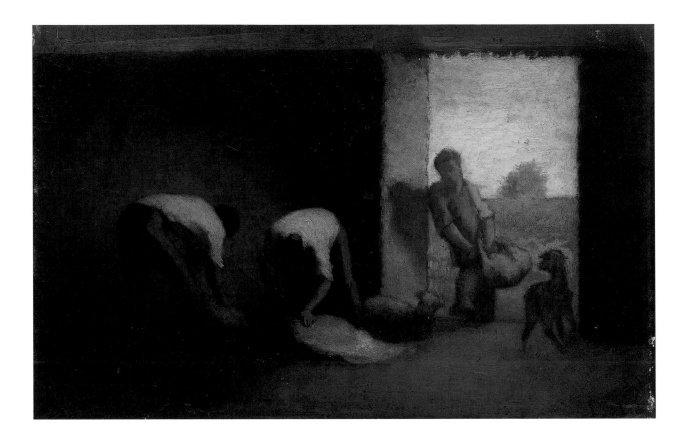

25 WILLIAM MORRIS HUNT
American, 1824–1879
Sheep Shearing at Barbizon, c. 1852
Oil on panel, 25.1 x 39.4 cm
Museum of Fine Arts, Boston. Bequest of Mrs Edward Wheelwright

26　EMILE CHARLES LAMBINET
French, 1815–1877
Village on the Sea, 1866
Oil on panel, 29.5 x 46 cm
Museum of Fine Arts, Boston. Bequest of Ernest Wadsworth Longfellow

27 ERNEST LEE MAJOR
American, 1864–1950
Resting – Montigny-sur-Loing, 1888
Oil on canvas, 65.4 x 81.3 cm
Museum of Fine Arts, Boston. Gift of the Morris Family

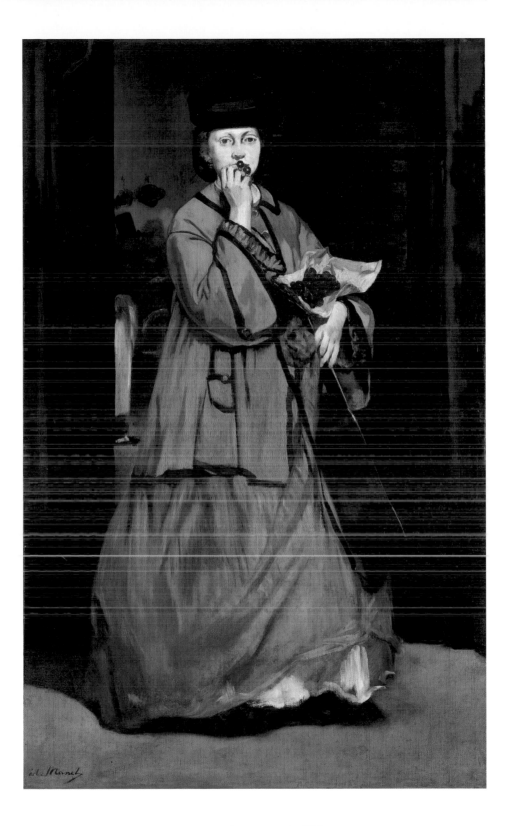

28 EDOUARD MANET
French, 1832–1883
Street Singer, c. 1862
Oil on canvas, 171.1 x 105.8 cm
Museum of Fine Arts, Boston. Bequest of Sarah Choate Sears
in memory of her husband, Joshua Montgomery Sears

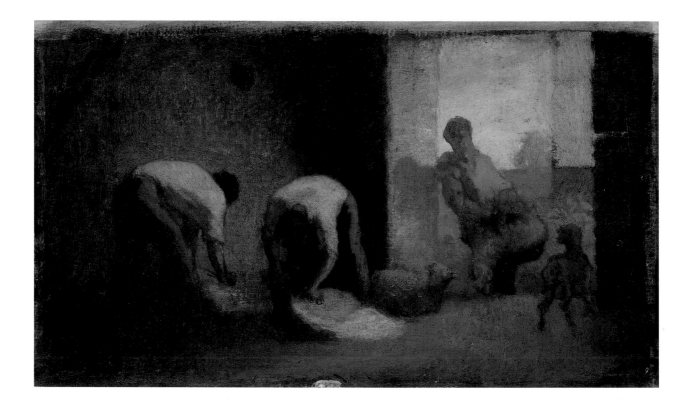

29 JEAN-FRANÇOIS MILLET
French, 1814–1875
Three Men Shearing Sheep in a Barn, c. 1852
Oil on canvas mounted on panel, 24.5 x 39.3 cm
Museum of Fine Arts, Boston. Partial gift of William Morris Hunt II

30 JEAN-FRANÇOIS MILLET
French, 1814–1875
End of the Hamlet of Gruchy, 1866
Oil on canvas, 81.6 x 100.6 cm
Museum of Fine Arts, Boston. Gift of Quincy Adams Shaw
through Quincy Adams Shaw, Jr, and Mrs Marian Shaw Haughton

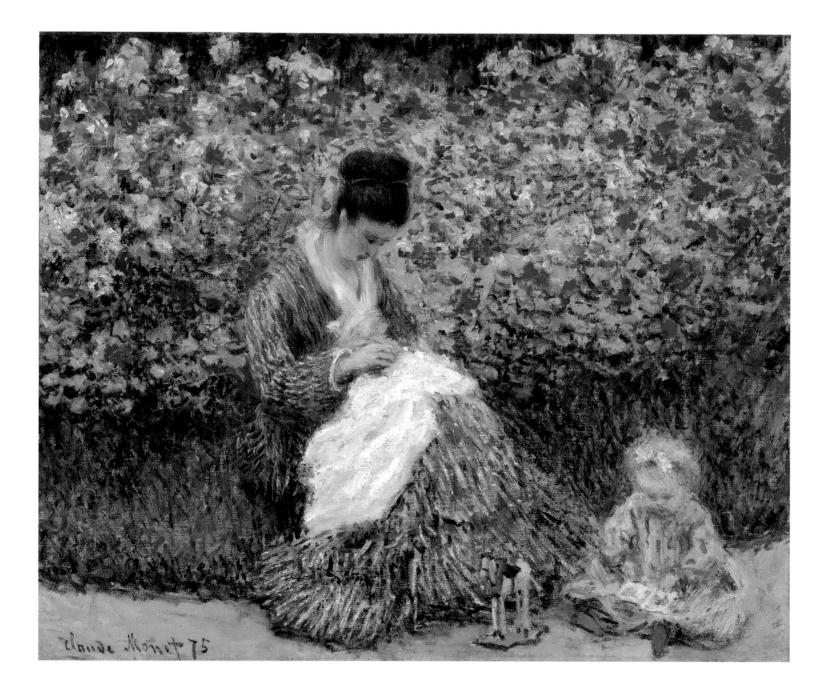

31 CLAUDE MONET
French, 1840–1926
Camille Monet and a Child in the Artist's Garden in Argenteuil, 1875
Oil on canvas, 55.3 x 64.7 cm
Museum of Fine Arts, Boston. Anonymous gift in memory of Mr and Mrs Edwin S. Webster

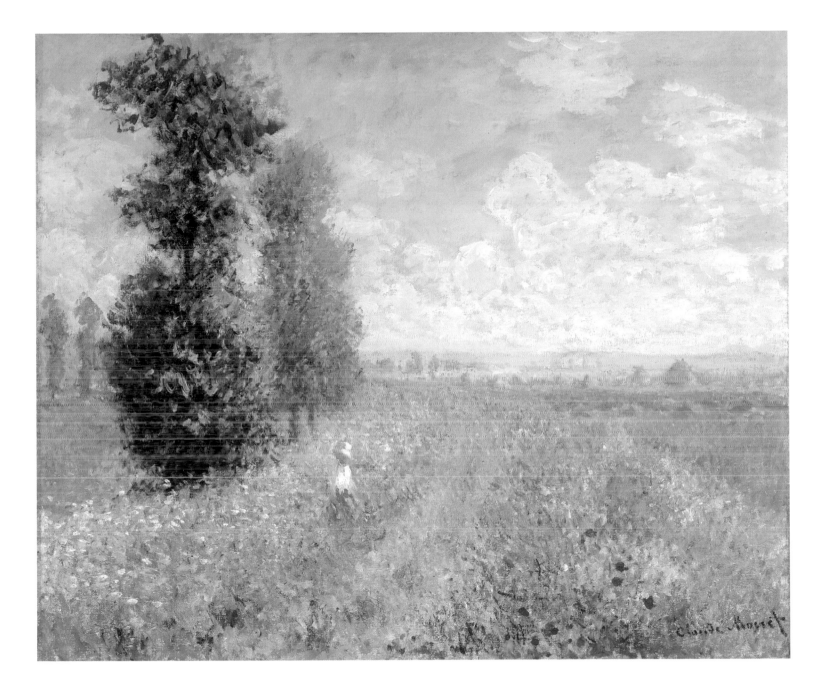

32 CLAUDE MONET
French, 1840–1926
Meadow with Poplars, c. 1875
Oil on canvas, 54.6 x 65.4 cm
Museum of Fine Arts, Boston. Bequest of David P. Kimball in memory of his wife Clara Bertram Kimball

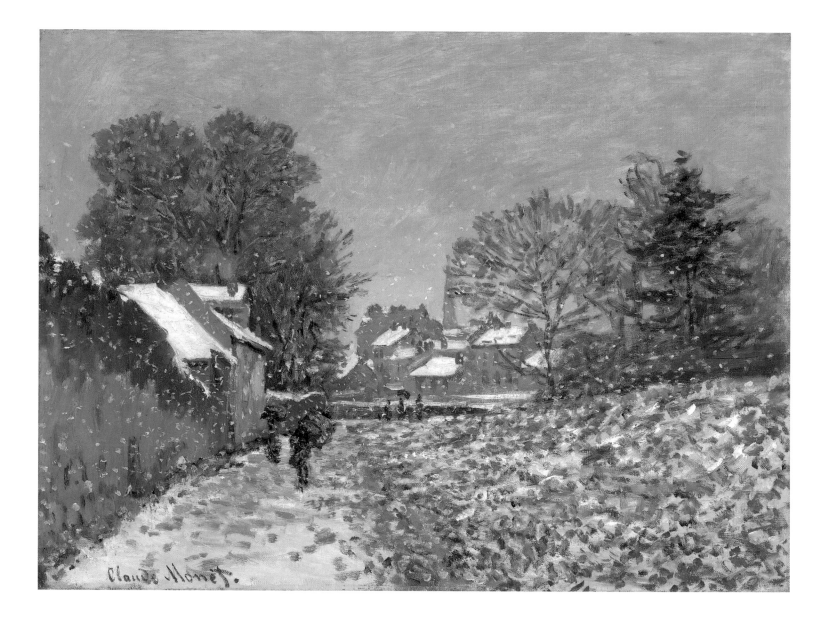

33 CLAUDE MONET
French, 1840–1926
Snow at Argenteuil, c. 1874
Oil on canvas, 54.6 x 73.7 cm
Museum of Fine Arts, Boston. Bequest of Anna Perkins Rogers

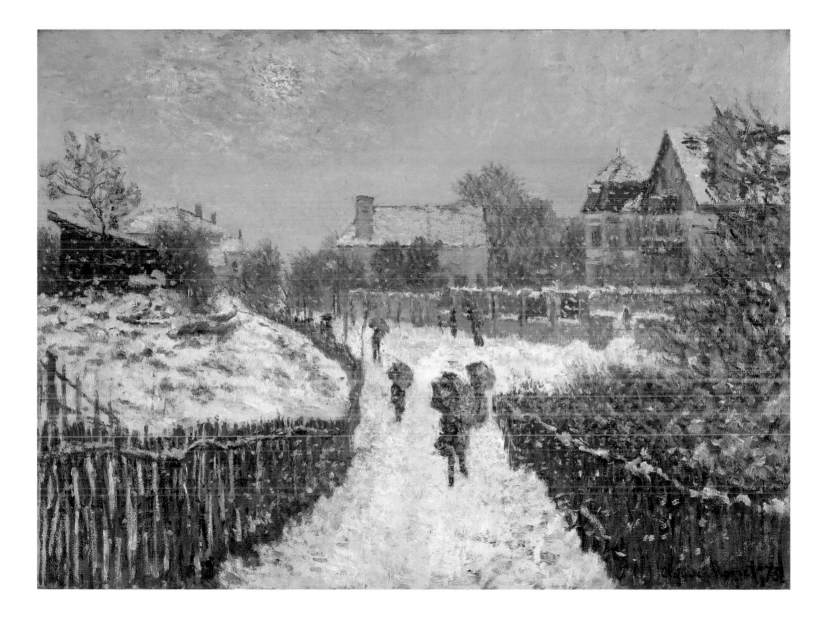

34 CLAUDE MONET
French, 1840–1926
Boulevard Saint-Denis, Argenteuil, in Winter, 1875
Oil on canvas, 60.9 x 81.6 cm
Museum of Fine Arts, Boston. Gift of Richard Saltonstall

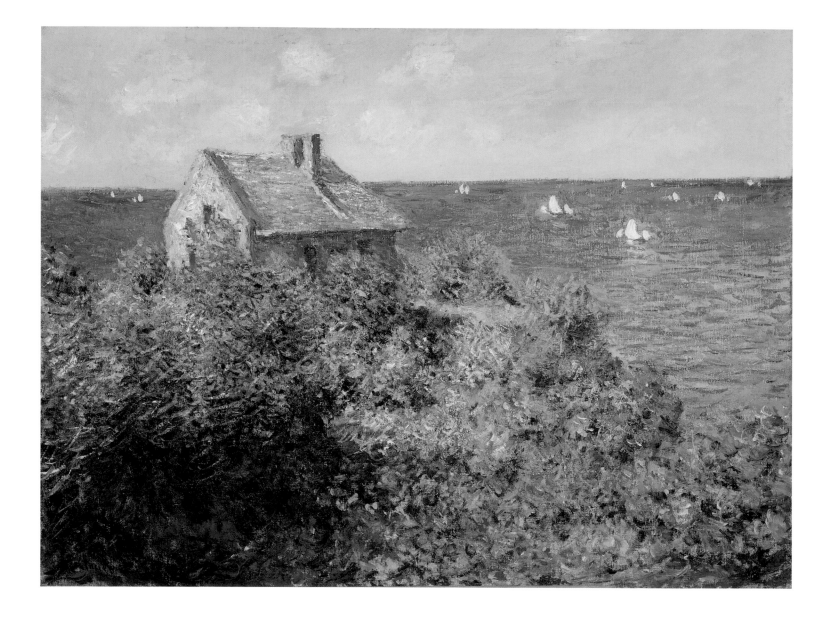

35 CLAUDE MONET
French, 1840–1926
Fisherman's Cottage on the Cliffs at Varengeville, 1882
Oil on canvas, 60.6 x 81.6 cm
Museum of Fine Arts, Boston. Bequest of Anna Perkins Rogers

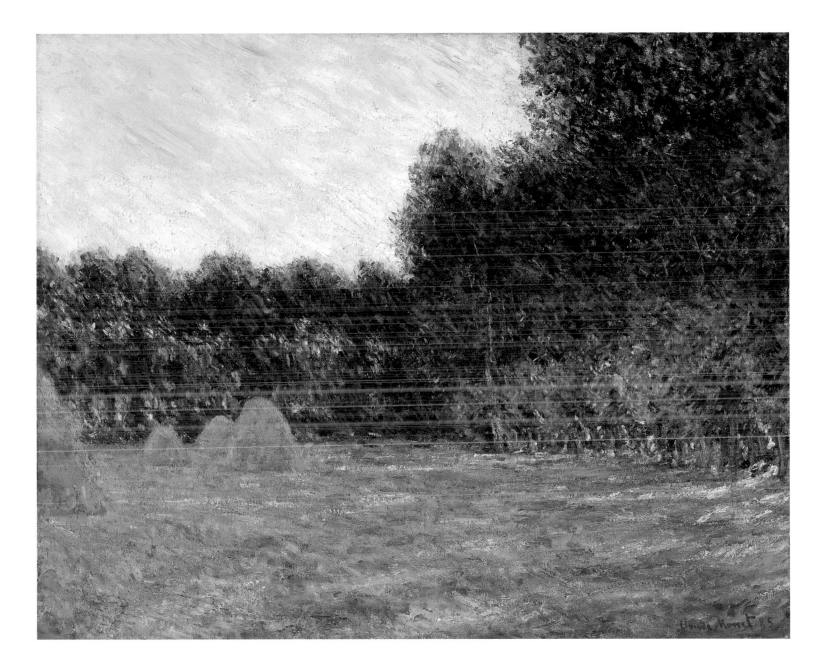

36 CLAUDE MONET
French, 1840–1926
Meadow with Haystacks near Giverny, 1885
Oil on canvas, 74 x 93.5 cm
Museum of Fine Arts, Boston. Bequest of Arthur Tracy Cabot

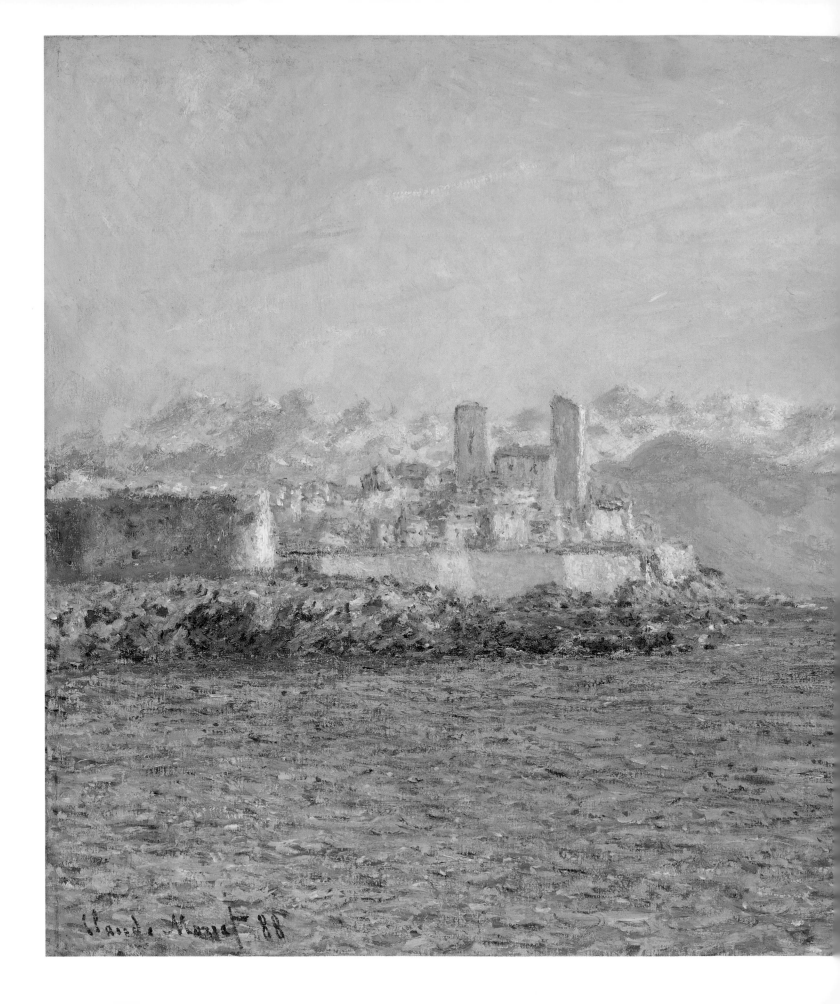

37 CLAUDE MONET
French, 1840–1926
The Fort of Antibes, 1888
Oil on canvas, 65.4 x 81 cm
Museum of Fine Arts, Boston. Anonymous gift

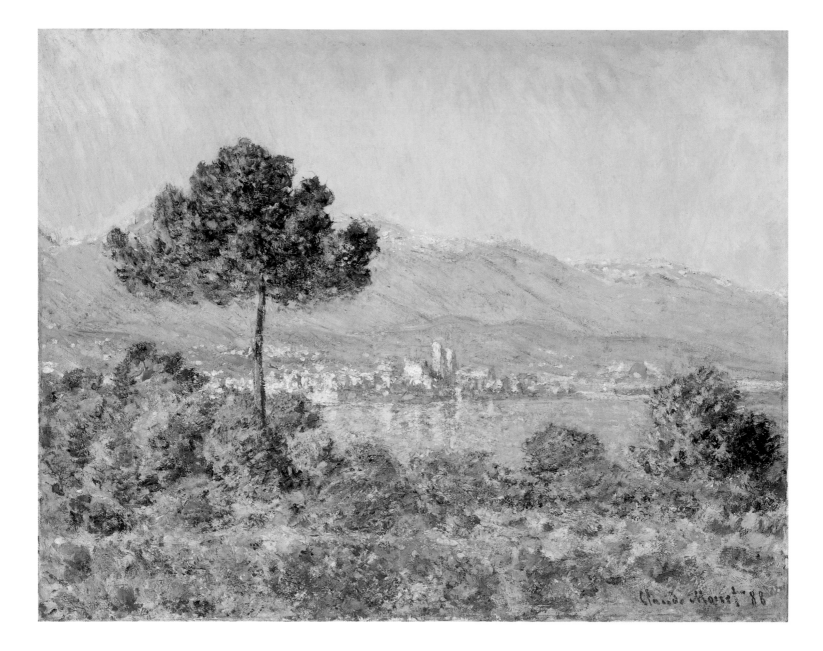

38 CLAUDE MONET
French, 1840–1926
Antibes Seen from the Plateau Notre-Dame, 1888
Oil on canvas, 65.7 x 81.3 cm
Museum of Fine Arts, Boston. Juliana Cheney Edwards Collection

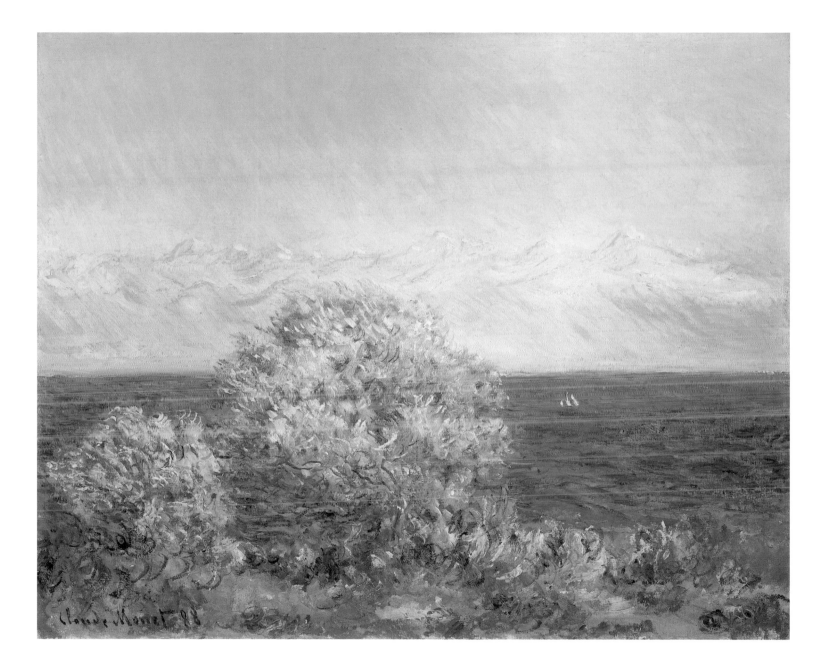

39 CLAUDE MONET
French, 1840–1926
Cap d'Antibes, Mistral, 1888
Oil on canvas, 66.0 x 81.3 cm
Museum of Fine Arts, Boston. Bequest of Arthur Tracy Cabot

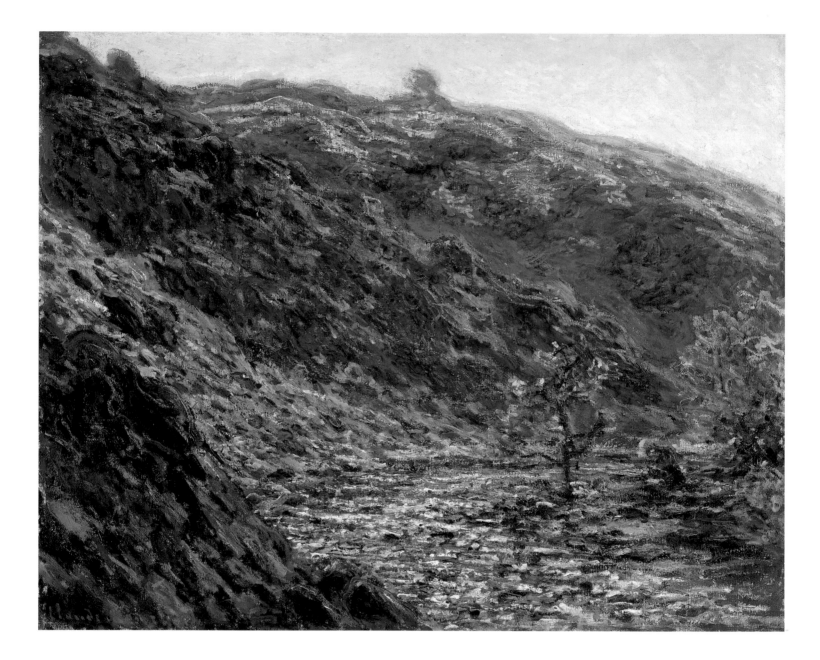

40 CLAUDE MONET
French, 1840–1926
Valley of the Petite Creuse, 1889
Oil on canvas, 65.4 x 81.3 cm
Museum of Fine Arts, Boston. Bequest of David P. Kimball in memory of his wife Clara Bertram Kimball

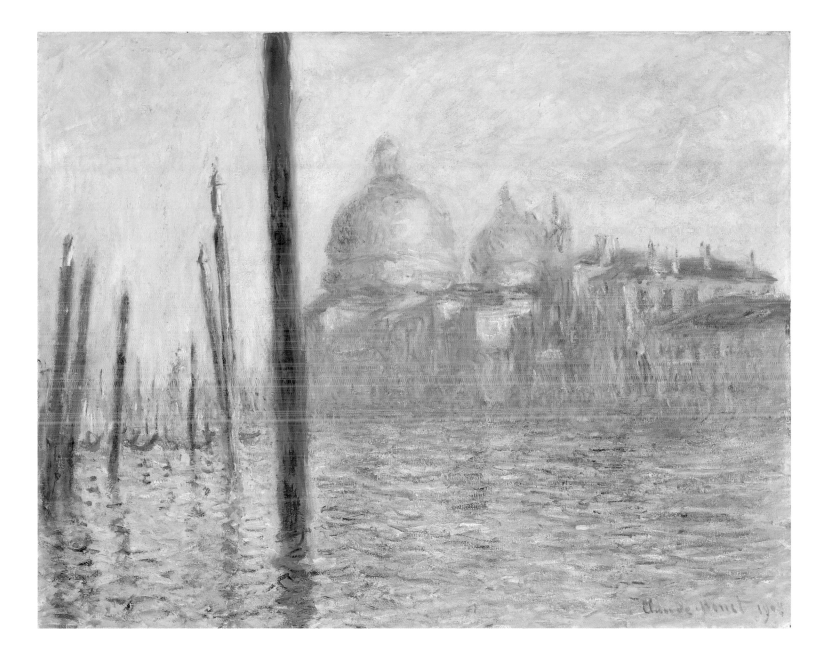

41 CLAUDE MONET
French, 1840–1926
Grand Canal, Venice, 1908
Oil on canvas, 73.7 x 92.4 cm
Museum of Fine Arts, Boston. Bequest of Alexander Cochrane

42 CLAUDE MONET
French, 1840–1926
Water Lilies, 1905
Oil on canvas, 89.5 x 100.3 cm
Museum of Fine Arts, Boston. Gift of Edward Jackson Holmes

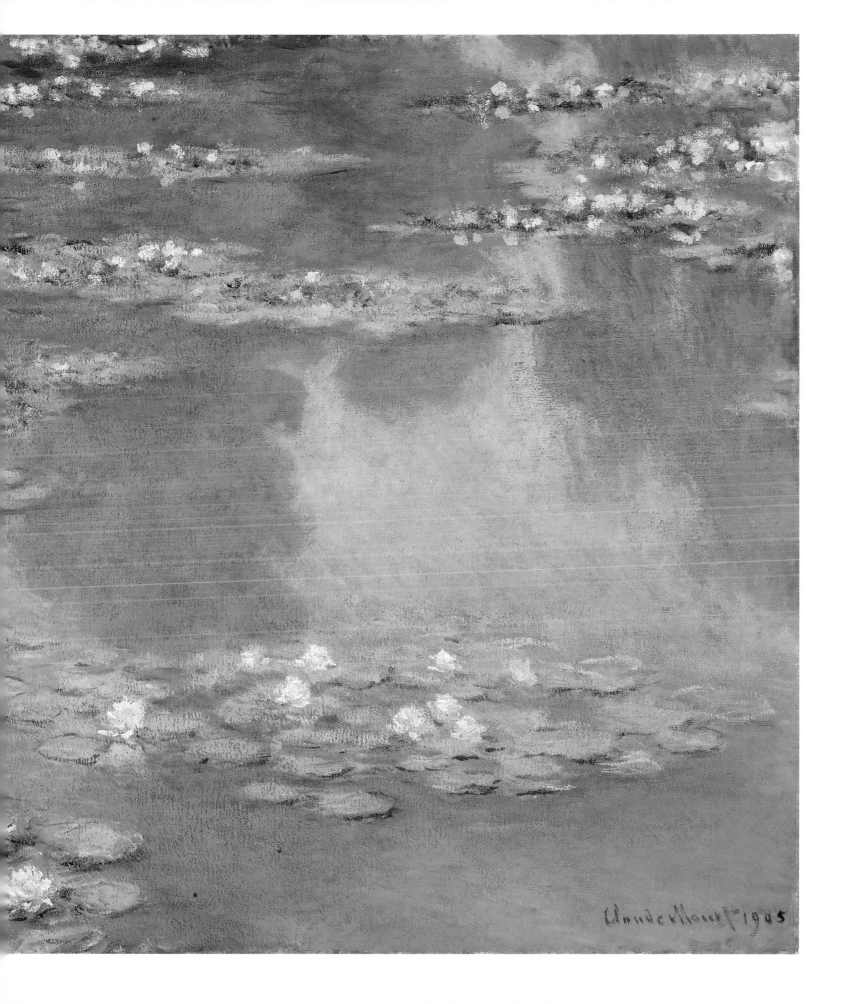

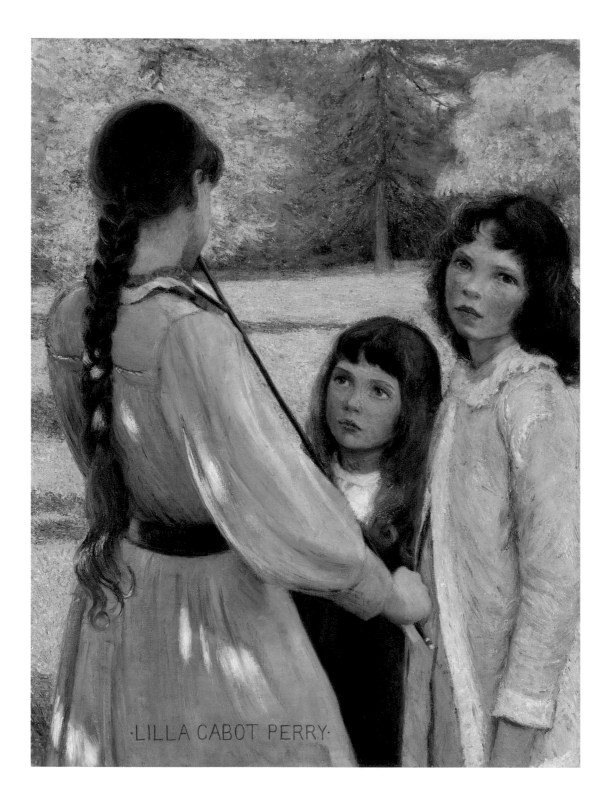

43 LILLA CABOT PERRY
American, 1848–1933
Open Air Concert, 1890
Oil on canvas, 101 x 76.5 cm
Museum of Fine Arts, Boston. Gift of Miss Margaret Perry

44 LILLA CABOT PERRY
American, 1848–1933
The Old Farm, Giverny, 1909
Oil on canvas, 65.1 x 81.3 cm
San Antonio Museum of Art. Purchased with funds provided by the Lillie and Roy Cullen Endowment Fund

89

45 CAMILLE PISSARRO
French, 1830–1903
Morning Sunlight on the Snow, Eragny-sur-Epte, 1895
Oil on canvas, 82.3 x 61.6 cm
Museum of Fine Arts, Boston.
The John Pickering Lyman Collection. Gift of Miss Theodora Lyman

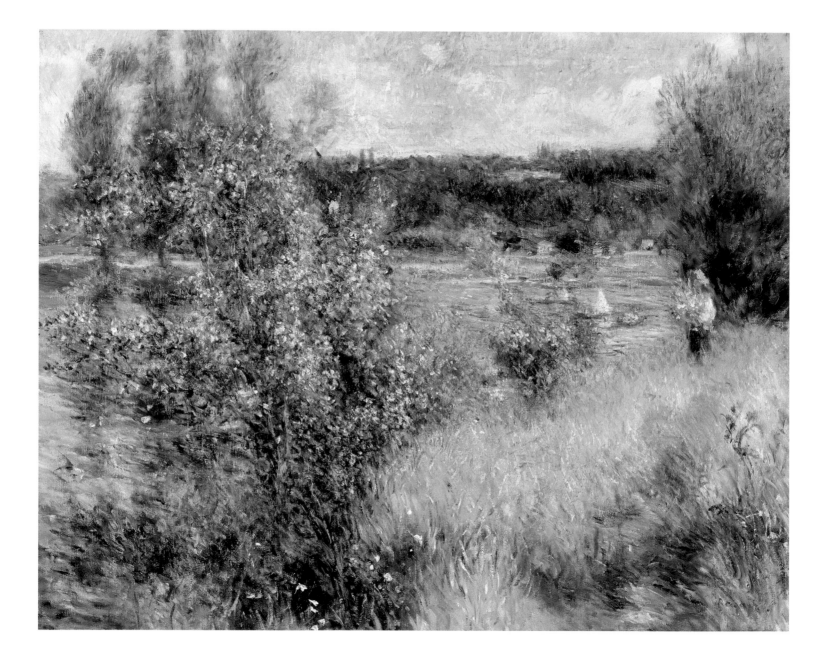

46 PIERRE-AUGUSTE RENOIR
French, 1841–1919
The Seine at Chatou, 1881
Oil on canvas, 73.3 x 92.4 cm
Museum of Fine Arts, Boston. Gift of Arthur Brewster Emmons

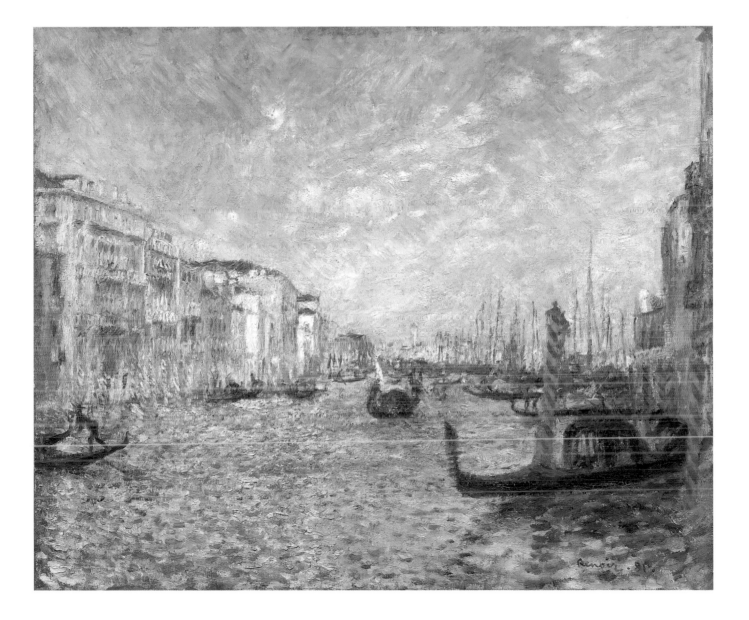

47 PIERRE-AUGUSTE RENOIR
French, 1841–1919
Grand Canal, Venice, 1881
Oil on canvas, 54 x 65.1 cm
Museum of Fine Arts, Boston. Bequest of Alexander Cochrane

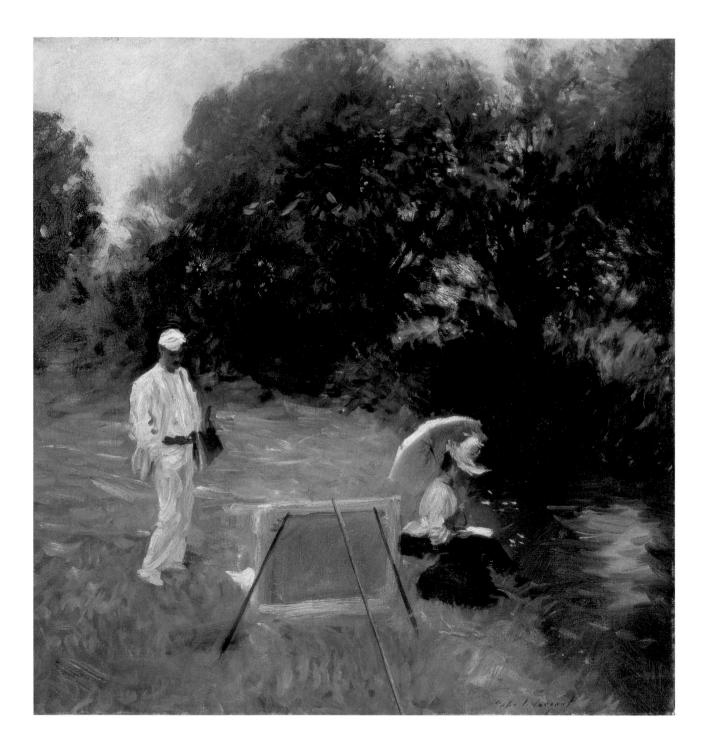

48 JOHN SINGER SARGENT
American, 1856–1925
Dennis Miller Bunker Painting at Calcot, 1888
Oil on canvas mounted on masonite, 68.6 x 64.1 cm
Terra Foundation for the Arts, Daniel J. Terra Collection

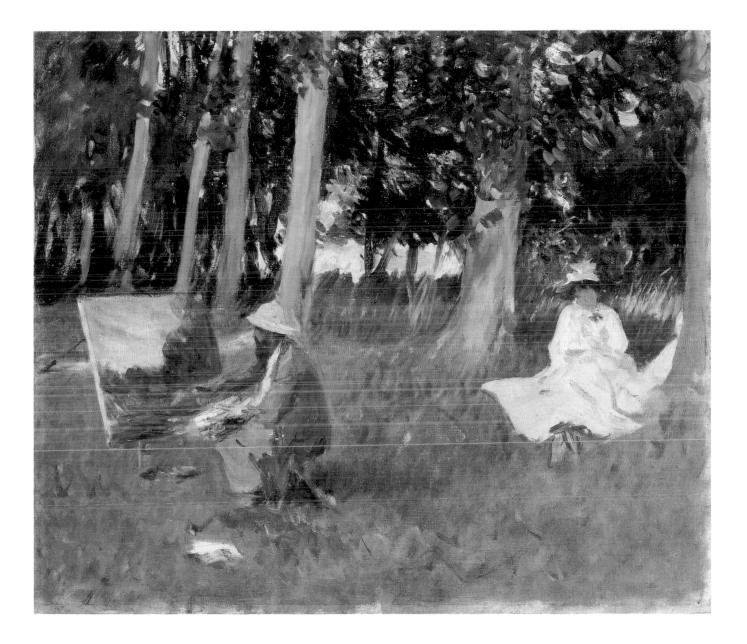

49 JOHN SINGER SARGENT
American, 1856–1925
Claude Monet Painting by the Edge of a Wood, 1885
Oil on canvas, 54 x 64.8 cm
Tate. Presented by Miss Emily Sargent and Mrs Ormond through the National Art Collections Fund, 1925

50 JOHN SINGER SARGENT
American, 1856–1925
Helen Sears, 1895
Oil on canvas, 167.3 x 91.4 cm
Museum of Fine Arts, Boston. Gift of Mrs J. D. Cameron Bradley

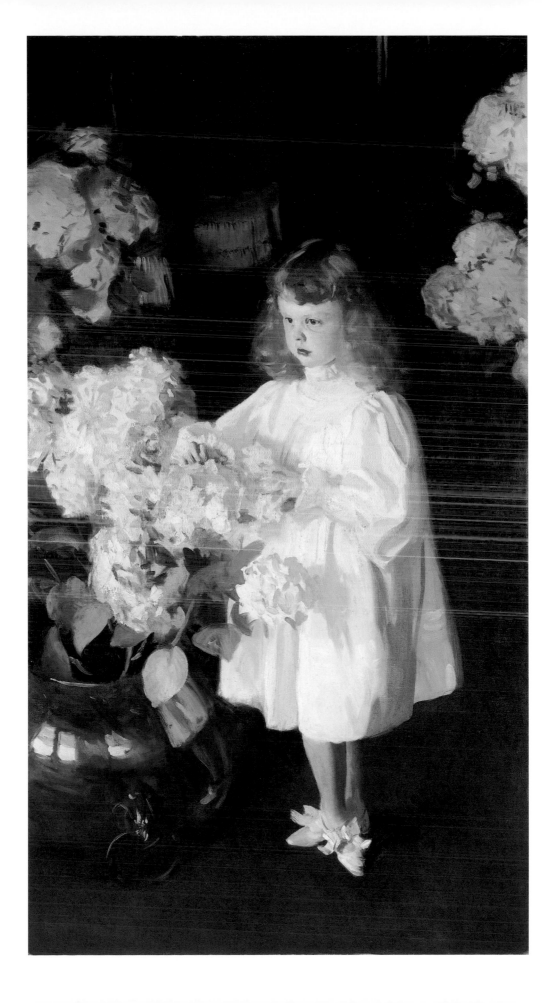

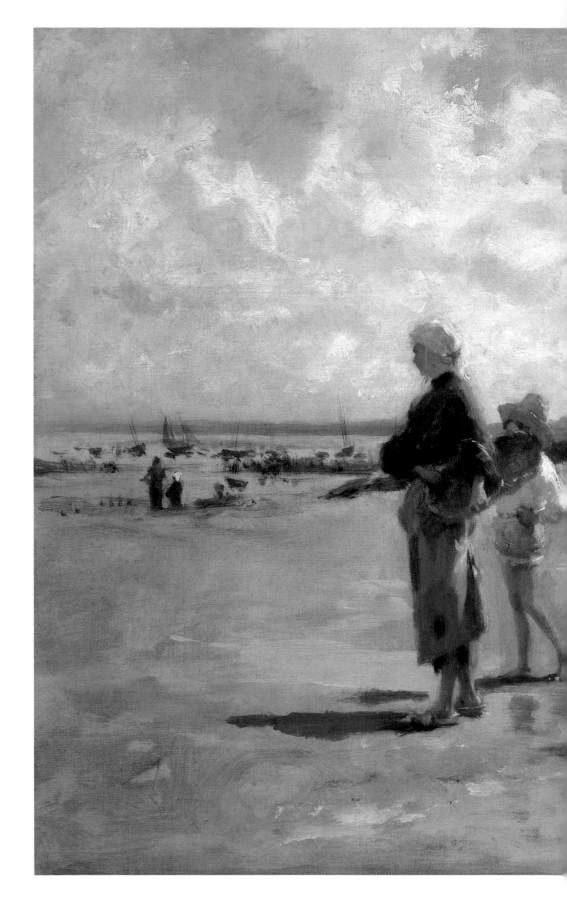

51 JOHN SINGER SARGENT
American, 1856–1925
Fishing for Oysters at Cancale, 1878
Oil on canvas, 41 x 61 cm
Museum of Fine Arts, Boston.
Gift of Miss Mary Appleton

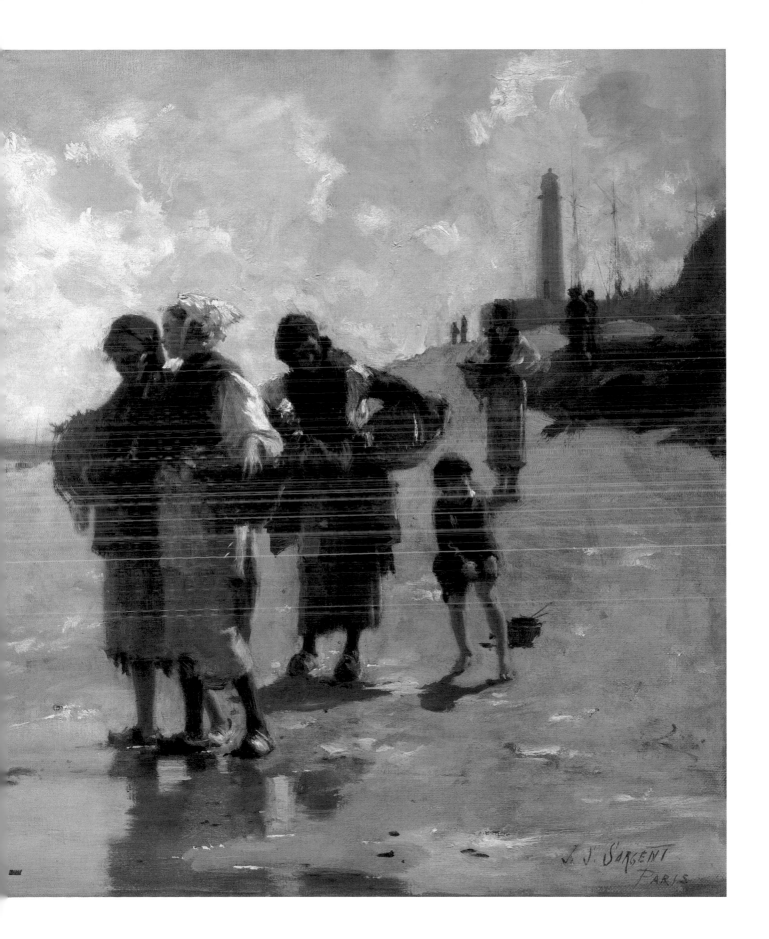

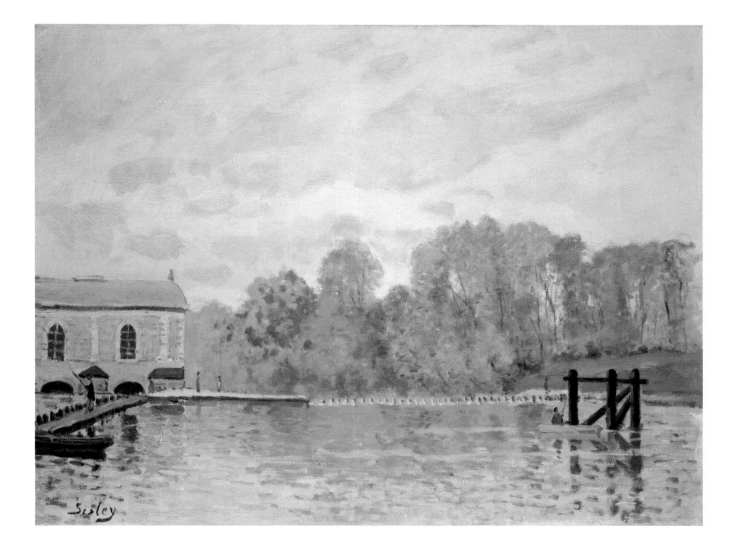

52 ALFRED SISLEY
British, 1839–1899
Waterworks at Marly, c. 1876
Oil on canvas, 46.5 x 61.8 cm
Museum of Fine Arts, Boston. Gift of Miss Olive Simes

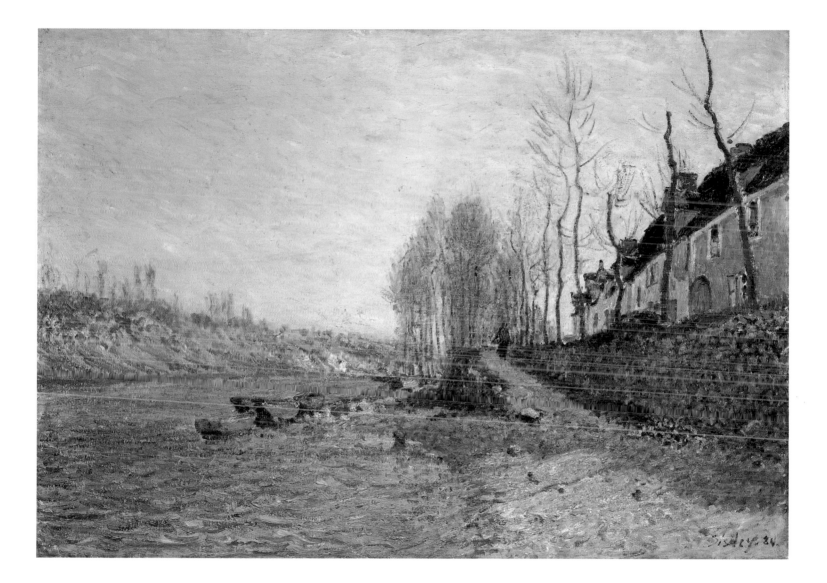

53 ALFRED SISLEY
British, 1839–1899
La Croix-Blanche at Saint-Mammès, 1884
Oil on canvas, 65.4 x 92.4 cm
Museum of Fine Arts, Boston. Juliana Cheney Edwards Collection

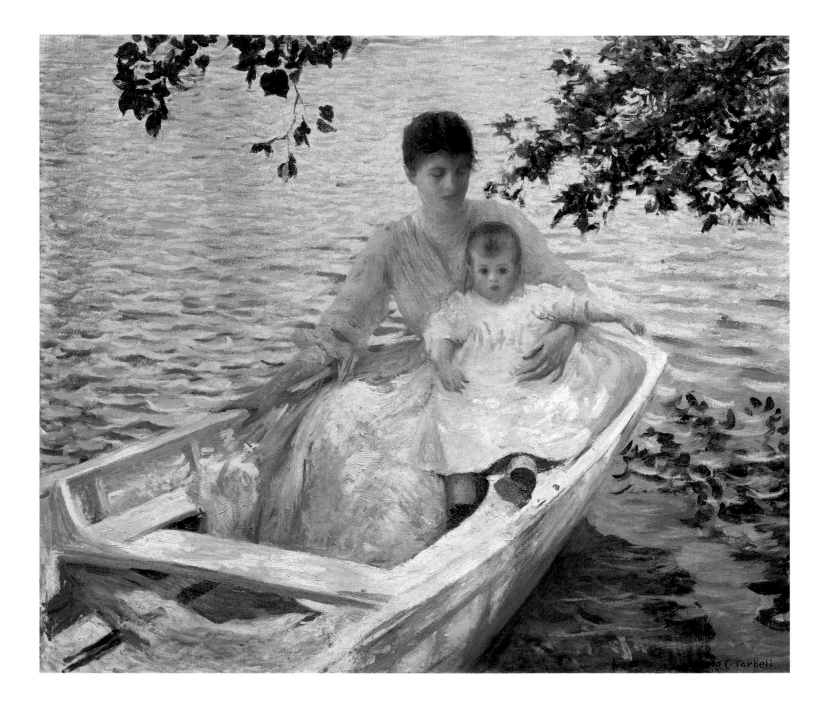

54 EDMUND CHARLES TARBELL
American, 1862–1938
Mother and Child in a Boat, 1892
Oil on canvas, 76.5 x 88.9 cm
Museum of Fine Arts, Boston. Bequest of David P. Kimball
in memory of his wife Clara Bertram Kimball

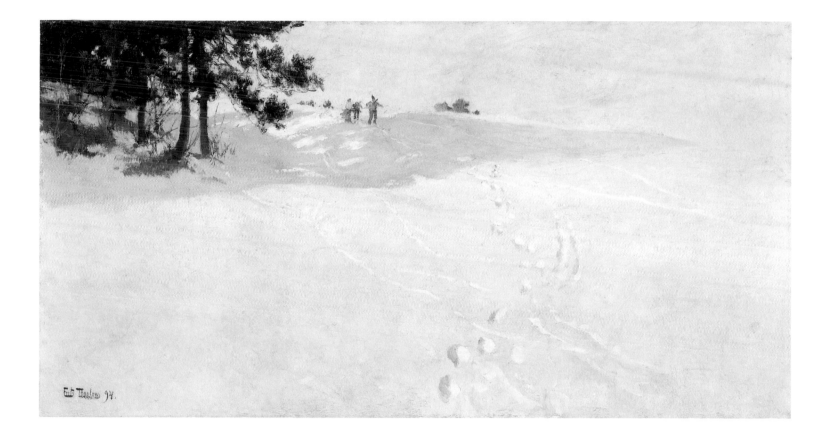

55 JOHAN FREDERIK (FRITS) THAULOW
Norwegian, 1847–1906
Skiers at the Top of a Snow-Covered Hill, 1894
Oil on canvas, 52.7 x 98.4 cm
Museum of Fine Arts, Boston. Gift of Miss Aimée and Miss Rosamond Lamb

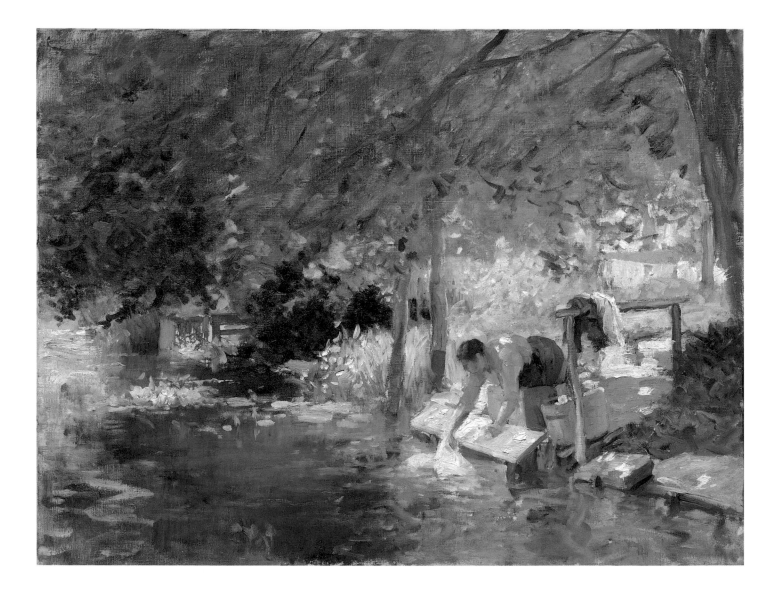

56 FREDERIC PORTER VINTON
American, 1846–1911
La Blanchisseuse, 1890
Oil on canvas, 46.4 x 61 cm
Museum of Fine Arts, Boston. Gift of Alexander Cochrane

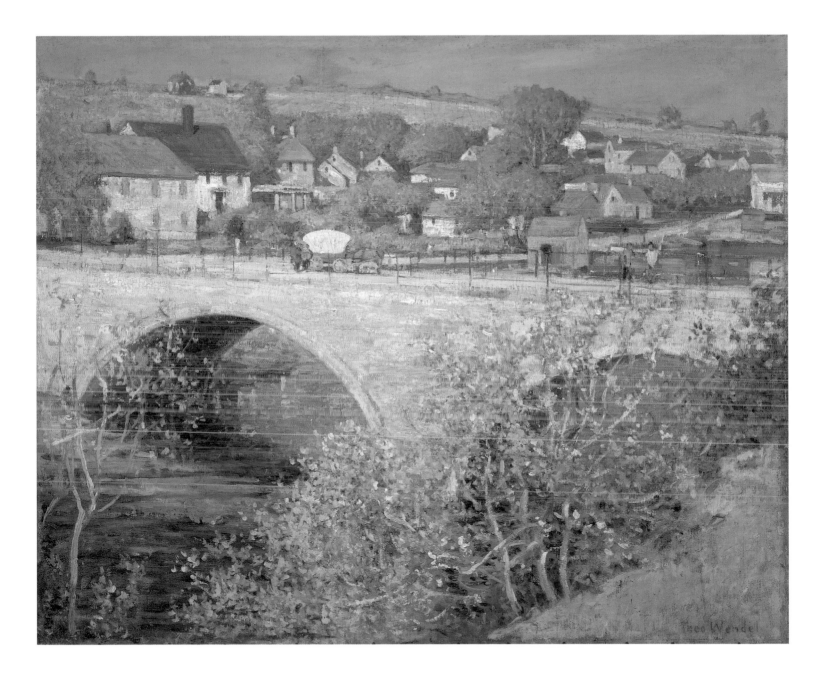

57 THEODORE M. WENDEL
American, 1859–1932
Bridge at Ipswich, c. 1905
Oil on canvas, 61.6 x 76.2 cm
Museum of Fine Arts, Boston. Gift of Mr and Mrs Daniel S. Wendel,
Tompkins Collection and Seth K. Sweetser Fund, by exchange

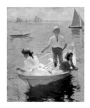

1 FRANK WESTON BENSON
American, 1862–1951
Calm Morning, 1904
Oil on canvas, 112.7 x 91.8 cm

Museum of Fine Arts, Boston.
Gift of the Charles A. Coolidge Family 1985.925

PROVENANCE: About 1905, Charles A. Coolidge, Boston;
Coolidge family; 1985, gift to the MFA.

EXHIBITION HISTORY: 1904, Boston, St Botolph Club,
Paintings by Frank W. Benson; 1905, New York, Montross Gallery,
Paintings by the Ten American Painters.

In the late 1890s Benson began to paint out of doors
and over the next two decades he produced many of
his most popular *plein air* paintings, primarily of his
family at play during idyllic summers. The setting is
North Haven Island, Maine at Wooster Farm, which
they first rented in 1901 and later purchased. In *Calm
Morning* Benson depicted his three oldest children
fishing over the side of a dory – Eleanor, the oldest,
to the left in the stern of the boat, Elisabeth to the
right, and George standing. Benson's bright, luminous
colours and long varied brushstrokes give the effect
of warm sun shining on the children and the inside
of the boat, contrasting with the cool, quiet ocean.
He skilfully captured the reflections on the stern of
the boat and the deep green colour of the water in
its shadow. Although Benson usually composed and
painted a finished oil directly on the canvas, for *Calm
Morning* he took a more academic approach, making
three oil studies which he used as the basis for this
larger work. Benson was pleased with the result,
declaring it his 'best out of door work' (Faith Andrews
Bedford, *Frank W. Benson: American Impressionist*,
New York, 1994, p. 98). JC

2 FRANK WESTON BENSON
American, 1862–1951
Early Morning, c. 1899
Oil on canvas, 61.3 x 152.7 cm

Museum of Fine Arts, Boston.
Bequest of Dr Arthur Tracy Cabot 13.2908

PROVENANCE: Dr Arthur Tracy Cabot, Boston; 1913, bequest to
the MFA.

EXHIBITION HISTORY: 1900, Boston, St Botolph Club,
Exhibition of Paintings by Frank W. Benson; 1900, New York,
Durand-Ruel Gallery, *Ten American Painters.*

Benson's life-long love of birds and his appreciation of
Japanese design, fashionable both in Paris and Boston,
are readily apparent in *Early Morning*. Benson had
explored the abundant bird life in the marshes near
his childhood home in Salem, Massachusetts, and
early on had even aspired to ornithological
illustration. His first known oil paintings are still lifes
of birds. Later, flying birds silhouetted against the sky
became a favourite subject for Benson, just as they
were popular motifs in the Japanese art that Benson
admired, especially when depicted in juxtaposition
against the still features of a landscape. *Early Morning*
bears a striking similarity to an eighteenth-century
Japanese screen entitled *Geese Flying over a Beach*
(Freer Gallery of Art) by Maruyama Okyo, and it is
possible that Benson saw that screen at the importer
Bunkyo Matsuki's shop in Boston or at the Matsuki
home in Salem before it was purchased by Charles
Freer in 1898. The decorative nature of *Early Morning*
is enhanced by Benson's choice of a long, horizontal
canvas. When the painting was exhibited in New York
in 1900, the *New York Times* critic singled it out for
praise, finding it 'especially good … with the ducks
in flight and the gray expanse of marsh and sky
rose-flushed in the east with the dawn' (Faith
Andrews Bedford, *Frank W. Benson: American
Impressionist*, 1994, p. 87). JC

3 EUGENE BOUDIN
French, 1824–1898
Washerwomen Near a Bridge, 1883
Oil on panel, 32 x 41 cm

Schmit, no. 1731
Museum of Fine Arts, Boston. Bequest of David P. Kimball
in memory of his wife Clara Bertram Kimball 23.512

PROVENANCE: 1886, sold by artist to Durand-Ruel, Paris;
to Durand-Ruel, New York; 1894, sold to J. Eastman Chase
Gallery, Boston; Clara Bertram Kimball, Boston; to her husband,
David P. Kimball, Boston; 1923, bequest to the MFA.

EXHIBITION HISTORY: Possibly 1903, New York, Durand-Ruel,
Boudin.

In the 1860s, Boudin had become well known for his
representations of seaside visitors in their brightly
coloured attire on the beaches of the newly fashionable
Normandy resorts of Deauville and Trouville. The
artist soon grew tired of this subject matter and, in an
1867 letter, referred to the tourists as 'gilded parasites'
and confessed that he felt 'a certain shame at painting
their idle laziness' (Georges Jean-Aubry, *Eugène Boudin
d'après des documents inédits: L'homme et l'oeuvre*, Paris,
1922, translated by Caroline Tisdale, 1968, p. 90). This
might explain Boudin's shift towards themes recording
local life.

Boudin made over one hundred paintings of
washerwomen. Laundresses were a favoured subject
of artists such as Daumier, J.-F. Millet and Boudin's
contemporary, Degas. Frederic Porter Vinton, an
American artist who met Boudin and admired his
work, also painted the motif in his more intimate
portrayal of a solitary laundress, *La Blanchisseuse*
(cat. 56). Symbols of the growing tourism industry,
laundresses were vital to the operations of the nearby
resorts. Here, we no longer see the 'idle laziness' of
the wealthy tourists lounging in Deauville and
Trouville, a short distance away from this site on the
river Touques. Instead, we observe the grandeur of
women working diligently at their task framed by
the carefully constructed masonry bridge, itself a site
of labour, their productivity mirrored in Boudin's
rhythmic brushstrokes. LL

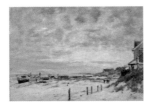

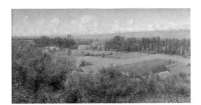

4 EUGÈNE BOUDIN
French, 1824–1898
Port of Le Havre, c. 1886
Oil on canvas, 39.7 x 54.3 cm

Schmit, no. 2012
Museum of Fine Arts, Boston.
Bequest of Miss Elizabeth Howard Bartol Res.27.90

PROVENANCE: 1894, Allard et Noël, Paris, sold to M. Knoedler
& Co., New York; 1898, sold to J. Eastman Chase Gallery,
Boston; until 1927, Elizabeth Howard Bartol, Boston; 1927,
bequest to the MFA.

Throughout the nineteenth century, scores of artists
were captivated by the bustling port of Le Havre
on the Normandy coast. Boudin, part owner of a
stationer's and frame shop frequented by many of
the Barbizon artists on their journeys to the area,
here met some of the most influential artists of his
time. J. F. Millet, for example, corrected Boudin's
first attempts at painting.

Le Havre, with a population of approximately
110,000, was a major harbour, second in trade only
to Marseilles in the south. A great number of the ships
in this seaport hailed from the distant American ports
of Boston and its environs. From the 1860s to the
1890s, the French government tried to overcome the
British and American domination of its shipping
industry. Boudin's use of the prominent white-hulled
ship, adorned with the French tricolour flag which
towers over the horizon, may indicate his national
pride. Boudin echoed the lively activity of the
variously sized boats and the people at work with the
billowing cumulous clouds that dance across the sky.
LL

5 EUGENE BOUDIN
French, 1824–1898
The Inlet at Berck (Pas-de Calais), 1882
Oil on canvas, 54.6 x 75 cm

Schmit, no. 1658
Museum of Fine Arts, Boston.
Bequest of Mrs Stephen S. FitzGerald 64.1905

PROVENANCE: 1892, E. O'Doard, Paris; 1892, sold to Durand-
Ruel, Paris; 1900, sold to Adolphe-Eugène Tavernier, Paris;
possibly with J. Eastman Chase Gallery, Boston; by 1926,
Desmond Fitzgerald, Brookline, Mass.; by descent to his
daughter-in-law, Agnes Blake FitzGerald (Mrs Stephen S.
FitzGerald), Weston, Mass., 1964, bequest to the MFA.

EXHIBITION HISTORY: 1899, Paris, École Nationale des
Beaux-Arts, *Exposition des œuvres d'Eugène Boudin*

In 1881, 1882 and 1890, Eugène Boudin summered
in Berck, a small seaside community on the English
Channel known as a salubrious retreat. Here, Boudin
painted Berck's working harbour, recording its broad
shores, its fishing boats at low tide and its seemingly
limitless sea. Nevertheless, in this work Boudin's real
focus was the drama of the sky. He devoted most of
his energies and three-quarters of his canvas to this
subject, living up to the accolade 'King of the Skies',
as bestowed upon him by Camille Corot. The sails of
the boats both stranded and at sea, the chimneys and
rooftops of the houses, and the random fence posts
all act like arrows subtly pointing upwards toward
Boudin's rolling, luminous clouds.

Desmond Fitzgerald, owner of this work and
seven others by Boudin, wrote in the brochure for
the artist's first American exhibition at Boston's Chase
Gallery that Boudin 'has been called an artist "risen
from the sea"' (*Boudin: Impressionist Marine Paintings*,
Peter C. Sutton, exh. cat., Peabody Museum of Salem,
Mass., 1991, p. 17). LL

6 JOHN LESLIE BRECK
American, 1860–1899
In the Seine Valley (Giverny Landscape), c. 1890
Oil on canvas, 69.9 x 130.8 cm

Private collection

PROVENANCE: Descended in the family of the artist

EXHIBITION HISTORY: 1890, Boston, St Botolph Club,
John Leslie Breck; 1893, J. Eastman Chase Gallery,
John Leslie Breck.

In 1887, five young American painters, John Leslie
Breck, Willard Metcalf, Louis Ritter, Theodore
Wendel (p. 138) and Theodore Robinson, founded
an art colony in Giverny, not far from the residence
of Claude Monet. They were among the earliest
Americans to settle there, and the paintings they
produced helped guide American art towards an
Impressionist aesthetic.

Working on a large scale, probably in his studio,
Breck depicted a Giverny not often acknowledged in
Monet's works. Instead of Monet's focused gaze upon
a meadow, pond or garden on his property, Breck
offers an expansive panorama of the village, showing
a hilltop-view of the red-tiled roofs, measured fields
and the poplars of the Seine river valley. Breck both
stipples his canvas to denote the autumn trees and
solidifies his strokes to depict the geometry of the
mowed green pastures.

Breck's view of Giverny was included in his 1890
solo exhibition, one of the first to feature the works
of an American painter working in the Impressionist
style. Three years later, Breck was dubbed the 'Head
of the American Impressionists' by a local newspaper
(*Boston Daily Globe*, 25 January 1893). LL

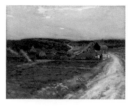

7 DENNIS MILLER BUNKER
American, 1861–1890
The Pool, Medfield, 1889
Oil on canvas, 47 x 62 cm

Museum of Fine Arts, Boston. Emily L. Ainsley Fund 45.475

PROVENANCE: Arthur T. Cabot, Boston; 1912,
Estate of Arthur T. Cabot; 1945, purchased by the MFA.

EXHIBITION HISTORY: Probably 1890, Boston, St Botolph Club,
Midwinter Exhibition.

The summer of 1889, which Bunker spent in
Medfield, Massachusetts about fifteen miles southwest
of Boston, was one of the most prolific of his short
life. By then comfortable with the *plein-air* techniques
he had learned the previous summer in Calcot Mill,
England with John Singer Sargent, Bunker created a
series of fully realised Impressionist landscapes of the
meadows near the source of the Charles River. Bunker
employed a variety of brushstrokes in *The Pool,
Medfield* to impart the effect of the flowing water,
the blades of grass in the foreground, the wild flowers
and trees beyond and the hint of a cottage in the
background to the right. His tipped-up composition
provides an intimate view of nature as if the viewer
were wading in the cool stream. The intense colours,
which convey the lushness of summer, provoked one
reviewer of an 1890 exhibition at Boston's St Botolph
Club, where four of the Medfield landscapes were
shown, to declare that certain artists 'look at nature
… through a blue glass'. The critic went on to praise
Bunker's paintings as 'very pretty, startling,
undoubtedly, and somewhat unique' (*Dennis Miller
Bunker: American Impressionist*, Erica E. Hirshler,
exh. cat., Museum of Fine Arts, Boston, 1994, p. 68).
Inspired by Medfield's luxuriant meadows, sparkling
brooks and rural cottages, Bunker was one of the
earliest American artists to apply the vocabulary of
modern French painting to his native landscape. JC

8 STANISLAS HENRI
JEAN-CHARLES CAZIN
French, 1841–1901
Riverbank with Bathers, c. 1882
Oil on canvas, 131.2 x 147 cm

Museum of Fine Arts, Boston. Peter Chardon Brooks Memorial
Collection; Gift of Mrs Richard M. Saltonstall 20.593

PROVENANCE: 1889, Antonin Proust, Paris; 1890, Galerie Georges
Petit, Paris; sold to Joseph Foxcroft Cole for Peter Chardon
Brooks, Boston; to his daughter, Eleanor Brooks Saltonstall (Mrs
Richard M. Saltonstall), Boston, Mass.; 1920, gift to the MFA.

EXHIBITION HISTORY: 1882, Paris, Salon, hors catalogue; 1889,
Paris, *Exposition Universelle*, as *La Marne*; 1897, Boston,
Copley Society, *Loan Exhibition of One Hundred Masterpieces*,
as *Pharaoh's Daughter Bathing in the Nile*.

Cazin, a favoured student in the atelier of Lecoq de
Boisbaudran at the Ecole Spéciale d'Architecture,
became proficient at his teacher's lessons combining
painting *en plein air* with recollections of models
observed in the studio. Here, Cazin demonstrated his
more modern tendencies by placing the traditional
subject of bathers amidst a contemporary scene on
the bank of the River Marne. The nudes are placed
in academic poses, appearing incongruous against
the background of a modern lock, factory and water
tower. This juxtaposition did not prevent Cazin from
earning high praise at the Exposition Universelle.
Theodore Child remarked: 'In its splendid harmony
… this picture is a complete and definitive vision of
evening calm at the river-side' (*Harper's New Monthly
Magazine*, May 1890, p. 828).

In 1897, *Riverbank with Bathers* was exhibited as
a history painting at Boston's Copley Hall, entitled
Pharaoh's Daughter Bathing in the Nile. The artist
may have reworked it, for pentimenti reveal a ghostly
boatman and a man's head and shoulders emerging
from the water, details outside the biblical source.

Antonin Proust, collector and compiler of
Edouard Manet's memoirs, was the first owner of this
work. Perhaps he enjoyed it for its affinity to Manet's
Dejeuner sur l'herbe, another painting which places
the nude in a contemporary setting. When Proust
sold *Riverbank,* it brought a higher price than three
Monets combined. LL

9 STANISLAS HENRI
JEAN-CHARLES CAZIN
French, 1841–1901
Farm Beside an Old Road, late 1880s
Oil on canvas, 65.1 x 81.6 cm

Museum of Fine Arts, Boston.
Bequest of Anna Perkins Rogers 21.1330

PROVENANCE: Until 1890, Ernest May, Paris; 1890, May sale,
Galerie Georges Petit, Paris, to Anna (Annette) Perkins Rogers,
Boston; 1921, bequest to the MFA.

EXHIBITION HISTORY: 1889, Paris, *Exposition décennale de 1889*;
1903, Boston, Copley Society, *Old Masters*.

1872 was a formative year for Jean-Charles Cazin.
After working in front of the motif in Holland, Cazin
decided to devote his efforts to painting the landscape
of his native France. He returned to France in 1875,
but concentrated primarily on history paintings until
1888. Those works were praised for their precision
and accuracy, no doubt a result of his early training
as a draughtsman.

In the late 1880s, Cazin turned his attention
exclusively to landscape and demonstrated his
understanding of the lessons he had learned from
Daubigny and Monet about representing atmospheric
and temporal conditions. He used patches and dabs
of thickly painted colour rather than controlled lines
to evoke a sentimental scene in rural France. He
chose the evocative time of twilight, a favourite of
the Impressionists, in order to showcase his ability to
render the setting sun, the golden glow of dusk and
the quiet peacefulness associated with this time of day.
Landscapes like these were emulated by many Boston
painters, including William Morris Hunt, with whom
Anna Rogers, the owner of this work, had studied. LL

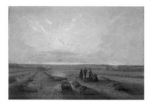

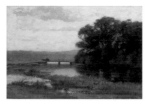

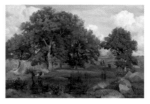

10 ANTOINE CHINTREUIL
French, 1814–1873
Last Rays of Sun on a Field of Sainfoin, c. 1870
Oil on canvas, 95.9 x 134 cm

De la Fizelière et al., 1874, no. 408
Museum of Fine Arts, Boston.
Gift of Mrs Charles Goddard Weld 22.78

PROVENANCE: By 1870 until at least 1874, Mr Fassin, Reims;
by 1889, Dr Charles Goddard Weld, Boston; by descent to
Mrs Charles Goddard Weld, Boston; 1922, bequest to the MFA.

EXHIBITION HISTORY: 1870, Paris, Salon; 1874, Paris,
Ecole Nationale des Beaux-Arts.

In this large-scale work, Chintreuil has updated the
Barbizon landscape, replacing its muted neutral
colours with a proto-Impressionist palette of vivid
colours that leap off the canvas. Influenced by Corot's
later style, which offered a softer, lyrical and more
generalised depiction of the French rural scene (see
cat. 13), Chintreuil portrayed the countryside with
dazzling light effects as his focus. The peasants
working in the vast field seem inconsequential to
the blaze of red-hot sunshine that lights everything
with an eerie glow. The *sainfoin*, a pink-flowered
perennial herb grown to feed livestock, presents
its own radiance amidst the tilled land.

Emile Zola, the French novelist, critic and
founder of the Naturalist movement in literature,
defined Impressionism as 'Nature seen through a
Temperament'. Upon viewing Chintreuil's work in
the Salon of 1870, Zola wrote, 'One senses an artist
who is striving to go beyond the leaders of the
Naturalist school of landscape painting and who,
although faithfully copying nature, attempted to
catch her at a special moment difficult to transcribe'
(Emile Zola, *Salons*, F. W. J. Hemmings and Robert
J. Neiss (eds), Paris, 1959, p. 270). LL

11 JOSEPH FOXCROFT COLE
American, 1837–1892
The Aberjona River, Winchester, c. 1880
Oil on canvas, 46 x 66.4 cm

Museum of Fine Arts, Boston. Gift of Alexander Cochrane 13.551

PROVENANCE: Alexander Cochrane; 1913, gift to the MFA.

Cole painted this Barbizon-inspired image of the
Aberjona River shortly after he had moved to
Winchester, an affluent suburban community eight
miles north-west of Boston. The scenic river, a slow-
moving waterway that meanders through Winchester,
empties into the picturesque Mystic Lakes, on the
shores of which Cole built his Colonial Revival home
and studio in 1878. In his many paintings of the
Aberjona, Cole was most influenced by Daubigny,
whom he had met at Jacque's Paris studio. Like
Daubigny, Cole worked out of doors and suggested
the features of the landscape with a broad painterly
style. Cole recorded the reflection of the turbulent
pink clouds in the river as had Daubigny in numerous
riverscapes. However, the quick strokes of green and
yellow, rendering the effects of light on the vegetation
in the foreground, reveal Cole's awareness of
Impressionist techniques, and is indicative of Cole's
marriage of the naturalistic approach of Barbizon
and the higher tonal palette of Impressionism.

Cole exhibited a painting entitled *Abbajona
River, Mass.* at the 1889 Universal Exposition in Paris.
It is likely, however, that this was the larger (but
almost identical) canvas now owned by the
Winchester Public Library rather than the one
now in the Museum of Fine Arts. JC

12 JEAN-BAPTISTE-CAMILLE COROT
French, 1796–1875
Forest of Fontainebleau, 1846
Oil on canvas, 90.2 x 128.8 cm

Robaut, vol. 2, p. 185, no. 502
Museum of Fine Arts, Boston.
Gift of Mrs Samuel Dennis Warren 90.199

PROVENANCE: 1872, contributed by artist to Anastasi sale, Paris,
sold to Alfred Robaut, Paris; 1878, possibly sold to Louis Latouche;
sold to Ferdinand Barbédienne, Paris; 1881, sold to Thomas
Robinson for Seth Morton Vose; by 1884, sold to Beriah Wall,
Providence, RI; 1886, Wall sale to S. M. Vose for Susan Cornelia
Clarke Warren (Mrs Samuel Dennis Warren), Boston; 1890,
gift to the MFA.

EXHIBITION HISTORY: 1846, Paris, Salon; 1875, Paris, Ecole des
Beaux-Arts, *Corot*; 1878, Paris, Durand-Ruel, *Maîtres Modernes*;
1886, Providence, RI, *Loan Exhibition in Aid of the First Light
Infantry*

Camille Corot painted this quintessential Barbizon
scene in his studio in 1846, basing it upon his outdoor
studies of the Apremont region of Fontainebleau of
1834. Corot had been visiting that area since 1822,
when he had gone there to sketch in the company
of one of his first teachers, Achille-Etna Michallon.
Forest of Fontainebleau won Corot a *Légion d'honneur*,
official recognition of his artistic talent, and was
esteemed as a pure landscape in no need of a central
human presence for its validation. It received mixed
reviews from contemporary critics, but Champfleury,
the realist critic, enthusiastically praised it for its
fidelity to nature. Later, the Impressionist Edgar
Degas remarked: 'I believe that Corot draws
a tree better than any one of us' (*Corot*, exh. cat.,
Wildenstein Gallery, New York, 1969, preface).

Corot's trees, broad and lush, act as both a
frame and canopy for his everyday subject of cows
approaching a pond to drink. The rocky outcroppings
in the foreground create a circular path for the
viewer's eye and Corot carefully placed the cows to
enhance his illusion of recession into the distance.
These compositional strategies were common in
landscape painting of that date, but with his direct
application of paint Corot added a freshness and
vitality to his scene that would be admired by such
Impressionists as Sisley and Pissarro. In 1849, just
three years after this work was made, a railway was
constructed near the forest, bringing tourists and
day-trippers to these once peaceful environs. LL

13 JEAN-BAPTISTE-CAMILLE COROT
French, 1796–1875
Bathers in a Clearing, c. 1870–5
Oil on canvas, 92 x 73.2 cm

Robaut, vol. 3, p. 228, no. 1966
Museum of Fine Arts, Boston. Gift of James Davis 76.4

PROVENANCE: 1875, posthumous Corot sale, Paris, to Rosimont; with Alexis-Eugène Detrimont, Paris; by 1876, James Davis, Boston; 1876, gift to the MFA.

Corot painted this romantic reverie in May 1874, nine months before his death. The scene is based on Ville d'Avray, a town ten miles outside of Paris, where Corot's father had bought a country house. Corot set numerous paintings in this region, which was marked by woods, ponds, meadows and streams. The expressive white birches, grey mist and glistening water are characteristic of Corot's later images of the area. He often added generic nudes or nymphs to works of this type, transforming a real scene into an idealised historical landscape.

Bathers in a Clearing is one of the last of the artist's forest fantasies, a series he had created over nearly a quarter-century. His first such picture, *A Morning, Dance of the Nymphs* (1850, Musée du Louvre, Paris), was exhibited in the Salon of 1850–1. Far from what one critic described as the 'dirty boot' realism of his *Forest of Fontainebleau* of 1846 (see cat. 12), this picture displayed a delicate charm and sentimentality (Tinterow et al., *Corot*, exh. cat., New York, 1996, p. 211). From 1855 on, the artist produced hundreds of these poetic idylls, which were sought after by American collectors and rewarded Corot with financial security and fame. LL

14 JEAN-BAPTISTE-CAMILLE COROT
French, 1796–1875
Woman with a Pink Shawl, c. 1865–70
Oil on canvas, 66.7 x 55.2 cm

Robaut, vol. 3, p. 122, no. 1580
Museum of Fine Arts, Boston.
The Henry C. and Martha B. Angell Collection 19.81

PROVENANCE: 1875, posthumous Corot sale, Paris, to Vérane; with Alexis-Eugène Detrimont, Paris; 1888, Aimé Diot, Paris; 1888, sold to Henry Clay Angell, Boston; to his wife, Martha Bartlett Angell, Boston; 1919, gift to the MFA.

Corot considered himself to be primarily a landscape painter, but during the late 1860s, suffering from gout, he was unable to make his usual annual excursion to the French countryside to collect further material for his landscapes. Instead, he devoted himself to figure painting in his studio. Corot showed only two figure subjects at the Salon during his fifty-year career; the majority, including this one, were sketches never intended to be exhibited in public and not seen until the posthumous sale of his estate in 1875.

This sitter is Corot's frequent model, Mariette, who is captured in a state of self-conscious melancholy. Corot alludes to her vulnerability by his placement of her hands: one clutching at the eponymous pink shawl and the other positioned at her throat. The intensity of her gaze seizes the viewers' attention and draws them to delight in Corot's expressive, gestural application of paint. The quickly brushed, abstracted background brings into focus the moody expressiveness of the sitter, a technique Degas emulated for his *Ballet Dancer with Arms Crossed* (cat. 17).

The Angells were strong promoters of the Barbizon School in America, most notably Corot, and owned thirty-four pictures by the artist. LL

15 CHARLES-FRANCOIS DAUBIGNY
French, 1817–1878
Ile-de-Vaux on the Oise near Auvers, 1876
Oil on panel, 40.6 x 68.6 cm

Museum of Fine Arts, Boston.
Bequest of Mrs David P. Kimball 23.400

PROVENANCE: About 1885 or before, with Goupil et Cie., Paris; 1885, Galerie Georges Petit, Paris, sold to M. Knoedler and Co., New York; 1886, sold to J. Eastman Chase Gallery, Boston, for Clara Bertram Kimball, Boston; to her husband, David P. Kimball, Boston; 1923, bequest to the MFA.

For over twenty years, Daubigny travelled up and down French waterways in his 'Botin', a small vessel converted into a floating studio from which he painted his riverside scenes. This floating studio allowed him to paint *en plein air*, capturing France's regional scenery and inflecting it with his own subjective expression, which he termed the 'moods' of his motifs. Daubigny's oeuvre is often seen as a bridge between the Barbizon School and the Impressionists. Indeed, Monet would paint from his own studio boat fifteen years later.

Painted on one of Daubigny's last journeys on the Botin before his death, *Ile-de-Vaux on the Oise near Auvers* displays the qualities that the Impressionists found so appealing. His brushstrokes are broken into short, choppy gestures, most evident in the foreground reflections in the water and reeds. His sentimental view of the French countryside during the twilight hours, with an expansive choice of hues, would also have attracted both Impressionist painters and collectors.

Careful examination reveals flecks of gold in the picture's original varnish layer, a decorative technique previously unrecorded in Daubigny's paintings. LL

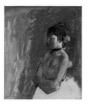

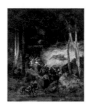

16 EDGAR DEGAS
French, 1834–1917
Race Horses at Longchamp, 1871,
possibly reworked in 1874
Oil on canvas, 34 x 41.9 cm

Lemoisne, no. 334
Museum of Fine Arts, Boston.
S. A. Denio Collection 03.1034

PROVENANCE: 1894, possibly Théodore Duret, Paris; 1894,
possibly Duret sale, Galerie Georges Petit, Paris, bought in;
1900, Bernheim-Jeune, Paris; 1900, sold to Durand-Ruel, Paris;
deposited with Cassirer, Berlin; 1900, returned to Durand-Ruel,
Paris; 1900, deposited with M. Whitaker, Montreal; 1901, sold to
Durand-Ruel, New York; 1901, sold to Mrs William H. Moore,
New York; 1901, returned to Durand-Ruel, New York; 1903,
sold to the MFA.

EXHIBITION HISTORY: 1911, Cambridge, Mass., Fogg Art
Museum, Harvard University, *Loan Exhibition of Paintings
and Pastels by H. G. E. Degas*

This painting was the first by Degas to enter an
American museum. Several Boston-based Impressionist
artists, among them Vinton, Tarbell, Benson and
Perry, voted enthusiastically for the Museum of Fine
Arts to acquire it. Some believed they could teach
Impressionist principles using this painting as a
model; others revered it for its avant-garde originality
(see pp. 37–8).

Degas fused his interest in photography and
Japanese prints with his emerging Impressionist
approach to subject in this work. The casual cropping
of the composition reflects his knowledge of the
photographic medium. The asymmetrical balance
reveals his interest in Japanese prints, and the dazzling
colours of the jockeys' costumes, the contrasting
subdued green of the meadow, and the atmospheric
light of dusk, relate his understanding of Impressionism.

Degas was the only Impressionist to focus on the
latest fashionable sport of the wealthy: horse racing.
Longchamp, the main Parisian racecourse, opened in
1857 only six miles from the city centre. Here, Degas
offers us not the equestrian excitement of the
competition, as did such painters as Géricault or
Bonheur, but rather the lethargic calm of race's end.
Degas often depicted subjects on the periphery of
the action, as he did in *Ballet Dancer with Arms
Crossed* (see cat. 17). LL

17 EDGAR DEGAS
French, 1834–1917
Ballet Dancer with Arms Crossed, c. 1872
Oil on canvas, 61.3 x 50.5 cm

Lemoisne, no. 1025
Museum of Fine Arts, Boston.
Bequest of John T. Spaulding 48.534

PROVENANCE: 1919, 3rd Degas atelier sale, Galerie Georges Petit,
Paris, to Durand-Ruel, Paris; 1920, sold to Durand-Ruel,
New York; 1920, sold to John Taylor Spaulding, Boston;
1948, bequest to the MFA.

Ballet dancers became a major subject for Degas
from 1869, explored through pastels, oils, wax
sculptures and monotypes for the three succeeding
decades. Like J.-F. Millet in his treatment of farm
labourers, Degas focused on the dancer at work,
usually anonymous, isolated and introverted, amidst
her milieu. Whereas Millet gave his labourers a
monumentality which imbued them with a classical
timelessness (see cat. 29), Degas, cool and detached,
turned a voyeuristic, objective eye on his subjects.

This unfinished work depicts a dancer who
not only avoids the viewer's gaze but whose body-
language prevents any communication whatsoever.
Nevertheless, the artist declared his presence with
bold, thick brushstrokes, painting fiery reds and
oranges surrounding his model. This composition
is a study for Degas's much smaller finished painting,
Dancers Backstage (1876/1883, National Gallery of Art,
Washington, DC). There the dancer has a context:
she waits behind a stage curtain next to a gentleman
in a black overcoat and top hat.

John T. Spaulding bought this painting in 1920,
his first purchase in what was to become an
impressive collection of French modernist paintings.
Spaulding may have appreciated this picture for its
bold colour, asymmetrical composition and the black
calligraphic outline of the dancer, which suggests
affinities with Japanese colour woodblock prints,
of which he was also a major collector. LL

18 NARCISSE-VIRGILE DIAZ DE LA PEÑA
French, 1808–1876
Bohemians Going to a Fête, c. 1844
Oil on canvas, 101 x 81.3 cm

Museum of Fine Arts, Boston.
Bequest of Susan Cornelia Warren 03.600

PROVENANCE: 1846, Paul Périer, Paris; 1849, possibly M. A.
Mosselman; to Getting; with Arnold et Tripp, Paris; by 1893,
Susan Cornelia Clarke Warren (Mrs Samuel Dennis Warren),
Boston; 1903, to Samuel Putnam Avery, New York, for the MFA.

EXHIBITION HISTORY: 1844, Paris, Salon; 1877, Paris, Ecole
Nationale des Beaux-Arts, *Diaz de la Peña* 1893, Chicago,
World Columbian Exposition; 1897, Boston, Copley Hall,
Loan Exhibition of One Hundred Masterpieces; 1901, Boston,
St Botolph Club; 1902, Boston, MFA, *Paintings from the
Collection of the Late Mrs Samuel Dennis Warren.*

Painted in homage to his mentor, Theodore Rousseau,
Diaz created a fanciful depiction of exotically dressed
figures descending through the forest for a grand
picnic. Diaz's reputation had been based on the festive
Rococo themes of *fêtes champêtres*, flower pieces, and
Orientalist subjects, which he had shown at the Salon
since 1831. He had begun to work at Fontainebleau as
early as 1835 and met Rousseau there in 1837. Rousseau
convinced him to concentrate on landscapes and this
work demonstrates Diaz's combination of a close study
of nature with his love of Rococo and Oriental motifs.

Diaz's *Bohemians* brought great acclaim to the
artist at the Salon of 1844, earning him a third class
medal despite the fact that he had reworked a
composition of Rousseau's, *Cattle Descending the Jura*,
that had been rejected by the Salon in 1835. Diaz
replaced Rousseau's descending cows with a glamorous
assortment of characters wearing costumes that recall
varying times and places. The landscape echoes the
form of the processional. LL

19 PHILIP LESLIE HALE
American, 1865–1931
Landscape, c. 1890
Oil on canvas, 46 x 55.9 cm

Museum of Fine Arts, Boston.
Gift of Nancy Hale Bowers 1985.689

PROVENANCE: 1931, Lilian Westcott Hale, artist's wife;
1964, Nancy Hale Bowers, artist's daughter; 1985,
gift to the MFA.

Landscape is perhaps Hale's most progressive painting,
reflecting his awareness of Monet's move towards
patterning in such works as his series of poplar
paintings made in 1891–2, and of the Nabis, a group
of young followers of Paul Gauguin who sought to
express abstract ideas through non-naturalistic
compositions that stressed the decorative. Led by
Paul Serusier, Maurice Denis, Pierre Bonnard and
Edouard Vuillard, the Nabis experimented with
simplified drawing, flat patches of colour and bold
contours in the pursuit of decorative beauty rather
than naturalistic description. Both Monet and the
Nabis were influenced by Japanese aesthetics, which
liberated the artist from a literal transcription of
nature and emphasised simplified natural forms and
the extraction from nature of decorative patterns.

The lack of a central focus, the bright colours
and loose brushwork of *Landscape* are reminiscent
of Monet's treatment of poplars on the River Epte
(1890–2). Hale used yellow pigment to convey the
effects of the midday sun, green for both the foliage
of the trees and their shadows, and blue and lavender
for the tree trunks. The influence of the Nabis is
apparent in the flatness of the design and the primacy
of surface pattern. Hale employed bands of colour in
a decorative grid of rhythmic verticals and horizontals,
relieved by the single tall tree in the left foreground.
Hale's inventive composition borders on abstraction
and presages developments that would occur in Paris
after the turn of the century. These experiments
proceeded without Hale, however, who retreated
toward more descriptive canvases after 1900. JC

20 PHILIP LESLIE HALE
American, 1865–1931
French Farmhouse, c. 1893
Oil on canvas, 64.8 x 81.3 cm

Museum of Fine Arts, Boston.
Gift of Nancy Hale Bowers 1985.688

PROVENANCE: 1931, Lilian Westcott Hale, artist's wife;
1964, Nancy Hale Bowers, artist's daughter; 1985,
gift to the MFA.

During his six-year sojourn in Paris and Giverny,
Hale was a keen observer of artistic trends. He
reported on the Parisian art world in several articles
in the Canadian journal *Arcadia* between 1891 and
1893 and became one of the few American artists to
incorporate one of the new styles, Divisionism, into
his own work. Developed by Georges Seurat during
the 1880s as a more rigorously scientific translation
of light into pigment, this new painting strove to
convey luminosity by juxtaposing separate flecks of
pure colour and allowing them to mix in the eye of
the viewer. In this view of a farmhouse, which in its
pink walls and green shutters has a resemblance to
Monet's house at Giverny, Hale has adapted
Divisionism, defining forms with dabs of unmixed
colour but none the less resorting to thin vertical
strokes of yellow pigment to indicate vibrating
sunlight. Later, he exhorted his students to bring
'plenty of chrome yellow no. 1. It is well to anticipate
the yellow fever' (Erica E. Hirshler, 'Artists'
Biographies' in *The Bostonians: Painters of an Elegant
Age, 1870–1930,* Trevor J. Fairbrother et al., exh. cat.,
Museum of Fine Arts, Boston, 1986, p. 211). Hale's
tightly focused view, with its sloping, empty
foreground, cropped vegetation and shutters, reflects
his engagement with both Japanese design and with
photography. The composition is enlivened by the
addition of a male figure, whose stance is reminiscent
of a model's pose for art students. Hale's avant-garde
paintings received a lukewarm reception from critics
in the United States, and his work became more
conservative after the turn of the century. JC

21 CHILDE HASSAM
American, 1859–1935
Grand Prix Day, 1887
Oil on canvas, 61.3 x 78.7 cm

Museum of Fine Arts, Boston.
Ernest Wadsworth Longfellow Fund 64.983

PROVENANCE: 1887, Williams and Everett Gallery, Boston; c. 1900,
Celian M. Spitzer, Toledo, Ohio; 1919, Sidney Spitzer; M. Spitzer,
Toledo; 1964, with Hirschl and Adler Galleries, New York; 1964,
purchased by the MFA.

In 1887, in response to French contemporary art,
Hassam altered his style when he painted *Grand Prix
Day*, using light colours that captured the effect of a
bright sunny day, rather than the darker, more tonal
palette of the Barbizon artists that he had previously
preferred. He depicted the parade of fashionably
dressed Parisians on their way to the Grand Prix at
Longchamp in the Bois de Boulogne, the premier
horse race in Paris held annually in June (see cat. 16).
Hassam exhibited a second, larger version entitled
Le Jour du Grand Prix (New Britain Museum of Art)
at the Salon of 1888. He described the picture to a
fellow artist, Rose Lamb: 'I am painting sunlight …
a "four in hand" and the crowds of fiacres filled with
the well dressed women who go to the "Grand Prix".'
Probably portraying the chestnut-tree-lined Avenue
Bois de Boulogne (now Avenue Foch), with the Arc
de Triomphe partially visible to the left, *Grand Prix
Day* demonstrates Hassam's adaptation of Monet's
colour and brushstrokes and the compositional
devices (cropping and empty foreground) often
utilised by Degas and Caillebotte to provide a
glimpse of modern Parisian life. However, Hassam's
more restrained form of Impressionism, influenced
by the work of Giuseppe de Nittis and Jean Béraud,
is evident in the solidity and detail of the horses,
carriages and figures. JC

22 CHILDE HASSAM
American, 1859–1935
Charles River and Beacon Hill, c. 1892
Oil on canvas, 41 x 45.7 cm

Museum of Fine Arts, Boston. Tompkins Collection 1978.178

PROVENANCE: After 1893, Frederick Amory, Boston; by 1916,
Margot Amory Ketchum, his niece; 1948, Phillips Ketchum,
her husband; 1978, purchased by the MFA.

EXHIBITION HISTORY: 1893, Boston, Doll and Richards Gallery,
Paintings by Childe Hassam.

In *Charles River and Beacon Hill* Hassam employed
the radical compositional effects that he had seen
in French painting to portray the changing aspects
of Boston. Like Caillebotte and other French
Impressionists, he used dramatically plunging
recession and a broad expanse of empty foreground
to draw the viewer into his cityscape, which includes
three of Boston's important topographical features.
On the left is the Charles River which divides the city
from Cambridge. In the centre is Beacon Hill, settled
in the eighteenth century and the site of the gold-
domed State House, and on the right is the Back Bay,
a fashionable residential area created over the previous
forty years by the filling of tidal flats. As Hassam was
no doubt aware, there had been much discussion in
Boston as to how to take best advantage of the
Charles River. Hassam showed the dirt road and
narrow walkway along the embankment, and he drew
attention to the river by including the boat landing
and the blue-coated man at the railing smoking his
pipe. Shortly thereafter, the scene was altered when
a one-hundred-foot-wide concrete promenade was
constructed beyond the sea wall. Here Hassam
captured the city of his youth as it was transforming
itself into a sophisticated urban centre. JC

23 CHILDE HASSAM
American, 1859–1935
Bathing Pool, Appledore, 1907
Oil on canvas, 63.2 x 75.6 cm

Museum of Fine Arts, Boston.
Ernest Wadsworth Longfellow Fund 64.982

PROVENANCE: After 1929, Carleton Palmer, Atlanta, Georgia;
1947, with Milch Galleries, New York; 1948, Robert Pollack,
New York; 1964, with Hirschl and Adler Galleries, New York;
1964, purchased by the MFA.

EXHIBITION HISTORY: 1929, New York, Macbeth Gallery,
Paintings by Childe Hassam.

From 1886 to 1916, Hassam made regular summer
visits to Appledore, the largest of nine rugged islands
that make up the Isles of Shoals about ten miles off
the coast of New Hampshire. Drawn to the island by
its natural beauty and leisure pursuits, Hassam was
also attracted by the salon and garden of the poet and
writer Celia Laighton Thaxter, whose family owned
the resort hotel and who welcomed writers, musicians
and artists to the flower-filled parlour of her cottage.
Hassam's illustrations of Thaxter's garden adorn her
book *An Island Garden*, published in 1894 just before
her death. Hassam had built a studio home on
Appledore and continued to visit after Thaxter's
death, although he no longer painted its lush floral
landscapes, concentrating instead on images of rocks
and sea. In *Bathing Pool, Appledore* he depicted the
resort life of the island in the foreground, including
swimmers in the pool area in front of colourful
bathhouses and strollers in the midday sunshine.
Beyond the holidaymakers stretches a benign sea
studded with the dome-shaped Babb's Rock and
other granite outcroppings, skilfully conveyed by the
artist using an elevated viewpoint, active brushwork
and a light, bright palette. JC

24 WILLIAM MORRIS HUNT
American, 1824–1879
Gloucester Harbor, 1877
Oil on canvas, 53.7 x 79.1 cm

Museum of Fine Arts, Boston. Gift of H. Nelson Slater,
Mrs Esther Slater Kerrigan and Mrs Ray Slater Murphy
in memory of their mother Mabel Hunt Slater 44.47

PROVENANCE: 1880, Hunt Estate Sale; 1880, Mr and Mrs John
L. Gardner, Boston; 1898, Isabella Stewart Gardner (Mrs John
L. Gardner); by 1914, Mrs H. N. Slater, artist's daughter,
Readville, Mass.; H. Nelson Slater, Mrs Esther Slater Kerrigan
and Mrs Ray Slater Murphy, her children; 1944, gift to the MFA.

EXHIBITION HISTORY: 1879, Boston, MFA,
William Morris Hunt Memorial Exhibition

Hunt spent the summer of 1877 in Kettle Cove, a
fishing village in Gloucester, north of Boston. The
surrounding area stimulated him to create a series
of landscape paintings, including *Gloucester Harbor*,
which were harbingers of the taste for Impressionism
that would soon infect Boston. Inspired by the late
landscapes of Corot and Daubigny that he had seen
on his second trip to Europe in 1866–8 and in Boston
collections, Hunt worked out of doors, painting this
view of Gloucester harbour in one afternoon and
writing of his pleasure in capturing the particular
opalescent light of the seaside. The spontaneity of
his brushwork, luminescent palette and summary
indication of harbour structures make this painting
one of Hunt's most modern works.

Isabella Stewart Gardner, known for the museum
she would create for her collection, purchased
Gloucester Harbor for the handsome price of $3,000
from Hunt's estate sale. She kept the painting for
thirty-four years before giving it to Hunt's daughter
for display in the newly opened Hunt Memorial
Gallery at Boston's Museum of Fine Arts. JC

25 WILLIAM MORRIS HUNT
American, 1824–1879
Sheep Shearing at Barbizon, c. 1852
Oil on panel, 25.1 x 39.4 cm

Museum of Fine Arts, Boston.
Bequest of Mrs Edward Wheelwright 13.455

PROVENANCE: By 1879, Edward Wheelwright; 1900,
Mrs Edward Wheelwright; 1913, bequest to the MFA.

EXHIBITION HISTORY: 1879, Boston, MFA,
William Morris Hunt Memorial Exhibition.

In the early 1850s Hunt became a friend, patron and
student of Jean-François Millet. Appalled by Millet's
modest economic circumstances, Hunt purchased
many of his paintings including his unfinished study,
Three Men Shearing Sheep in a Barn (cat. 29). He also
copied the composition in order to understand the
poses of men working in a typical rural activity and
the technique of rendering light streaming through
the doorway. Hunt's painting is somewhat more
finished than Millet's, especially in the strongly
outlined figure of the man in the doorway, who leans
from the weight of the sheep he carries. Hunt adapted
the soft brushwork, compositional devices and rural
subject matter that he learned from Millet in many
of his own canvases throughout the 1850s.

By the time of Hunt's memorial exhibition, *Sheep
Shearing at Barbizon* was in the possession of Edward
Wheelwright, Hunt's Harvard classmate and also a
student of Millet's in the late 1850s. Although
Wheelwright abandoned his attempt to become a
painter, he did contribute to Millet's reputation in
America through his activities as a writer, collector
and fundraiser. Hunt, as well as Wheelwright, helped
shape the taste for Millet's work in Boston, where it
was avidly collected. Millet's paintings, pastels and
drawings, radical at the time, inspired many local
artists just as they influenced Pissarro, van Gogh
and others. JC

26 EMILE CHARLES LAMBINET
French, 1815–1877
Village on the Sea, 1866
Oil on panel, 29.5 x 46 cm

Museum of Fine Arts, Boston
Bequest of Ernest Wadsworth Longfellow 37.600

PROVENANCE: Until 1921, Ernest Wadsworth Longfellow, Boston;
1937, bequest to the MFA.

A highly respected landscape artist of his day,
Lambinet has been overshadowed by his
contemporaries from the Barbizon School. Instead
of painting in the forest of Fontainebleau, Lambinet
found his visual delights at Ecouen, a town just north
of Paris. Ecouen was the site of an important artist's
colony that would come to include a number of
American painters, among them Mary Cassatt and
Henry Bacon.

Village on the Sea is an unidentified view of the
French countryside replete with peasant figures,
cows and cottages bordering the water. The artist
demonstrates his interest in the effects of light upon
the cirrus and cumulus clouds and on the sea's foamy
whitecaps. He also captures other atmospheric
conditions such as wind, evident at left in the
blowing wisps of brown grass.

In the 1850s and 1860s, Lambinet's work found a
receptive audience in Boston and helped pave the way
for their interest in the Barbizon School. The Boston
artist J. Foxcroft Cole encountered one of Lambinet's
works and set off for Paris in 1860 to become his
pupil. As other Boston artists visited Cole in Paris,
they were in turn introduced to the fluid, loose
brushwork of this notable French landscapist. LL

27 ERNEST LEE MAJOR
American, 1864–1950
Resting – Montigny-sur-Loing, 1888
Oil on canvas, 65.4 x 81.3 cm

Museum of Fine Arts, Boston.
Gift of the Morris Family 1993.901

PROVENANCE: The Morris Family; 1993, gift to the MFA.

In 1885 Major began his three years of study in
Europe by enrolling at the Académie Julian in Paris,
and the acceptance of his work at the Salon each year
from 1886 to 1889 confirmed his early success. It is
clear from *Resting – Montigny-sur-Loing* that Major
also became aware of the avant-garde developments
in Paris, especially the peasant pictures of Camille
Pissarro.

Rural and peasant motifs had become
increasingly popular in both France and America
in the 1870s and 1880s. Paintings by Millet and Jules
Breton were especially sought after in American
galleries and auction houses. Like Pissarro, Major
adopted those rural themes, rendering his workers
with a similarly modern Impressionist vocabulary.
Major portrayed his farm women in Montigny-sur-
Loing, a village southeast of Paris on the edge of
the Forest of Fontainebleau, between Moret, where
Sisley was working, and Grèz, an international artists'
colony. In his idealised vision of rustic life, Major
surrounded the women resting on farm implements
with a halo of light, which makes them stand out
from the background of rambling stone farm
buildings. Integrating his academic training in
figure painting and traditional composition with
Impressionist techniques, Major ably captured
the effect of sunlight on this pastoral scene, using
broken brushwork and a light palette. JC

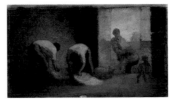

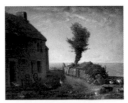

28 EDOUARD MANET
French, 1832–1883
Street Singer, c. 1862
Oil on canvas, 171.1 x 105.8 cm

Rouart/Wildenstein, vol. 1, no. 50
Museum of Fine Arts, Boston. Bequest of Sarah Choate Sears
in memory of her husband, Joshua Montgomery Sears 66.304

PROVENANCE: 1872, sold by artist to Durand-Ruel, Paris; 1872,
sold to Ernest Hoschedé, Paris; 1878, Hoschedé sale, to Jean-
Baptiste Faure, Paris; about 1895, sold to Durand Ruel, Paris,
1895, sold to Sarah Choate Sears, Boston; 1935, by descent to
her daughter, Helen Sears Bradley (Mrs J. D. Cameron Bradley),
Boston; 1966, bequest to the MFA.

EXHIBITION HISTORY: 1863, Galerie Louis Martinet, Paris,
14 Paintings by Manet; 1867, Exposition Universelle, Paris,
Tableaux de M Edouard Manet; 1884, Ecole Nationale des
Beaux-Arts, Paris, *Exposition Posthume de Manet.*

Antonin Proust, in his *Souvenirs* of Manet, recounts
the story of an evening when Manet, unable to paint
owing to insufficient light, strolled through Paris.
Proust relates this story much as Manet documented
his chance encounter in *Street Singer* with an
impromptu air and gritty realism. Upon observing a
cabaret musician exiting a 'sleazy café', Manet asked
her to pose, and was rejected (Antonin Proust,
Edouard Manet, Souvenirs, Paris, 1913, p. 40). Still
intrigued with the episode, Manet asked his newest
model, Victorine Meurend, who later figured in
Le Dejeuner sur l'herbe (1863) and *Olympia* (1865),
to assume the role.

The artist crystallises the musician's moment of
departure, catching her in the act of eating cherries
and hiking up her skirt to exit through the swinging
doors. Despite this impromptu pose, Manet carefully
arranged his model in his studio with props and
scenery familiar from other paintings. The large-scale
canvas was intended for the Salon, but when the jury
rejected it, Manet displayed *Street Singer* in his solo
show at the Galerie Martinet. Manet had challenged
artistic convention by creating a monumental canvas
of a provocative subject (female street musicians were
said to have questionable morals). He also chose a
casual and ephemeral moment, when the singer's hand
blocked her face. The painting was badly received;
only Emile Zola defended Manet, saying this work
evidenced 'the keen search for truth' (Emile Zola,
Salons, F. W. J. Hemming and Robert Neiss (eds),
Paris, 1959, p. 95). LL

29 JEAN-FRANCOIS MILLET
French, 1814–1875
Three Men Shearing Sheep in a Barn, c. 1852
Oil on canvas mounted on panel, 24.5 x 39.3 cm

Museum of Fine Arts, Boston.
Partial gift of William Morris Hunt II 2000.1221

PROVENANCE: About 1853, sold by artist to William Morris Hunt,
Boston; to his widow, Louisa Dumaresq Perkins Hunt; to her
children, Elinor Hunt Diederich, Enid Hunt Slater and Paul
Hunt; to Paul Hunt's son, William Morris Hunt II; 2000,
partial gift to the MFA.

Jean François Millet introduced a new approach to
the realistic representation of the rural working scene.
Although Courbet and Daumier had depicted
impoverished labourers before him, Millet portrayed
them with dignity. Unlike his fellow artists, who
showed the toil of farm work, Millet monumentalised
his rustic labourers, glorifying their vocation,
celebrating their resigned acceptance of their lot,
and exalting the timeless beauty of the land upon
which they toiled.

Millet was attracted to such rural subjects as
sheep shearing, an event he doubtless witnessed
as a boy in the Normandy countryside and a motif
he saw in Dutch and French genre paintings of the
seventeenth and eighteenth centuries. Sheep shearing
heralds the start of summer and appeared regularly in
medieval illuminated calendars. This small, crowded
composition, unusual for Millet, has the feel of an
observed scene recorded on the spot. Nevertheless,
Millet has added noble weightiness to the men by
posing them in classical *contrapposto*. The artist also
played with the formal aspects of interior and exterior
light, bringing twilight through the doorway into the
barn to create shadowy contrasts between the glow of
nature's light and the deep recesses of the labourer's
workspace.

William Morris Hunt bought and copied this
painting (see cat. 25), marking the influence the
Barbizon painter had upon the American artist. LL

30 JEAN-FRANCOIS MILLET
French, 1814–1875
End of the Hamlet of Gruchy, 1866
Oil on canvas, 81.6 x 100.6 cm

Museum of Fine Arts, Boston.
Gift of Quincy Adams Shaw through Quincy Adams Shaw, Jr,
and Mrs Marian Shaw Haughton 17.1508

PROVENANCE: 1866, sold by artist to Hector Brame and Antoine-
François Monmartel, Paris; 1868, Monmartel sale, to Hector
Brame; probably sold by Brame and Durand-Ruel, Paris, to
Jean-Baptiste Faure, Paris; 1873, Faure sale, probably to
Durand-Ruel, Paris; by 1879, Quincy Adams Shaw, Boston;
1917, gift to the MFA.

EXHIBITION HISTORY: 1866, Paris, Salon; 1889, New York,
American Art Association, *The Works of Antoine-Louis Barye …
His Contemporaries and Friends for the Benefit of the Barye
Monument Fund.*

Millet was born in Gruchy, a small village at the tip
of the Cotentin peninsula in the north-west corner
of Normandy. He left this remote area at age
nineteen, but revisited it following his mother and
grandmother's deaths in 1854. He made several studies
of this simple stone house at the edge of the sea,
flanked by a wind-blown elm tree. On a subsequent
visit in 1866 to see his ailing sister, he discovered
the tree had succumbed to the forceful gales of the
Channel coast. Millet wrote to his friend and
biographer, Alfred Sensier, 'Everywhere broken trees
cover the ground, and among them is my old elm
that I had counted on seeing again. That's the way
of everything, and us, too' (*Jean François Millet*,
Alexandra R. Murphy, exh. cat., Museum of Fine
Arts, Boston, 1984, p. 161). Working from the earlier
studies and from memory, Millet immortalised the
tree in this sentimental composition.

Millet challenged himself to convey both shadow
and sunlight: he bathed half the canvas in darkness
and half in the sun's glow, a technique he also used
in *Three Men Shearing Sheep in a Barn* (see cat. 29).
His scene is not without humour. The woman and
child move from the shade to the sun, enjoying a
view of the light-dappled sea. Meanwhile the geese
seize the moment to head inside the house. LL

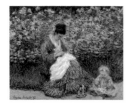

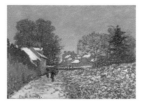

31 CLAUDE MONET
French, 1840–1926
*Camille Monet and a Child in the Artist's Garden
in Argenteuil*, 1875
Oil on canvas, 55.3 x 64.7 cm

Wildenstein 382
Museum of Fine Arts, Boston. Anonymous gift in memory
of Mr and Mrs Edwin S. Webster 1976.833

PROVENANCE: 1875, possibly sold by artist to Clément Courtois,
Mulhouse; Julius Oehme, Paris; 1900, with Durand-Ruel, Paris
and New York; by 1905, Desmond Fitzgerald, Brookline, Mass.;
1927, Fitzgerald sale, American Art Association, New York, to
Edwin Sibley Webster, Boston; 1972, by descent to an
anonymous donor, New York; 1976, gift to the MFA.

EXHIBITION HISTORY: 1905, Boston, Copley Hall, *Monet–Rodin*;
1911, Boston, MFA, *Monet*.

Monet painted this affectionate portrait of his first
wife, Camille, and an unidentified child in his
Argenteuil garden. During his years in Argenteuil,
Monet became an avid gardener, an avocation he
would perfect in his extensive garden at Giverny after
1883. Here, Monet recorded the splendour of his first
garden, allowing its brilliant colours to compete with
the beauty of his wife and the child.

The cultivated urban flower garden had only
recently become a feature of the middle-class home
in France. Monet used the new motif to confront
traditional forms of painting. Based on his recent
study of colour theory, he flattened the picture plane
by painting the foreground figures in cool blues
which recede, and the background flowers in hot reds
and pinks which advance to the front. Monet also
defied tradition with his fragmented brushstrokes
which uniformly affect both landscape and figures,
giving prominence to neither. This, in turn, asserts
yet another challenge, confusing the distinct genres
of figure painting and landscape, and questioning
the primacy of the human form. LL

32 CLAUDE MONET
French, 1840–1926
Meadow with Poplars, c. 1875
Oil on canvas, 54.6 x 65.4 cm

Wildenstein 378
Museum of Fine Arts, Boston.
Bequest of David P. Kimball in memory of his wife
Clara Bertram Kimball 23.505

PROVENANCE: 1878, sold by artist to M. Du Fresnay;
1894, sold to Durand-Ruel, Paris; to Durand-Ruel, New York;
1897, sold to J. Eastman Chase Gallery, Boston, for Clara
Bertram Kimball, Boston; by inheritance to her husband,
David P. Kimball, Boston; 1923, bequest to the MFA.

EXHIBITION HISTORY: 1895, New York, Durand-Ruel, *Monet*;
1897, Boston, Copley Hall, *Loan Exhibition of One Hundred
Masterpieces*; 1905, Boston, Copley Society, *Monet*; 1911, Boston,
MFA, *Monet*.

Monet employed a wide spectrum of colours to
depict this idyllic meadow near Argenteuil. Adapting
the theory of complementary colours to assist in the
description of space, he placed the brighter hues of
the flowers in the foreground and the cooler blues
and purples behind, thus pushing the horizon more
deeply into the depth of the composition. He
recorded the dazzling light shimmering off the poplar
leaves, the wild flowers and even the clouds, using
dashes of yellow rather than the traditional white.
The poplar trees on the left and the field of haystacks
on the right, framing a path of wild flowers, represent
early explorations of the themes Monet developed in
two of his series paintings of the 1890s.

Monet painted four versions of this riverside
meadow, which had become a focus of much local
debate during Monet's residence in Argenteuil.
Government officials in Paris had sought to build
a new system of sewers to carry sewage from Paris
to the Seine, thus polluting the fields and water in
towns lying below the capital, including Argenteuil.
LL

33 CLAUDE MONET
French, 1840–1926
Snow at Argenteuil, c. 1874
Oil on canvas, 54.6 x 73.7 cm

Wildenstein 348
Museum of Fine Arts, Boston.
Bequest of Anna Perkins Rogers 21.1329

PROVENANCE: 1890, sold by artist to Durand-Ruel, Paris;
1890, sold to Anna (Annette) Perkins Rogers, Boston;
1921, bequest to the MFA.

EXHIBITION HISTORY: 1879, Paris, *4e exposition de peinture*; 1892,
Boston, St Botolph Club, *Monet*; 1899, Boston, St Botolph Club,
Monet; 1903, Boston, Copley Hall, *A Loan Collection of Pictures
by Old Masters and Other Painters*; 1905, Boston, Copley Hall,
Monet–Rodin; 1911, Boston, Museum of Fine Arts, *Monet*; 1927,
Boston, Museum of Fine Arts, *Claude Monet Memorial
Exhibition*.

1874 was a monumental year for Claude Monet.
In April, he was instrumental in the organisation
of the first Impressionist exhibition. During the
summer, his friends Manet and Renoir came to
Argenteuil to paint with him, crystallising the
philosophy and technical approach of the group.
And, the following winter, after moving into his
new home on the Boulevard Saint Denis, he began
to paint nearly twenty-four snowscapes of the
neighbourhood. The remaining leaves on the trees
and the greenery visible in the square indicate that
this work dates to early winter, and it may have been
painted during a rapid snowfall on 19 December
1874, when large flakes of snow fell all day long.
Monet's asymmetrical composition and patterning
of snowflakes across the surface of his canvas
demonstrate his knowledge of Japanese woodblock
prints (see pp. 24–5).

Impressionist scenes had been largely inspired
by spring flowers and summer recreation along the
Seine. Monet now added a new season to his
repertoire, and he would produce over 140 snow
scenes during his career. His passion for the snow
would bring him to frigid Norway to paint with
his friend, Frits Thaulow (see cat. 55), in 1895. LL

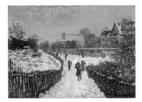

34 CLAUDE MONET
French, 1840–1926
Boulevard Saint-Denis, Argenteuil, in Winter, 1875
Oil on canvas, 60.9 x 81.6 cm

Wildenstein 357a
Museum of Fine Arts, Boston.
Gift of Richard Saltonstall 1978.633

PROVENANCE: By 1888, Henri Kapferer, Paris; 1888, sold to
Durand-Ruel, Paris; 1890, sold to J. Foxcroft Cole for Peter
Chardon Brooks, Boston; to his daughter, Eleanor Brooks
Saltonstall (Mrs Richard M. Saltonstall), Boston; by descent
to her son, Richard Saltonstall, Boston; 1978, gift to the MFA.

Monet's primary concern was to record changing
weather and light conditions. His observations of
the variable properties of light, whether it was the
effect of sunset on his pond of water lilies at Giverny
(see cat. 42) or the sudden burst of sunshine that
brightens the blustery cold day in this work, were
virtuoso recordings of the natural world. He also
noted the transformation of Argenteuil, the small
town to the west of Paris that was experiencing rapid
modernisation through industrialisation and the
arrival of the train link with Paris. He lived in the
town from 1871 to 1878, painting over 175 images of
its environs. Monet alluded to this urban change by
placing his easel on the unpaved road just a few steps
from the railway station. The work also includes
autobiographical detail in that it shows the artist's
first residence, the large structure in the distance
towards the end of the snowy road, and his current
home, the newly built green-shuttered house on the
far right of the canvas.

Joseph Foxcroft Cole purchased this and two
other Monets – *The Fort at Antibes* (cat. 37) and
Seine at Lavacourt (1880, Harvard University Art
Museums) – for Peter Chardon Brooks in 1890
from Durand-Ruel. LL

35 CLAUDE MONET
French, 1840–1926
Fisherman's Cottage on the Cliffs at Varengeville, 1882
Oil on canvas, 60.6 x 81.6 cm

Wildenstein 805
Museum of Fine Arts, Boston.
Bequest of Anna Perkins Rogers 21.1331

PROVENANCE: 1882, possibly sold by artist to Durand-Ruel, Paris;
1883, possibly sold to Galerie Georges Petit, Paris; 1890, Georges
de Porto-Riche, Paris; 1890, to Durand-Ruel, Paris; 1890, sold
to Anna (Annette) Perkins Rogers, Boston; 1921, bequest to
the MFA.

EXHIBITION HISTORY: 1892, Boston, St Botolph Club, *Monet*,
1899, Boston, St Botolph Club, *Monet* 1903, Boston, Copley
Hall, *A Loan Collection of Pictures by Old Masters and Other
Painters*; 1905, Boston, Copley Hall, *Monet–Rodin*; 1911, Boston,
MFA, *Monet*.

In 1881, Monet embarked upon what would become
a peripatetic lifestyle for two decades. In search of
new motifs, he left his family for extended periods,
exploring and painting in France, Italy and Holland.
He began his travels in the region of his youth, the
coast of the Channel in Normandy. In 1882, he spent
six months at Pourville, a small seaport just west of
Dieppe. He rented a summer home and welcomed
his companion, Alice Hoschedé, and their extended
family in mid-June.

Upon arriving in a new place, Monet would
investigate the area by foot, scouting for locations to
paint. Fascinated by this stone cabin situated on the
cliffs at Varengeville just down the coast, he depicted
it at least seventeen times in 1882 and would return
to the subject in 1896 and 1897. The structure was a
coast guards' cottage, one of many that dotted the
coast and a vestige from the Napoleonic Era when, in
1806, the Emperor declared a 'Continental Blockade',
forbidding all trade with England. In Monet's time,
these buildings were used by fishermen for storage.
From the artist's depiction, the house does not appear
to be reachable, either by land or by sea. LL

36 CLAUDE MONET
French, 1840–1926
Meadow with Haystacks near Giverny, 1885
Oil on canvas, 74 x 93.5 cm

Wildenstein 995
Museum of Fine Arts, Boston.
Bequest of Arthur Tracy Cabot 42.541

PROVENANCE: 1885, sold by artist to Durand-Ruel, Paris; 1886,
with Bernheim-Jeune, Paris; 1886, with Durand-Ruel, New York;
1897, J. Eastman Chase Gallery, Boston; by 1899, acquired by
Lilla Cabot Perry for her brother, Arthur Tracy Cabot, Boston;
to his widow, Susan Shattuck Cabot; 1942, bequest to the MFA.

EXHIBITION HISTORY: 1886–7, New York, American Art Galleries,
Modern Paintings 1887, New York, National Academy of Design,
Celebrated Paintings by Great French Masters; 1895, New York,
Durand-Ruel, *Tableaux de Claude Monet* as *La Pré à Giverny*,
1899, Boston, St Botolph Club, *Monet*; 1905, Boston, Copley
Hall, *Monet Rodin*; 1911, Boston, MFA, *Monet*.

In April of 1883, Monet moved to a large home on 96
acres in Giverny, an agrarian village located 50 miles
north west of Paris. Unlike Millet, who focused on
the dignified labour of rural workers (see cat. 29),
Monet seldom painted farmers, concentrating instead
on the daily and seasonal passage of light upon the
local fields. Here he documented the effects of late
afternoon sun streaking a grassy meadow with yellow
and orange and setting the haystacks and trees aglow
with pastel pinks and mauves. As if the sun had
suddenly broken through dense clouds, ethereal
rays of light bathe the entire scene.

John Singer Sargent's *Claude Monet Painting
by the Edge of a Wood* (see cat. 49), depicts Monet
painting this canvas during Sargent's visit to the artist
at Giverny in 1885. Both pictures were exhibited in
Boston in February of 1899. LL

37 CLAUDE MONET
French, 1840–1926
The Fort of Antibes, 1888
Oil on canvas, 65.4 x 81 cm

Wildenstein 1161a
Museum of Fine Arts, Boston. Anonymous gift 1978.634

PROVENANCE: 1890, sold by artist to Durand-Ruel, Paris; 1890,
sold to J. Foxcroft Cole for Peter Chardon Brooks, Boston;
by descent to his daughter, Eleanor Brooks Saltonstall
(Mrs Richard M. Saltonstall), Boston; 1962, by descent to
an anonymous donor; 1978, gift to the MFA.

EXHIBITION HISTORY: Possibly 1889, Paris, Galerie Georges Petit,
Monet–Rodin; 1892, Boston, St Botolph Club, *Monet*.

Monet went to great lengths to paint *The Fort of
Antibes* because of a new statute prohibiting the
making of images of military sites. Obsessed with
the motif, Monet asked the Minister of the Army
for special authorisation to circumvent this law in
order to continue painting the fort.

Using a traditional compositional structure, in
which the horizontal strips of brightly coloured sea,
mountains and sky are balanced by the two strong
verticals of the fort, Monet created a 'rich, daring
landscape' (Wildenstein 1979, vol. 3, p. 10, fn. 714),
as noted by Vincent van Gogh, who saw ten of
Monet's paintings of Antibes when they were shown
by his brother Theo at Galerie Boussod et Valadon
in Paris in the summer of 1888. Vincent's admiration
was complemented by extremely favourable critical
response. Through repeatedly addressing the same
subject, Monet was able to work out a variety of
issues concerning compositional design, the capturing
of atmospheric conditions and colour gradations,
which paved the way for his more systematic series
paintings of the next decade. LL

38 CLAUDE MONET
French, 1840–1926
Antibes Seen from the Plateau Notre-Dame, 1888
Oil on canvas, 65.7 x 81.3 cm

Wildenstein 1172
Museum of Fine Arts, Boston.
Juliana Cheney Edwards Collection 39.672

PROVENANCE: 1889, Georges Petit, Paris; 1889, sold to M.
Knoedler and Co., New York; 1890, sold to Doll and Richards,
Boston; 1890, sold to J. Foxcroft Cole, Boston; by inheritance to
his daughter, Adelaide H. L. A. de Pelgrom Cole Chase, Boston;
1911, still with Chase; by 1927, Hannah Marcy Edwards, Boston;
1929, by inheritance to her sister, Grace M. Edwards, Boston;
1939, bequest to the MFA.

EXHIBITION HISTORY: 1889, Paris, Galerie Georges Petit,
Monet–Rodin; 1892, Boston, St Botolph Club, *Monet*; 1899,
Boston, St Botolph Club, *Monet*; 1905, Boston, Copley Society,
Monet; 1911, Boston, MFA, *Monet*.

In letters from 1888, Monet referred to Antibes, on
the French Riviera, as 'a small fortified town, baked
to a golden crust by the sun', (Wildenstein 1979,
vol. 3, p. 225, letter 811), and declared he was 'working
from morning to evening, brimming with energy …
I'm fencing and wrestling with the sun. And what
a sun it is. In order to paint here one would need
gold and precious stones' (Wildenstein 1979, vol. 3,
p. 227, letter 825).

In four short months, Monet completed thirty-
nine paintings, despite unexpected fluctuations in the
climate and his emotional state. When the weather was
inclement, Monet's anxiety about finishing his newly
begun canvases mounted. This view, one of at least
four made from a similar vantage point, shows the old
fortified city of Antibes from across the Baie des Anges
in the area of Pointe Bacon. Monet took more interest
in the overall composition of land, sea, mountains
and sky, unified by a solitary pine tree, rather than
in defining the architecture of the town. LL

39 CLAUDE MONET
French, 1840–1926
Cap d'Antibes, Mistral, 1888
Oil on canvas, 66.0 x 81.3 cm

Wildenstein 1176
Museum of Fine Arts, Boston.
Bequest of Arthur Tracy Cabot 42.542

PROVENANCE: 1890, sold by artist to Durand-Ruel, Paris; 1892,
J. Eastman Chase Gallery, Boston; by 1903, acquired by Lilla
Cabot Perry for her brother, Arthur Tracy Cabot, Boston;
to his widow, Susan Shattuck Cabot; 1942, bequest to the MFA.

EXHIBITION HISTORY: 1889, Paris, Galerie Georges Petit,
Monet–Rodin; 1903, Boston, Copley Hall, *A Loan Collection
of Pictures by Old Masters and Other Painters*; 1905, Boston,
Copley Hall, *Monet–Rodin*; 1911, Boston, MFA, *Monet*.

Monet simplified this view of Antibes by situating
himself further east across the bay, from whence he
could focus his attention on the snow-capped
mountain peaks in the distance rather than the
fortified city. This also allowed him to concentrate
on an atmospheric condition endemic to this region,
the mistral. This cold, northerly wind, most common
during the winter (Monet was here from January to
April), passes along the Riviera coast, often at speeds
reaching over 100 knots, tossing sand and surf in its
path. Monet wrote in a letter, 'A curse follows me to
the end: there is a splendid sun, but the mistral wind
is so strong that it is impossible to stand up in it'
(Wildenstein 1979, vol. 3, p. 234, letter 867). At one
point, he was forced to chain his easel and canvas to
the ground during the forceful gale, but soon his
palette and painting were covered with sand. Monet's
vigorous and curvaceous strokes convey the brisk
movement of trees and sea in the face of the strong
wind. LL

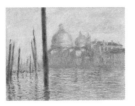

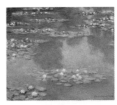

40 CLAUDE MONET
French, 1840–1926
Valley of the Petite Creuse, 1889
Oil on canvas, 65.4 x 81.3 cm

Wildenstein 1230
Museum of Fine Arts, Boston.
Bequest of David P. Kimball in memory of his wife
Clara Bertram Kimball 23.541

PROVENANCE: 1890, sold by artist to Durand-Ruel, Paris;
to Durand-Ruel, New York; 1891, sold to J. Eastman Chase
Gallery, Boston, for Clara Bertram Kimball, Boston;
by inheritance to her husband, David P. Kimball; 1923,
bequest to the MFA.

EXHIBITION HISTORY: 1889, Paris, Georges Petit, *Monet–Rodin*;
1891, New York, Union League Club, *Monet*; 1891, Boston,
Chase Gallery, *The Impressionists of Paris: Monet. Pissarro, Sisley*;
1895, Boston, St Botolph Club, *Monet*; 1899, Boston, St Botolph
Club, *Monet*, 1905, Boston, Copley Society, *Monet–Rodin*; 1911,
Boston, MFA, *Monet*.

In 1889, Monet enjoyed critical success at several
Parisian exhibitions, including the Exposition
Universelle and a concurrent retrospective, shared
with Auguste Rodin, of 145 paintings shown at the
Galérie Georges Petit. His work was now being bought
by American and European collectors, and American
artists began to work in proximity to him at Giverny.

In search of new subject matter, after his forays
to the Mediterranean and at Belle Ile, he travelled to
Fresselines, a remote town about 190 miles south of
Paris in the Massif Central overlooking the confluence
of the Petite and the Grande Creuse rivers. Here,
from mid-February to mid-May 1889, Monet
produced twenty-four paintings. Although dismal
weather plagued the artist for most of his stay, he
depicted the range of weather effects, including the
brilliance of sunlight on the river, as seen in this
work, which he compared to 'sequins and diamonds'
(Wildenstein 1979, p. 247, letter 971). The Creuse
group is the first, and possibly one of Monet's boldest,
with monumental shapes built from a thick crust of
glimmering paint. The artist saw himself as the lonely
old tree, vulnerable to the power of nature. But it was
Monet who prevailed: when the tree began to sprout
leaves, he had it stripped, thus preserving his winter
composition despite the arrival of spring. LL

41 CLAUDE MONET
French, 1840–1926
Grand Canal, Venice, 1908
Oil on canvas, 73.7 x 92.4 cm

Wildenstein 1738
Museum of Fine Arts, Boston.
Bequest of Alexander Cochrane 19.171

PROVENANCE: 1912, sold by artist to Bernheim-Jeune, Paris
and Durand-Ruel, Paris; to Durand-Ruel, New York; 1912,
sold to Alexander Cochrane, Boston; 1919, bequest to the MFA.

EXHIBITION HISTORY: 1912, Paris, Galerie Bernheim-Jeune,
Monet–Venise.

At the age of sixty-eight, Monet finally agreed to visit
Venice, a city he had believed was 'too beautiful to be
painted' (Philippe Piguet, *Monet et Venise*, Paris, 1986,
p. 27). Mrs Mary Hunter, a friend of the artist John
Singer Sargent, had invited Monet and his wife Alice
to stay at the Palazzo Barbaro, a fifteenth-century
Gothic palace on the Grand Canal that she had
rented from her friends, the Boston-based Curtis
family. After seeing the customary tourist sites, the
vacation quickly turned into another painting
expedition. Monet made thirty-seven works during
his two-month stay, concentrating on a small number
of motifs: the Doge's Palace, the palaces on the Grand
Canal, views of San Giorgio Maggiore, and the
Grand Canal as shown here.

From the landing stage of the Palazzo Barbaro
Monet produced this view of the Grand Canal with
the seventeenth-century church of Santa Maria della
Salute. Unlike Renoir, who came to Venice in 1881
and depicted the Grand Canal with choppy dabs of
colour and perspectival space given by the recession
of the canal (cat. 47), Monet flattened the space by
patterning his canvas with strokes of lavenders, blues,
greens and yellows and by pushing the gondola
mooring pole into the viewer's space. A selection
of Monet's Venetian works were exhibited at Galerie
Bernheim-Jeune in 1912 to great critical acclaim.
American and English collectors purchased two-thirds
of the works on display, dispersing the series shortly
after its creation. LL

42 CLAUDE MONET
French, 1840–1926
Water Lilies, 1905
Oil on canvas, 89.5 x 100.3 cm

Wildenstein 1671
Museum of Fine Arts, Boston.
Gift of Edward Jackson Holmes 39.804

PROVENANCE: 1909, sold by artist to Durand-Ruel, Paris and
New York, and Bernheim-Jeune, Paris; 1909, sold to Alexander
Cochrane, Boston; 1909, bought back by Durand-Ruel, Paris
and New York; 1911, sold to Mrs Walter Scott Fitz (Henrietta
Goddard Wigglesworth), Boston; by descent to her son,
Edward Jackson Holmes, Boston; 1939, gift to the MFA.

EXHIBITION HISTORY: 1909, Paris, Durand-Ruel, *Monet:
Nymphéas*; 1909, New York, Durand-Ruel, [*Monet*]; 1910,
Boston, Walter Kimball Gallery, *Monets from the Durand-Ruel
Collection*; 1911, New York, Durand-Ruel, *Tableaux de Claude
Monet à différentes périodes*.

The year 1893 marked the beginning of Monet's work
on the creation of a water garden on his property in
Giverny. Despite local opposition to his plan to divert
water from the River Ru to construct a small pond in
which to grow his water lilies, Monet persevered and
won the day. In 1895 he began to paint waterscapes,
a practice he continued until his death. After the
completion of the Japanese Bridge series (1899–1901)
he enlarged the pond, using it for both the series of
water lilies made between 1903 and 1908, and for his
later 'decorations', to which he devoted the closing
years of his life.

This work, made in 1905, is one of a group of
water-lily subjects in which Monet abandoned any
reference to the banks of the pond, concentrating
instead on the water and plants. The surfaces of the
painting and of the pool merge into one. The top
of the composition bulges with lilies, while the water
reads as both an illusion of depth and a reflection
of the nearby trees and distant sky. The effect is to
invert the composition, and in doing so Monet has
overturned the traditional expectation of landscape
painting, namely the inclusion of the horizon line
and perspective. When forty-eight of these works
were shown at Durand-Ruel in 1909, they enjoyed
a favourable critical reception, with analogies being
drawn between the paintings and music and poetry.
LL

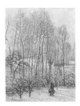

43 LILLA CABOT PERRY
American, 1848–1933
Open Air Concert, 1890
Oil on canvas, 101 x 76.5 cm

Museum of Fine Arts, Boston.
Gift of Miss Margaret Perry 64.2055

PROVENANCE: 1933, Margaret Perry, artist's daughter; 1964,
gift to the MFA.

EXHIBITION HISTORY: 1891, New York, National Academy of
Design; 1893, Chicago, World's Columbian Exposition; 1897,
Boston, St Botolph Club, *Lilla Cabot Perry*; 1915, San Francisco,
Panama-Pacific International Exposition; 1933, Boston Art Club,
Lilla Cabot Perry Memorial Exhibition; 1934, Art Association of
Newport, RI, Memorial Exhibition.

In 1890 Perry painted three *plein-air* compositions,
including *Open Air Concert,* at the home of friends
with whom the Perrys resided for the summer in
Milton, Massachusetts, near Boston. The previous
year Perry had admired the paintings by Monet
shown at Galerie Georges Petit in Paris and had spent
the summer at Giverny, where she befriended the
master and began adapting his style. Perry frequently
used her three daughters as models: Margaret (born
1876) shown here playing the violin, Alice (born 1884)
between her two older sisters, and Edith (born 1880)
looking out at the viewer. Combining her academic
training with Impressionism, Perry modelled the
figures solidly but dissolved the forms of the
landscape behind the girls and suggested dappled
sunlight on Margaret's blue dress with broad strokes
of white and pink pigment. The acceptance of *Open
Air Concert* by the juries of prestigious international
exhibitions testifies to their recognition of Perry's
artistic accomplishment. JC

44 LILLA CABOT PERRY
American, 1848–1933
The Old Farm, Giverny, 1909
Oil on canvas, 65.1 x 81.3 cm

San Antonio Museum of Art. Purchased with funds provided
by the Lillie and Roy Cullen Endowment Fund 96 38

PROVENANCE: By 1933, with daughter, Margaret Perry; to Patricia
Cowse Holsaert; by 1974, with her brother, James Holsaert; 1992,
sold to Meredith Long and Co. Gallery, Houston, TX; 1996,
purchased by the San Antonio Museum of Art.

EXHIBITION HISTORY: 1911, Boston, Copley Gallery,
An Exhibition of Portraits and Other Pictures by Lilla Cabot Perry;
1917, Boston, Guild of Boston Artists; 1920, Milton, Mass.,
Milton Public Library.

Profoundly inspired by Monet and the countryside
surrounding his home, Perry spent nine summers
in Giverny depicting sun-dappled landscapes in an
Impressionist style. She eliminated the dark colours
and solid strokes she used in her portraiture and
delighted in her mentor's suggestion that she 'try to
forget what objects you have before you, a tree, a
house, a field or whatever. Merely think here is a little
square of blue, here an oblong of pink, here a streak
of yellow, and paint it just as it looks to you' (*Lilla
Cabot Perry*, Meredith Martindale, exh. cat., National
Museum of Women in the Arts, Washington, DC,
1990, p. 116). Here, Perry applies her paint directly
onto the canvas in a mosaic of pastel colours that
evoke a windy early autumn day at twilight. The
mauve farmhouses sit solidly in the centre of her
composition, providing a clear focal point. John Leslie
Breck, another American devotee of Monet, depicted
similar structures in his panoramic view of the Seine
Valley (cat. 6). LL

45 CAMILLE PISSARRO
French, 1830–1903
Morning Sunlight on the Snow, Eragny-sur-Epte, 1895
Oil on canvas, 82.3 x 61.6 cm

Pissarro/Venturi, vol. 2, no. 911
Museum of Fine Arts, Boston.
The John Pickering Lyman Collection.
Gift of Miss Theodora Lyman 19.1321

PROVENANCE: 1895, sold by artist to Durand-Ruel, Paris
and New York; 1910, sold to John Pickering Lyman; 1914,
to Theodora Lyman; 1919, gift to the MFA.

EXHIBITION HISTORY: 1915, Boston, MFA, *Evans Wing Opening*.

In 1884, Pissarro moved from the semi-industrialised
area of Pontoise to Eragny, a rural village on the River
Oise north of Paris. With Monet's financial assistance,
Pissarro purchased a home, converted its barn into a
studio, and painted its environs for the last twenty
years of his life. Eragny was Pissarro's Giverny. Just
as Monet painted the gardens surrounding his home
in Giverny, Pissarro portrayed Eragny's meadows,
farmland and workers during the 1880s and 1890s.
Unable to work out-of-doors owing to a condition
that made his eyes easily aggravated by wind and dust,
Pissarro depicted scenes from his window at different
times of day throughout the year.

 Despite the snowy scene, a motif used by many
of the Impressionists (see cats 33, 34 and 55), Pissarro,
remarkably, used no pure white in this work. Instead,
he mixed his colours to create a pastel palette
intended to represent the luminosity of the snow.
Despite his clear delight in Impressionist technique,
Pissarro, an admitted anarchist, often communicated
his political convictions through his subject matter.
Here, in the early morning hours of a winter day, a
farm worker, confined by a screen of interconnected
trees and restricted to the bottom left corner of the
canvas, possibly expresses the artist's sympathy with
the lot of the labouring rural poor. LL

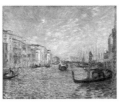

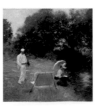

46 PIERRE-AUGUSTE RENOIR
French, 1841–1919
The Seine at Chatou, 1881
Oil on canvas, 73.3 x 92.4 cm

Museum of Fine Arts, Boston.
Gift of Arthur Brewster Emmons 19.771

PROVENANCE: 1891, sold by artist to Durand-Ruel, Paris;
to Durand-Ruel, New York; 1900, sold to Mrs Blair; 1901,
J. M. Sehley, New York; 1901, sold to Durand-Ruel, New York;
1906, sold to Arthur Brewster Emmons, Newport, RI,
and New York; 1919, gift to the MFA.

EXHIBITION HISTORY: 1882, Paris, 251 rue Saint-Honoré, March,
7e exposition des artistes indépendants.

Small suburban towns on the Seine such as Chatou,
north west of Paris, grew in popularity for both artists
and city dwellers during the course of the nineteenth
century. Artists were attracted by the low cost of
living, easy access to Paris by train, and a constant
flow of pictorial subjects provided by the Parisians
who flocked to these suburban leisure spots during
summer weekends to indulge in swimming, boating
and other waterside pleasures.

Renoir, encouraged to paint the area by Monet,
had just completed one of the most ambitious and
complex works of his career, *Luncheon of the Boating
Party* (1880–1, The Phillips Collection, Washington,
DC). *The Seine at Chatou*, created the following
spring, is much more carefree. In true Impressionist
fashion, Renoir did not differentiate between the
textures of the girl gathering flowers and the
springtime meadow in bloom. Instead, he absorbed
her into the landscape as if she were another wild
flower. He cunningly variegated his brushstrokes to
evoke the bushiness of trees in flower, the length
of the flowing grasses and the fluidity of the water. LL

47 PIERRE-AUGUSTE RENOIR
French, 1841–1919
Grand Canal, Venice, 1881
Oil on canvas, 54 x 65.1 cm

Museum of Fine Arts, Boston.
Bequest of Alexander Cochrane 19.173

PROVENANCE: 1882, sold by artist to Durand-Ruel, Paris;
to Durand-Ruel, New York; 1889, sold to Alexander Cochrane,
Boston; 1919, bequest to the MFA.

EXHIBITION HISTORY: 1882, Paris, 251 rue Saint-Honoré, March,
7e exposition des artistes indépendants; possibly 1899, Paris, Galerie
Durand-Ruel, *Monet, Pissarro, Renoir, Sisley*; 1915, Boston, MFA,
Evans Wing Opening.

A fascination with the relationship between light and
water drew the Impressionists to Venice; Manet and
Monet went there in 1875 and 1908 respectively. Many
American artists, including Whistler and Sargent, also
depicted its canals and local scenes. It may have been
Whistler who recommended Venice to Renoir during
their sojourn in Chatou in the spring of 1881, just
after Whistler had returned from the city.

The purchase early in 1881 of a considerable
number of Renoir's paintings by the dealer Durand-
Ruel enabled the artist to travel abroad for the first
time in his life. He visited Algeria in February and
March 1881 and went to Italy in the autumn of the
same year. His Venetian canvases focus on major
tourist sights such as the Piazza San Marco or this
view of the Grand Canal with its elaborate Gothic
and Renaissance palaces. The verticals of the
stately edifices and the gondola mooring poles
counterbalance the horizontals of the canal waters
and windy sky. Renoir had not planned to exhibit
Grand Canal, Venice in the seventh Impressionist
exhibition in 1882, but Durand-Ruel included it
there, along with twenty-four other paintings that
the dealer had purchased the previous year. LL

48 JOHN SINGER SARGENT
American, 1856–1925
Dennis Miller Bunker Painting at Calcot, 1888
Oil on canvas mounted on masonite, 68.6 x 64.1 cm

Terra Foundation for the Arts, Daniel J. Terra Collection

PROVENANCE: By 1890, with Bunker's widow, Mrs Charles A.
Platt, Windsor, Vermont; 1943, The Milch Galleries; sold to
David Findlay; 1951, sold to Vernon West; sold to Vose Gallery,
Boston; 1953, sold to Scott and Fowles, New York, sold to Mrs
William C. Breed; 1977, Sotheby's sale, New York, sold to
Kennedy Galleries, Inc, New York (agent), Daniel J. Terra
Collection, Chicago; 1999, Terra Foundation for the Arts,
Chicago.

Sargent met Bunker in Boston during his sojourn
to America in 1887, and invited him to Calcot Mill,
a small, idyllic town located one hour west of
London, for the following summer. Sargent was
then at the peak of his experimentation with
Impressionism, and the two painters spent several
weeks working *en plein air*

In this work Sargent explores the relationship
between his fellow artist, his canvas and the
surrounding landscape. He used staccato strokes
of paint to illuminate the bright, summery scene.
Unlike Sargent's depiction of Monet, who he shows
at work in *Claude Monet Painting by the Edge of a
Wood* (cat. 49), his representation of Bunker portrays
the artist at odds with his painting and the landscape
around him. Bunker's canvas balances precariously
on his easel and he regards it from a distance, his
hand in his pocket. Sargent was perceptive, for
Bunker, dissatisfied with his work, saved nothing
from that summer. The following year, however,
Bunker created astonishing Impressionist works
in the American countryside, at Medfield,
Massachusetts (see cat. 7). LL

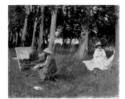

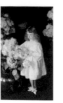

49 JOHN SINGER SARGENT
American, 1856–1925
Claude Monet Painting by the Edge of a Wood, 1885
Oil on canvas, 54 x 64.8 cm

Ormond/Kilmurray vol. 1, no. 153
Tate. Presented by Miss Emily Sargent and Mrs Ormond
through the National Art Collections Fund 1925 No4103

PROVENANCE: 1925, artist's sale, Christie's, London, withdrawn
by artist's sisters, Miss Emily Sargent and Mrs Francis Ormond,
and presented to the Tate Gallery through the National Art
Collections Fund.

EXHIBITION HISTORY: 1899, Boston, Copley Hall,
John Singer Sargent.

Despite his allegiance to the Salon system, Sargent
experimented extensively with Impressionist technique
during the mid-1880s. One British critic even called
him the 'Arch-Apostle of the Spot and Dab School'
(*Art Journal*, 26, June 1887, p. 248). Sargent had met
Monet at the second Impressionist exhibition in 1876,
when he was twenty, and the two painters remained
friends for the rest of their lives. Sargent visited Monet
at Giverny in 1885, two years before the first colony
of Americans was established there. In the painting
shown here, Sargent presents Monet at work outdoors
on *Meadow with Haystacks near Giverny* (cat. 36).
Absorbed in his work, Monet's hand, brush and coat
literally blend into his canvas, his body appearing
like the roots of the tree behind him. Sargent adopted
the loose brushwork and informal subject of
Impressionism to portray the French master, one of
several compositions he made depicting fellow artists
at work.

 Sargent kept this painting in his collection until
his death, evidence of his profound admiration for
the French painter whose work he promoted and
collected. LL

50 JOHN SINGER SARGENT
American, 1856–1925
Helen Sears, 1895
Oil on canvas, 167.3 x 91.4 cm

Ormond/Kilmurray vol. 2, no. 318
Museum of Fine Arts, Boston.
Gift of Mrs J. D. Cameron Bradley 55.1116

PROVENANCE: Sarah Choate Sears (Mrs J. Montgomery Sears),
mother of the sitter, Boston; 1935, Helen Sears (Mrs J. D.
Cameron Bradley), Southboro, Mass.; 1955, gift to the MFA.

EXHIBITION HISTORY: 1896, New York, Society of American
Artists, Eighteenth Exhibition; 1897, Boston, Copley Hall,
Loan Exhibition of One Hundred Masterpieces; 1899, Boston,
Copley Hall, *Paintings and Sketches by John S. Sargent*; 1916,
Boston, MFA, *John Singer Sargent*; 1925, Boston, MFA,
Memorial Exhibition; 1926, New York, Metropolitan Museum
of Art, Memorial Exhibition.

Helen Sears was one of two portraits Sargent
completed in 1895 when he travelled to Boston to
install his first murals at the Boston Public Library.
Six-year-old Helen was the daughter of Sarah Choate
Sears, a friend and an accomplished photographer,
painter and art patron. Sargent's high viewpoint and
tilted perspective serve to silhouette Helen against
the dark-red carpet, and the creamy tones of her dress
and bright illumination of her face lend her an air of
childhood innocence, belied in part by her wistful
mood as she stares solemnly into the distance. Helen
had posed for another portrait by Abbott H. Thayer
three years earlier and was a frequent subject of her
mother's photographs. Sears sent Sargent her
photograph of Helen in the same dress and shoes,
prompting him to respond that it 'makes me feel
like returning to Boston and putting my umbrella
through my portrait. But how can an unfortunate
painter hope to rival a photograph by a mother?
Absolute truth combined with absolute feeling'
(Erica E. Hirshler, 'The Fine Art of Sarah Choate
Sears', *Antiques,* September 2001, p. 323). JC

51 JOHN SINGER SARGENT
American, 1856–1925
Fishing for Oysters at Cancale, 1878
Oil on canvas, 41 x 61 cm

Museum of Fine Arts, Boston.
Gift of Miss Mary Appleton 35.708

PROVENANCE: Samuel Colman, Newport, RI and New York;
Susan Travers; by 1905, Mary Appleton, Boston; 1935, gift to
the MFA.

EXHIBITION HISTORY: 1878, New York, Society of American
Artists, First Exhibition; 1880, New York, Metropolitan Museum
of Art, Inaugural Exhibition; 1905, Boston, MFA; 1925, Boston,
MFA, Memorial Exhibition.

In 1877 the twenty-one-year-old Sargent spent the
summer in Cancale on the coast of Brittany sketching
fisherfolk. He sent his first completed painting, *Fishing
for Oysters at Cancale*, a finished sketch, to New York
for display at the newly formed avant-garde Society
of American Artists. Sargent submitted the second
painting, *Oyster Gatherers of Cancale* (Corcoran Gallery
of Art, Washington, DC), a larger, more finished
version of the same subject, to the 1878 Paris Salon,
where it was awarded an Honorable Mention. Critics
praised *Fishing for Oysters at Cancale,* the first Sargent
painting to be exhibited in America, for its silvery
hue and almost palpable marine atmosphere. Samuel
Colman, a landscape painter twenty-four years
Sargent's senior, bought it for $200 as a standard to
emulate. Sargent's choice of subject was not
revolutionary – a similar scene of oyster harvesters
had won a medal at the Salon in 1874. However, his
ability to paint the reflections in the tidal pools and
the light sparkling on the figures and clouds dazzled
viewers, clearly demonstrating that his talents
extended beyond portraiture. JC

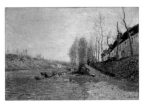

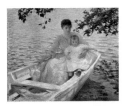

52 ALFRED SISLEY
British, 1839–1899
Waterworks at Marly, c. 1876
Oil on canvas, 46.5 x 61.8 cm

Daulte, no. 216
Museum of Fine Arts, Boston.
Gift of Miss Olive Simes 45.662

PROVENANCE: By about 1910–15, with Durand-Ruel, New York
and Paris; about 1910–15, bought from Durand-Ruel by William
Simes; by 1945, inherited by Miss Olive Simes (his daughter),
Boston; 1945, gift to the MFA.

Like many of his fellow Impressionists, Sisley avoided
traditionally picturesque views. In *Waterworks at
Marly*, Sisley chose to depict not the renowned
fountains in the park at Versailles but the pumping
station near the town of Marly-le-Roi which supplied
water to both the gardens of Versailles and Marly.

The pumping station at Marly was originally
commissioned by Louis XIV in the late seventeenth
century to lift water from the Seine to the aqueduct
at Louveciennes from whence it was carried to the
basins and fountains in the parks of two royal
residences, the Château de Marly and the Château
de Versailles. In the 1850s, Napoleon III modernised
the historic waterworks. The new machinery was
considered a technological marvel, making it a
popular nineteenth-century tourist attraction.

Though Sisley selected a scene rich in social and
political associations, the resulting canvas lacks any
distinct commentary on the *ancien régime* and the
Imperial order. The artist chose instead to concentrate
on the shimmering water, the brilliant autumn foliage
and the geometric forms created by the architecture
of the pumping station. Sisley painted at least six
other views of the waterworks and three canvases
that include the aqueduct. KM

53 ALFRED SISLEY
British, 1839–1899
La Croix-Blanche at Saint-Mammès, 1884
Oil on canvas, 65.4 x 92.4 cm

Daulte, no. 509
Museum of Fine Arts, Boston.
Juliana Cheney Edwards Collection 39.680

PROVENANCE: 1884, sold by artist to Georges Petit, Paris; 1899,
possibly with Durand-Ruel, Paris; by 1929, Hannah Marcy
Edwards, Boston; by descent to her sister, Grace M. Edwards,
Boston; 1939, bequest to the MFA.

EXHIBITION HISTORY: Possibly 1899, Durand-Ruel, Paris,
Monet, Pissarro, Renoir et Sisley.

Having previously painted the Seine north of Paris in
Marly-le-Roi (see cat. 52), Sisley shifted his attention
to the river south-east of the capital in Saint-Mammès.
A bustling village known for its boat builders and
woodworkers, Saint-Mammès was near the edge of
the Forest of Fontainebleau, the region where Sisley
had first began to paint outdoors. Sisley created a
visual panorama of this riverside town, producing
nearly three hundred paintings between 1880 and
1885.

The white house on the right, known as La
Croix-Blanche, was a turreted seventeenth-century
manor with an eighteenth-century mural of King
Louis XIV within its historic walls. Yet, as he had
done in his images of the king's water works at Marly,
Sisley did not focus on the grandeur of his subject.
Instead, he concentrated on its ordinary aspects: the
undulations of the Seine, the large overcast sky, and
the long shadows of a late afternoon in winter.

Hannah Edwards purchased this and another
view of Saint-Mammès by Sisley, which she hung
prominently in the music and dining rooms of her
Beacon Street home in Boston. LL

54 EDMUND CHARLES TARBELL
American, 1862–1938
Mother and Child in a Boat, 1892
Oil on canvas, 76.5 x 88.9 cm

Museum of Fine Arts, Boston.
Bequest of David P. Kimball in memory of his wife
Clara Bertram Kimball 23.532

PROVENANCE: By 1893, Clara Bertram Kimball;
to David P. Kimball, her husband; 1923, bequest to the MFA.

Although Tarbell had been exposed to Impressionism
during his student days in Paris from 1884 to 1886, it
was not until 1890 that he started painting in this
new style. His conversion was no doubt influenced
by the exhibition in 1890 of Sargent's *A Morning Walk*
(private collection), the first of his Impressionist works
to be shown in Boston. Tarbell painted *Mother and
Child in a Boat* using his wife Emeline and daughter
Josephine as models. He rendered the shimmer of light
on the water and the dappled sunlight on the boat and
costumes with strokes of pure colour. Reluctant to
relinquish his hard-earned drawing skills – his avowed
purpose for studying in Paris – Tarbell carefully
delineated his wife's hands and features and deftly
foreshortened his daughter's left leg. The overhanging
branches and high viewpoint, aspects borrowed from
Japanese prints, provide an intimate view of these
figures in a boat, a popular motif for both French
and American Impressionists. Sargent had painted a
strikingly similar composition, *Two Women Asleep in a
Punt under the Willows* (Calouste Gulbenkian Museum,
Lisbon), which Tarbell may have known through his
friend Dennis Bunker, who worked with Sargent in
1888 and who had exhibited his own Impressionist
landscapes (see cat. 7) alongside Sargent's. JC

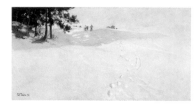 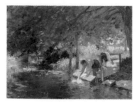

55 JOHAN FREDERIK (FRITS) THAULOW
Norwegian, 1847–1906
Skiers at the Top of a Snow-Covered Hill, 1894
Oil on canvas, 52.7 x 98.4 cm

Museum of Fine Arts, Boston.
Gift of Miss Aimée and Miss Rosamond Lamb 1978.681

PROVENANCE: By 1926, probably Horatio Appleton Lamb, Boston; probably by descent to his daughters, Aimée Lamb and Rosamond Lamb, Boston; 1978, gift to the MFA.

Norwegian landscape painter Frits Thaulow secured an international reputation for winter scenes of his homeland. From 1888 to 1892, Thaulow travelled throughout Norway depicting skiers in the district of Aker, west of Oslo, in the county of Telemark (known as the birthplace of skiing) and in the region of Hvalstad. At this time, the Norwegian Fridtjof Nansen made the first crossing of Greenland on skis, making him a national hero. The report of his expedition was published throughout Europe and aroused a great interest in skiing. From this time forward, the sport was in the news regularly and became adopted as a popular leisure activity by the wealthier classes.

Like Degas in his depictions of the racetrack (see cat. 16), Thaulow chose not to focus on the thrill and excitement associated with the sport of skiing, emphasising instead its visual and aesthetic aspects. Thaulow cropped his composition and assumed a low angle of vision to create a canvas more concerned with the painterly challenges of portraying snow, light and air.

Thaulow enjoyed celebrity in his native Norway, but also spent many years in France studying and befriending such artists as Claude Monet, Paul Gauguin and Jacques Emile Blanche. The year after depicting this snowy scene, Thaulow arranged for Monet to come to Norway to paint winter landscapes alongside him. LL

56 FREDERIC PORTER VINTON
American, 1846–1911
La Blanchisseuse, 1890
Oil on canvas, 46.4 x 61 cm

Museum of Fine Arts, Boston.
Gift of Alexander Cochrane 13.554

PROVENANCE: 1911, Mrs Frederic Vinton, Boston; Alexander Cochrane, Boston; 1913, gift to the MFA.

In June 1889, Vinton and his wife travelled to Europe for eighteen months, spending part of their sojourn in Grèz-sur-Loing, a village on the south-eastern edge of the Forest of Fontainebleau, about two hours by train from Paris. Artists had been drawn to this rural village by the picturesque Loing River, stone bridge and medieval church, and an international art colony arose there after 1875.

During this trip to France, Vinton visited Sisley in nearby Moret, and the two artists walked along the Loing River, which Sisley had so often portrayed. Further up that same river, Vinton executed this *plein-air* painting of a woman washing clothes. Images of laundresses are abundant, popular especially with such French artists as Greuze, Chardin and Fragonard in the eighteenth century and Boudin and Degas in the nineteenth century (see cat. 3). Although washerwomen were sometimes represented as seductresses, Vinton's hard-working *blanchisseuse*, with her tub and the wooden box in which she kneels to keep her own clothes dry, provided an interesting subject for his new-found skill at Impressionist effects. With fluid brushstrokes, Vinton rendered the foliage of the trees and the reflections in the river. Dazzling daubs of white paint indicate white laundry and the sun dappling the river's edge. Vinton seems to have painted *La Blanchisseuse* for his own pleasure as it remained with him and was never exhibited until his death. JC

57 THEODORE M. WENDEL
American, 1859–1932
Bridge at Ipswich, c. 1905
Oil on canvas, 61.6 x 76.2 cm

Museum of Fine Arts, Boston.
Gift of Mr and Mrs Daniel S. Wendel, Tompkins Collection and Seth K. Sweetser Fund, by exchange 1978.179

PROVENANCE: Mr and Mrs Daniel S. Wendel, son and daughter-in-law of the artist; 1978, with Vose Galleries, Boston; 1978, purchased by the MFA.

EXHIBITION HISTORY: 1918, Boston, Guild of Boston Artists, *Paintings by Theodore Wendel*; 1976, New York, Whitney Museum of American Art, *Theodore Wendel: An American Impressionist 1859–1932*.

In 1898, Theodore Wendel moved to his wife's large family farm in Ipswich, Massachusetts, a rural seaside town north of Boston. For the next fifteen years, he portrayed this typical New England village with the Impressionist colour and broken brushstrokes he had learned from Monet at Giverny in 1886. Like many other Impressionists, he chose a bridge as the focus for his painting – the handsome granite twin-arched Green Street Bridge, built in 1894 over the Ipswich River. Wendel's canvas differs from French Impressionist paintings in its clarity and solidity, since American artists tended to use light and colour to define forms rather than to dissolve them. However, Wendel was very much like his French counterparts in his use of compositional devices borrowed from Japanese aesthetics. He employed a high horizon line, diagonals that divide the composition, truncated forms, the juxtaposition of architectonic manmade structures with soft natural growth, and enlivening red colour notes in his painting. The resulting arrangement is flattened and compressed, and the surface pattern is as interesting and important as the subject matter. JC

Opposite: Detail of cat. 17

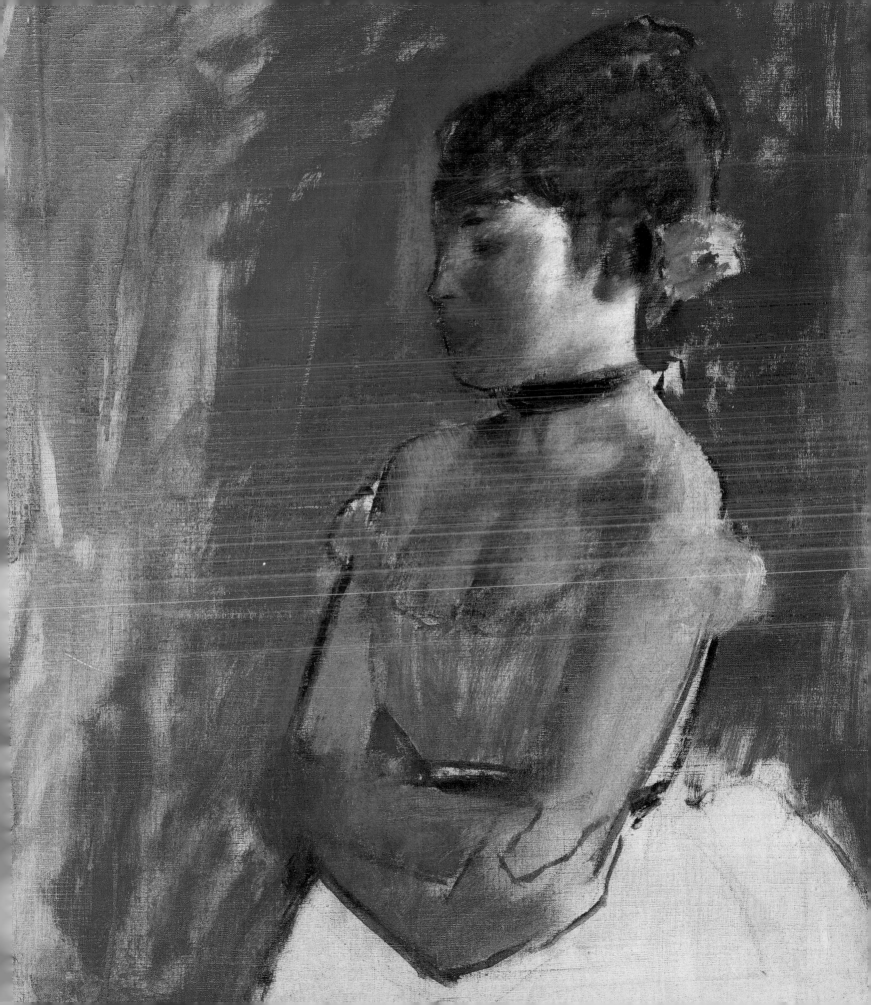

FREDERIC AMORY
Born 1844, Boston; died 1928, Boston

Amory was for many years the treasurer of the Nashua Manufacturing Company, which operated textile mills in Nashua, New Hampshire. He was also a director of the Indian Head Mills of Alabama, the Second National Bank of Boston, and the Cochrane Chemical Company of Boston, owned by Alexander Cochrane (see p. 127). Little is known about Amory's collection, apart from the fact that he had owned a number of important paintings. A great grandson of the artist John Singleton Copley, Amory inherited from his mother Copley's famous portrait of his step-brother, *Henry Pelham (Boy with a Squirrel)*, now in the Museum of Fine Arts, Boston. His collection also included Hassam's *Charles River and Beacon Hill* (cat. 22), which he purchased from Doll and Richards, as well as two canvases by William Trost Richards, a Charles H. Davis landscape and *Morning on the Seine* by Claude Monet (Wildenstein 1480, private collection, United States). JC

HENRY CLAY ANGELL
Born 1829, Providence, RI; died 1911, Boston

Angell, a distinguished ophthalmologist, formed an impressive collection of Barbizon paintings. He saw his first Barbizon landscapes in Paris in 1864, as he recalled in his memoir, *Our Pictures and About Them* (1909–10). When a Parisian dealer visited Boston a year later, Angell traded pictures by American artist Richard Fuller for his first Barbizon paintings. Thus, he began his frequent practice of buying paintings from contemporary American artists and exchanging them for Barbizon works. Angell's friend J. Foxcroft Cole occasionally acted as his agent – Cole bought Angell's Pissarro for him in 1874 and his Millet for him in 1875. Angell also acquired Impressionist pictures by Monet and Boudin, as well as Barbizon-style American paintings by Cole and William Morris Hunt. He promoted Barbizon artists in essays in *American Art Review* and *Atlantic Monthly*.

Angell bought Corot's *Woman with a Pink Shawl* (cat. 14) from Parisian dealer Aimé Diot for $200 in 1888. He especially admired Corot and owned thirty-four of his pictures, more than any other artist. Angell

left his paintings to the MFA, giving the Museum its first Boudin and Pissarro as well as a pre-eminent Barbizon collection. ER

ELIZABETH HOWARD BARTOL
Born 1842, Boston; died 1927, Boston

Bartol's eclectic collection included European and American paintings, prints and furniture. She studied art with Stephen Tuckerman, William Rimmer and William Morris Hunt, and then with Hunt's teacher Thomas Couture in Villiers-le-Bel, France. Although she was acclaimed as one of Hunt's most talented students, she stopped painting around 1895, probably because of illness. She continued to design posters and metalwork, however.

Bartol inherited a major collection, primarily of French furniture, from her eminent ancestors James and Hepzibah Swan, which she left to the MFA. She also bought art herself, although her cousin John Bartol wrote that her holdings were 'never considered by her in the light of a "collection" or exhibited by her as such' (Bartol to MFA, 2 May 1940, MFA collector files). She mainly purchased nineteenth-century paintings by such European artists as Boudin and Thaulow and by American painters working in Couture's broad style, such as Hunt. In addition, she acquired significant old master prints and eighteenth- and nineteenth-century furniture, tableware and Sèvres porcelain. In her will, Bartol allowed the MFA to choose works from her collection; the Museum's selections included her Boudin, *Port of Le Havre* (cat. 4). ER

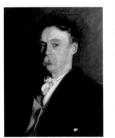

John Singer Sargent,
Peter Chardon Brooks, 1890.
Oil on canvas, 68.5 x 58.4 cm.
Private collection

PETER CHARDON BROOKS
Born 1831, West Medford, Mass.; died 1920, Boston

Brooks amassed a major early collection of Barbizon and Impressionist paintings. From a distinguished Boston family, he became a leading philanthropist. Brooks may have become interested in French painting through his

friend J. Foxcroft Cole. He owned a Corot as early as 1871 and acquired works by Millet, Daubigny, Diaz and Couture. Cole bought pictures on Brooks's behalf in Paris, including Cazin's *Riverbank with Bathers* (cat. 8) from Galerie Georges Petit in 1890.

Two years before, Cole bought Brooks Monet's *Boulevard Saint-Denis, Argenteuil, in Winter* (cat. 34), the first of at least four Monets Brooks would own. Brooks's sixteen-year-old niece Marian Lawrence described them in her diary in 1891: 'After dinner Uncle Peter showed us all his new pictures by a man named Monet which have just arrived. He has always had a house full of paintings of the Barbizon School, but these are very different and *very* impressionistic so they cannot be hung near the others … I thought they were very lovely, so light and sparkling and sunny' (Peabody, *To Be Young Was Very Heaven*, p. 34). Brooks also owned Impressionist pictures by Benson and family portraits by Hunt, Sargent and Vinton. ER

ARTHUR TRACY CABOT
Born 1852, Boston; died 1912, Boston

Cabot owned a notable collection of American and European Impressionist paintings. From an eminent Boston family, he became a respected surgeon at Massachusetts General Hospital, teacher at Harvard Medical School, and ardent advocate for public health.

Much more is known about Cabot's medical career than his art collecting. He was an amateur watercolourist and may have been introduced to Impressionism by his sister, the artist Lilla Cabot Perry (cats 43–4; p. 137). Perry apparently acquired Cabot's two Monets for him, the first, *Meadow with Haystacks near Giverny* (cat. 36), in 1899. She may have found them at Chase's gallery in Boston, which had both pictures in the 1890s. Although Cabot also owned an Impressionist picture by Frits Thaulow, his collection consisted primarily of American Impressionist paintings, including Frank Benson's *Early Morning* (cat. 2), Dennis Bunker's *The Pool, Medfield* (cat. 7), and other works by Benson, Perry and Theodore Wendel. In addition, he had watercolours by Winslow Homer and Dodge Macknight and oils by earlier American artists Gilbert Stuart and Washington Allston. A trustee of the MFA, Cabot bequeathed first choice of his paintings to the Museum. ER

ALEXANDER COCHRANE
Born 1840, Bar Head, Scotland; died 1919, Boston

Cochrane assembled a small but noteworthy collection of French and American Impressionist paintings. Born in Scotland, he emigrated as a child to the United States, where his family settled near Boston. His father founded a chemical manufactory, and Cochrane eventually took over the operation, turning it into the largest such business in New England. His wealth also derived from early investment in the Bell Telephone Company.

Cochrane was a friend of J. Foxcroft Cole (p. 134), who may have first interested him in Impressionism. From dealer Durand-Ruel, Cochrane bought Venetian subjects by Renoir in 1889 (cat. 47) and Monet in 1912 (two, including cat. 41), as well as two Monet water lily pictures in 1909 (including cat. 42). Cochrane also acquired Vinton's Impressionist *La Blanchisseuse* (cat. 56), immediately giving it to the MFA. He owned other contemporary American works by Ernest Longfellow and Cole, including *The Aberjona River, Winchester* (cat. 11). Cochrane's bequest allowed the MFA to choose four of his paintings. The Museum selected two Monets (including *Grand Canal, Venice*), a Corot (now reattributed), and his Renoir (cat. 47), the first painting by that artist to enter the collection. ER

SAMUEL COLMAN
Born 1832, Portland, Maine; died 1920, New York City

Samuel Colman, in S. G. W. Benjamin, *Our American Artists*, Boston, 1886, p. 135

A significant second-generation Hudson River School painter, Colman travelled extensively, recording in oil and watercolour his excursions to Europe, North Africa and the American West. He also designed interiors in collaboration with Tiffany and Company. An active participant in the New York art world, he was a founder and first President of the American Society of Painters in Water Colors, a member of the New York Etching Club, an Academician of the National Academy of Design and an organiser of the Society of American Artists. Widely admired and prolific, Colman earned considerable sums for his paintings and thus was able to afford a Newport, Rhode Island house designed by McKim, Mead and White. This he decorated with Persian objects, Chinese porcelains, and paintings by Corot, Delacroix and Rembrandt. He also amassed a significant collection of Asian prints, ceramics, swords, textiles and other objects.

When Colman purchased the young John Singer Sargent's *Fishing for Oysters at Cancale* (cat. 51), he explained that he 'wanted to have it near me to key myself up with. I am afraid that I may fall below just such a standard, and I wish to have it hanging in my studio to reproach me whenever I do' (Corcoran Gallery Collection Catalogue, 1973, p. 25). JC

CHARLES ALLERTON COOLIDGE
Born 1858, Boston; died 1936, Locust Valley, Long Island, New York

Coolidge entered the office of renowned architect Henry Hobson Richardson in 1883, after studying at Harvard and the Massachusetts Institute of Technology. Following Richardson's untimely death in 1886, Coolidge helped to found Shepley, Rutan & Coolidge, the firm which continued Richardson's work. Over the years Coolidge steered the company through three partnerships, among them Coolidge, Shepley, Bulfinch & Abbott, which practised from 1924 until 1952. Coolidge designed the Chicago Public Library and the Art Institute of Chicago, the original quadrangle at Stanford University, the Fogg Art Museum, and many other buildings at Harvard University and elsewhere.

Coolidge bought *Calm Morning* (cat. 1) from his friend Frank Benson after seeing the painting in sculptor Bela Pratt's studio, where Benson was storing it. It is said that the depiction of Benson's children reminded Coolidge of his own offspring enjoying their summer pursuits. Among the other works in Coolidge's small and eclectic collection were Homer and La Farge watercolours, a Paul Revere silver tankard, an eighteenth-century French tapestry, Italian nineteenth- or twentieth-century vestments, and a fifteenth-century Chinese painting. JC

JAMES DAVIS
Circumstances of birth and death unknown

Virtually nothing is known about James Davis. He owned Corot's *Bathers in a Clearing* (cat. 13), a late work by the artist that was sold at the Corot estate sale in 1875. Davis may have bought the painting in Paris – he had acquired it by early the next year and immediately gave it to the MFA on 7 January 1876. Like other collectors of this period, Davis's interests seem to have been quite wide-ranging: he also gave the museum numerous plaster casts of ancient objects, primarily from Egypt, in 1878. ER

ROBERT J. EDWARDS
Died 1924, Boston

HANNAH MARCY EDWARDS
Died 1929, Boston

GRACE M. EDWARDS
Died 1938, Boston

Siblings Robert, Hannah and Grace Edwards shared a house on Beacon Street in Boston and amassed a remarkable collection, including a stunning group of Impressionist paintings, between 1907 and 1924. They individually bequeathed these to the Museum of Fine Arts, Boston in 1938 in memory of their mother, Juliana Cheney Edwards. Their grandfather, Jacob Edwards of Southbridge, Massachusetts had made a fortune as a silk merchant, and the Edwards family supported a variety of philanthropic causes in addition to their collecting activities. They purchased six paintings by Renoir and ten by Monet, as well as works by Pissarro, Sisley, Degas, Boudin, Harpignies, Corot, Fantin-Latour, Gainsborough, Reynolds, Copley, Sargent, Stuart and others. They also owned a number of Dodge MacKnight watercolours, Chinese export porcelain, and fine furniture. JC

ARTHUR BREWSTER EMMONS
Born 1850, Quincy, Mass.; died 1922, Newport, RI

Emmons, an engineer and lawyer, had an impressive collection of Monets and Renoirs. He attended the Massachusetts Institute of Technology and Harvard Law School and then moved to New York and Newport, Rhode Island. Although he eventually made the latter his permanent home, he remained a leading figure in Boston and New York society.

Relatively little is known about Emmons's art collecting, but he seems to have been especially interested in Impressionism. Between 1906 and 1915 he bought a staggering twenty-six Monets from Durand-Ruel. Emmons seems to have been particularly drawn to the landscapes Monet painted in London between 1899 and 1901 (he owned seven of these) and in Venice in 1908 (he owned four). He had at least nineteen Monets and six Renoirs in his New York home, all but one of which were sold in 1920. The year before, in preparation for the sale, he gave the MFA Renoir's *The Seine at Chatou* (cat. 46), which he had purchased from Durand-Ruel in New York in 1906. It was the second Renoir the MFA acquired. Emmons also owned a variety of other art objects, including at least two seventeenth-century Dutch pictures. ER

The letter on the left (handwritten):

Letter from Arthur Brewster Emmons to Arthur Fairbanks (whose name Emmons mistook for Fairfax).
Archives, Museum of Fine Arts, Boston

DESMOND FITZGERALD
Born 1846, Nassau, Bahamas; died 1926, Brookline, Mass.

Fitzgerald had one of the foremost collections of Impressionist paintings and East Asian ceramics in Boston. A leading American hydraulic engineer, he was the chief engineer of the Boston and Albany Railroad and a superintendent at the Boston water works. He began collecting art in the 1870s, acquiring eight Boudins – including *The Inlet at Berck* (cat. 5) some time after 1900 – two Sisleys, two Thaulows, a Degas, a Pissarro and a Renoir and other French paintings. He also collected American Impressionist works by Sargent, Benson, Hassam, Tarbell, Vinton and Wendel and pictures by Cole.

However, Fitzgerald's greatest passion was Monet. Introduced to the artist's work by Perry (see p. 137), he bought his first Monet in Paris in 1889 and eventually owned nine works by the painter, several purchased directly from Monet himself. He bought *Camille Monet and a Child in the Artist's Garden in Argenteuil* (cat. 31) in 1905 from Durand-Ruel. Fitzgerald also encouraged appreciation of Monet's work in Boston. He spearheaded the 1892 Monet exhibition at the St Botolph Club, one of the artist's first non-commercial solo shows anywhere, and wrote texts on the painter for exhibition catalogues and journals. ER

Desmond Fitzgerald, from *Paintings by the Impressionists: Collection of the Late Desmond Fitzgerald*, New York, 1927, p. 6

ISABELLA STEWART GARDNER
Born 1840, New York City; died 1924, Boston

The daughter of a wealthy New York family, Isabella Stewart married the distinguished Bostonian John Lowell Gardner (1837–1898) in 1860 and moved into a home on Beacon Street. Travel around the world piqued her interest in art, and she began to educate herself by attending lectures at Harvard by Charles Eliot Norton, a proponent of Ruskin. In 1880, the Gardners bought an adjacent house on Beacon Street, enlarging their

home and prompting them to acquire more art. They bought Hunt's *Gloucester Harbor* (cat. 24) as well as paintings by J. Foxcroft Cole and several French Barbizon canvases. Mrs Gardner's collecting was transformed when she inherited $1.6 million upon the death of her father in 1891. Advised by Bernard Berenson, she became one of the foremost collectors in the world, eventually owning outstanding works in all media: paintings by Giotto, Vermeer, Titian, Botticelli, Rubens, Rembrandt, Sargent, Degas, Whistler and others; sculpture; rare books; stained glass; tapestries; and other precious objects from Europe, the Middle East and Asia. She built a Venetian-style museum and residence in Boston known as Fenway Court to house her collection. Completed and opened to the public in 1903, it remains her legacy and extraordinary achievement. JC

John Singer Sargent, *Isabella Stewart Gardner*, 1888. Oil on canvas, 190 x 81.2 cm. Isabella Stewart Gardner Museum, Boston. 117.

CLARA MILLET BERTRAM KIMBALL
Born after 1822, Salem, Mass.; died between 1913 and 1923, Boston

Kimball had a significant collection of Barbizon and Impressionist paintings, but little is known about her life. The daughter of a wealthy merchant from Salem, Massachusetts, she married lawyer and railway tycoon David Pulsifer Kimball in 1858.

Clara built the couple's collection of paintings. Her Barbizon pictures included at least three Corots, a Rousseau, a Millet and Daubigny's *Ile-de-Vaux on the Oise near Auvers* (cat. 15). She frequently worked with Chase's Gallery in Boston, which often bought paintings on her behalf. Chase's, for instance, purchased both her Monets for her from Durand-Ruel – *Valley of the Petite Creuse* (cat. 40) in 1891 and *Meadow with Poplars* (cat. 32) in 1897. Kimball also owned Boudin's *Washerwomen Near a Bridge* (cat. 3), which she probably bought from Chase's soon after they obtained it from Durand-Ruel in 1894, at least two Thaulows, and at least two Raffaellis. In addition, Kimball collected American pictures, including a Benson and Tarbell's important early Impressionist work *Mother and Child in a Boat* (cat. 54), which she probably acquired directly from the artist. ER

William Baxter Palmer Closson, *Mrs David P. Kimball (Clara Bertram)*, c. 1890. Pastel on paper mounted on paper board, 57.5 x 35.9 cm. Museum of Fine Arts, Boston. Gift of Mrs William Baxter Closson in memory of William Baxter Closson. Res.29.40

HORATIO APPLETON LAMB

Born 1850, Boston; died 1926, probably Boston or Milton, Mass.

Descended from a prominent Boston family, Lamb collected widely in a variety of media. After graduating from Harvard, he entered the dry-goods business but then quit to travel. He later led or served on the boards of numerous Boston banks and insurance companies and was the park commissioner of Milton, Massachusetts.

Lamb married Annie Lawrence Rotch, another venerable Bostonian, and the couple inherited family portraits by American artists such as Benjamin West, Henry Sargent and Thomas Sully. Horatio Lamb's sister, Rose Lamb, studied with Hunt and may have interested her brother in more contemporary art. He acquired a large collection of nineteenth-century paintings, including Impressionist works by Monet and Cassatt, Barbizon pictures by Millet and Troyon, and earlier paintings by Delacroix and Courbet. Like several other Bostonians, Lamb had a special interest in Thaulow's work. He owned a Thaulow painting, a pastel, and probably a third oil by the artist, *Skiers at the Top of a Snow-Covered Hill* (cat. 55), which was given to the MFA by his daughters, Aimée and Rosamond Lamb. The family gave numerous other gifts of art to the MFA, including paintings, sculpture, works on paper and furniture. ER

Julian Russell Story, *Ernest Wadsworth Longfellow*, 1892. Oil on canvas, 55.9 x 45.7 cm. Museum of Fine Arts, Boston. Bequest of Ernest Wadsworth Longfellow. 23.503

ERNEST WADSWORTH LONGFELLOW

Born 1845, Cambridge, Mass.; died 1921, Boston

Longfellow assembled an impressive collection of nineteenth-century French and American paintings. Son of distinguished poet Henry Wadsworth Longfellow, Ernest earned an engineering degree from Harvard but then became a painter. He later wrote in his autobiography: 'The pictures of the Barbison [*sic*] school … that began to appear in the dealers' galleries inspired me with such

Desmond Fitzgerald's picture gallery with Monet's *Camille Monet and a Child in the Artist's Garden in Argenteuil* (cat. 31) at centre; from *Paintings by the Impressionists: Collection of the Late Desmond Fitzgerald*, New York, 1927, p. 134

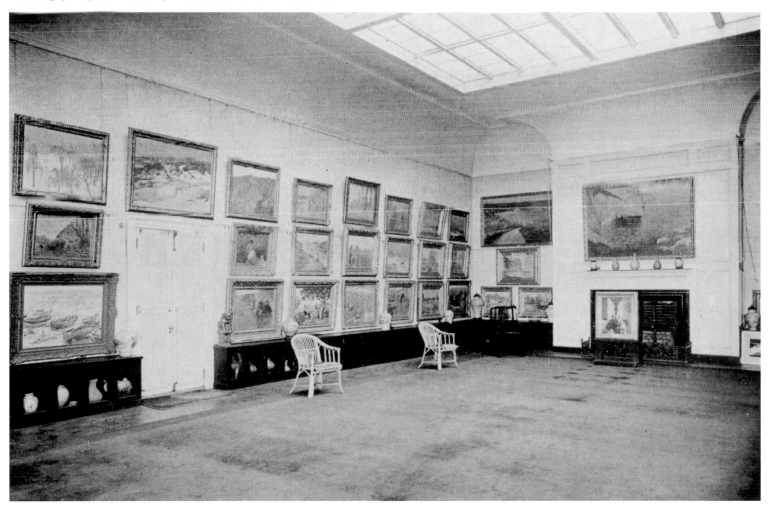

enthusiasm for the French school that I determined to go to Paris to study' (E. Longfellow, *Random Memories*, Boston and New York, 1922, p. 101). He worked in France intermittently in the 1860s and 1870s with Ernest Hebert, Léon Bonnat and Thomas Couture and became acclaimed for his carefully executed landscapes.

The majority of Longfellow's collection consisted of Barbizon paintings bought between 1880 and 1910. He acquired three Lambinets – including *Village on the Sea* (cat. 26) – two Corots and two Diazes, among others. He also owned contemporary American and European and Italian old master paintings. In general, Longfellow preferred either Barbizon or academic pictures, disliking modernist styles such as Impressionism. However, he did acquire some distinctly modern works such as John White Alexander's art nouveau masterpiece *Isabella and the Pot of Basil*, which he bought and gave to the MFA in 1898. ER

JOHN PICKERING LYMAN
Born 1847, Portsmouth, NH; died 1914, Boston

Lyman accumulated a significant collection of French and American Impressionist paintings. A Harvard graduate, he became a banker and president of the Webster and Atlas National Bank of Boston. He bought most of his art in the early twentieth century, purchasing Impressionist pictures by French artists such as Monet and Pissarro, and American artists such as Hassam, Willard Metcalf and John Twachtman. His other great interest was ceramics, and he acquired examples from cultures all over Europe and Asia, although the majority came from China and Japan. Lyman also owned a few Japanese woodblock prints, works on paper and pieces of European furniture.

Lyman obtained his Pissarro, *Morning Sunlight on the Snow, Eragny-sur-Epte* (cat. 45), in 1910 from the dealer Durand-Ruel, from whom he bought most of his European Impressionist pictures. When he died in 1914, his sister, Theodora Lyman, put much of his collection on loan to the MFA. She bequeathed it to the Museum upon her death in 1919, giving the institution a major group of Impressionist paintings, including its first Sisley. ER

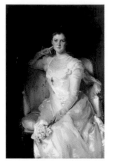

Invoice from Durand-Ruel to Anna Perkins Rogers for Monet's *Fisherman's Cottage on the Cliffs at Varengeville* (cat. 35) and Monet's *Snow at Argenteuil* (cat. 33), 4 July 1890. Archives, Museum of Fine Arts, Boston

ANNA PERKINS ROGERS
Born 1841, Boston; died 1920, Boston

Anna Perkins Rogers, often called Annette, was a painter of landscapes and still lifes and an early collector of Monet's work. She studied art with Hunt, probably in his first Boston class in 1868, and travelled to Europe in 1881. In the 1880s she exhibited at a number of Boston galleries and was particularly praised for her floral still lifes.

Rogers had a small art collection primarily of contemporary American and French paintings. She owned works by her teacher Hunt, her fellow Hunt student Sarah Wyman Whitman, and contemporary American painter George Fuller. In June 1890 she bought three French paintings in Paris – three months before leading Boston collector Peter Chardon Brooks (p. 126) made a strikingly similar purchase – acquiring Cazin's *Farm Beside an Old Road* (cat. 9), Monet's *Snow at Argenteuil* (cat. 33) and Monet's *Fisherman's Cottage on the Cliffs at Varengeville* (cat. 35). She lent both Monets to the 1892 Monet exhibition at the St Botolph Club. Rogers was generous to the MFA in her lifetime and left six paintings, including her Cazin and two Monets, and a Roman Imperial vase to the Museum on her death. ER

SARAH CHOATE SEARS
Born 1858, Cambridge, Mass.; died 1935, West Gouldsboro, Maine

Sears, a photographer and painter, assembled one of the most sophisticated collections of modern art in Boston. Born into a prominent Boston family and married into another, Sears studied with Bunker and Tarbell and had great success with her watercolours and photographs, the latter created in the 1890s after she befriended photographer F. Holland Day.

John Singer Sargent, *Mrs Joshua Montgomery Sears (Sarah Choate Sears)*, 1899. Oil on canvas, 147.6 x 96.8 cm. The Museum of Fine Arts, Houston. Gift of George R. Brown in honour of his wife, Alice Pratt Brown. 80.144

As a collector, Sears was always forward-looking. She bought early Impressionist works by her teachers, Bunker and Tarbell. She befriended Sargent, buying his most progressive pictures and commissioning him to paint her daughter, Helen, in 1895 (cat. 50) and herself in 1899. Sears also knew American Impressionist Mary Cassatt, who encouraged her interest in modern French art, including Manet's *Street Singer* (cat. 28), which Sears bought from Durand-Ruel in Paris in 1895. Sears owned other experimental Impressionist paintings as well, including an abstract Monet water lily picture, similar to *Water Lilies* (cat. 42). Diverging from relatively conservative Boston taste, she collected modern paintings by Matisse and Charles Demuth, among others. She even lent a Cézanne to the controversial International Exhibition of Modern Art (The Armory Show) in New York in 1913. ER

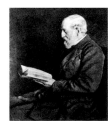

Quincy Adams Shaw
Archives, Museum of Fine Arts, Boston.

QUINCY ADAMS SHAW
Born 1825, Boston; died 1908, Boston

The scion of a distinguished Boston family, Shaw graduated from Harvard in 1849 and made a fortune from copper as president of the Calumet and Hecla Mining Company. After 1871 he left the management of the company to his brother-in-law Alexander Agassiz and turned his attention to acquiring works of art. Shaw is best known for his extraordinary Millet collection. He met Millet in Barbizon through Hunt, and he commissioned a painting from him in the early

1870s. Over the next ten years he bought twenty-six oils and twenty-seven pastels. Shaw endeavoured to include works from all periods of Millet's career, persuading Millet to part with early canvases and purchasing examples from other collectors. Shaw's collection, the largest privately owned group of Millet's work, was given to Boston's Museum of Fine Arts by his heirs in 1917. Shaw owned other Barbizon paintings, and he acquired Corot's large *Dante and Virgil* in 1875. He also collected exquisite Renaissance drawings, paintings and sculpture, including Donatello's marble relief *Madonna of the Clouds*, one of the few masterworks by that artist in the United States. JC

WILLIAM SIMES
Born 1846, Portsmouth, NH; died 1927, Boston

Simes had a small but select collection consisting primarily of prints. Raised in Portsmouth, New Hampshire, he was a tea importer and travelled extensively as a young man both within and beyond the United States. He was a prominent citizen in Boston, residing on Beacon Hill and joining the Union Club.

Little is known about Simes as an art collector. He owned at least one oil painting, Sisley's *Waterworks at Marly* (cat. 52), which he purchased between 1910 and 1915 from Durand-Ruel. He and his daughter, Olive Simes, gave a great deal of art to the MFA, but their respective roles in forming the collection remain unclear. Its highlights included oils by sixteenth-century Italian artist Jacopo Tintoretto and contemporary French painter Antoine Vollon, a drawing by Millet and nineteenth-century English watercolours by J. M. W. Turner and others. The great strength of their holdings was in prints: they acquired etchings by J. Foxcroft Cole, Whistler and Rembrandt, as well as works by numerous seventeenth-century Dutch, eighteenth-century French and English and nineteenth-century English and American printmakers. ER

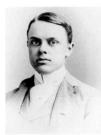

John Taylor Spaulding
Archives, Museum of Fine Arts, Boston.

JOHN TAYLOR SPAULDING
Born 1870, Boston; died 1948, Boston

Spaulding had one of the leading collections of Japanese prints and modern French paintings in the world. Son of a wealthy sugar merchant, he worked only briefly in his father's business before retiring to travel. In 1909, he and his brother William went to Japan, where they became deeply engaged with Japanese art. Back in Boston, they amassed a spectacular collection of woodblock prints, donating six thousand to the MFA in 1921.

Around 1920 Spaulding's interest shifted to modern American and French paintings. He met leading American artists, including Robert Henri and George Bellows, and acquired their pictures as well as works by other American modernists. Spaulding also had impressive holdings of watercolours by Americans Winslow Homer and Edward Hopper. French paintings became his greatest interest, however, perhaps because French modernist artists shared his passion for Japanese prints. In 1920 he bought his first French picture, Degas's *Ballet Dancer with Arms Crossed* (cat. 17). Gradually, he built up a comprehensive French modernist collection, including two more paintings by Degas, six Renoirs, three Pissarros, two Sisleys, and works by Manet, Monet, Boudin, Mary Cassatt and Berthe Morisot. Unlike most Bostonians, he also owned significant Post-Impressionist works. ER

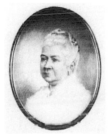

Susan Cornelia Clarke Warren, from *A Memory of My Mother*, Boston, 1908, frontispiece.

SUSAN CORNELIA CLARKE WARREN
Born 1825, Boston; died 1901, Boston

Warren's collection, once described as 'one of the art wonders of Boston' (*The Collector*, 1895, p. 114), included some of the greatest examples of Barbizon and old master paintings in the city. The daughter of a minister, Susan married Samuel Warren, a wealthy paper manufacturer. She began collecting late in life, first decorative arts to beautify her home, and then paintings, primarily from the Barbizon School. She acquired Corot's *Forest of Fontainebleau* (cat. 12) in 1886, one of at least six Corots she would own. By 1893 she had purchased Diaz's *Bohemians Going to a Fête* (cat. 18), one of four works she bought by him. She also owned at least four Daubignys, five Millets, a Lambinet and a Couture. In addition, she had paintings by American artists experimenting with the Barbizon style such as Hunt and Cole.

Warren's collection was distinguished by its breadth. She eventually acquired important nineteenth-century paintings by French artists such as Delacroix, Ingres and Daumier as well as a Goya. Her old master paintings, some of which were purchased by her son Edward in Europe on her behalf, included significant works by Filippino Lippi, Jan Breughel and Peter Paul Rubens. ER

Fred G. Quinby,
Charles Goddard Weld, 1918.
Oil on canvas, 39 x 29 cm.
The Peabody Essex Museum,
Salem. M2285

CHARLES GODDARD WELD
Born 1857, Brookline, Mass.; died 1911, Brookline

Weld amassed one of the greatest collections of Japanese art outside Asia. He worked as a surgeon in Boston and New York before retiring early to manage his family estate. An intensely private man, Weld left no record of his art collecting. He owned Chintreuil's *Last Rays of Sun on a Field of Sainfoin* (cat. 10) by 1889, the year he lent it to the MFA, where it remained until his wife bequeathed it to the Museum in 1922. The only other Western painting that Weld is known to have bought was also a Barbizon School landscape, by Cazin.

Weld's lasting legacy, however, was his outstanding collection of Asian art, particularly Japanese. He first travelled to Japan in 1885, acquiring numerous decorative arts. He augmented his holdings upon returning to Boston when, urged by fellow Boston doctor and japanophile William Sturgis Bigelow, he bought Ernest Fenollosa's exceptional collection of Japanese and Chinese paintings, enabling it to remain at the MFA. Weld also partially funded a new wing of the Museum to house the collection. On his death in 1911 he bequeathed his art to the MFA. ER

FRANK WESTON BENSON
Born 1862, Salem, Mass.; died 1951, Salem

Benson, a painter, watercolourist and etcher of figure studies, portraits, landscapes, sporting scenes, still lifes and murals, was a leading painter in Boston and helped to spread enthusiasm for Impressionism there. He studied at the School of the Museum of Fine Arts and the Académie Julian in Paris. He subsequently joined the faculty of the MFA School in 1889.

In the 1890s Benson began to experiment with Impressionism. He became a founding member of the American Impressionist group The Ten American Painters in 1898. His mature works, typically *plein air* studies of women and children, brilliantly lit and rendered with fluid brushstrokes and vibrant colours, were extremely popular, helping to bring Impressionism into the mainstream of American art. Benson also promoted the style through his teaching. He was an artistic leader in Boston, influencing both painters and collectors, including the MFA, which sometimes solicited his advice. ER

- Faith Andrews Bedford, *Frank W. Benson: American Impressionist*, New York, 1994.
- Faith Andrews Bedford, *The Sporting Art of Frank W. Benson*, Boston 2000.
- William Howe Downes, 'Frank W. Benson and His Work', *Brush and Pencil*, 6, no. 4 (July 1900), pp. 145–7.

EUGÈNE BOUDIN
Born 1824, Honfleur; died 1898, Deauville

Raised in Le Havre, Boudin devoted much of his career to painting the seaside. In the 1840s, he owned an art supply shop in Le Havre through which he met many artists, including Constant Troyon and Jean-François Millet. He began to paint around 1846, and in 1851 received a scholarship from the municipality of Le Havre to study art in Paris. Thereafter, he spent most winters in Paris, visiting the coast of Normandy and Brittany each summer. In 1858, he met Monet, to whom he acted as a mentor, encouraging the younger artist to paint *en plein air*.

Boudin painted certain themes repeatedly, in particular beach scenes and ports, but also washerwomen, market places and meadows. His scenes of fashionable groups on the beach brought him significant financial success. Boudin's works were accepted regularly at the Salon. In 1874, he exhibited with the Impressionists at their first exhibition. He never showed with them again, but he did begin to use Impressionist colour and brushwork in his later paintings. The art dealer Paul Durand-Ruel organised Boudin's first solo exhibition outside Paris in Boston in 1890. KM

- Amy Barker, *Boudin, Monet and the Sea Painters of Normandy*, exh. cat., Bowes Museum, County Durham, 2004.
- Robert Schmit, *Eugène Boudin: Catalogue raisonné*, 3 vols, Paris, 1973; and *Boudin: Premier Supplément*, Paris 1984.
- Peter C. Sutton, *Boudin: Impressionist Marine Paintings*, exh. cat., Peabody Museum of Salem, Mass., 1991.

JOHN LESLIE BRECK
Born 1860, near Guam; died 1899, Boston

The son of a Navy captain, Breck was born on his father's ship while at sea in the Pacific Ocean. After an education at boarding academies near Boston, Breck studied in Munich and Antwerp, returning to America in 1882. From 1886–8, he trained in Paris at the Académie Julian. Breck was one of several American painters to work at Giverny in 1887, helping to establish an Impressionist art colony there. He remained at Giverny through the winters of 1888 and 1889 and became one of the only Americans to form a close relationship with Monet, earning a rare invitation to paint in the artist's garden. Monet once told Breck: 'Come down with me to Givetny [*sic*] and spend a few months. I won't give you lessons, but we'll wander about the fields and woods and paint together' (*Boston Sunday Globe*, 19 March 1899).

Lilla Cabot Perry saw Breck's work in Giverny in 1889 and arranged a private viewing in her Boston home. He returned to Boston in 1890, and held a successful one-man show. During the 1890s, he applied his Impressionist techniques to New England terrain, receiving acclaim for his work. Breck died suddenly of gas poisoning in Boston in 1899 at the age of thirty-nine. LL

- Kathryn Corbin, 'John Leslie Breck, American Impressionist', *Antiques*, 134 (November 1988), pp. 1142–9.

- William H. Gerdts, *Lasting Impressions: American Painters in France, 1865–1915*, exh. cat., Terra Foundation for the Arts, Evanston, Ill., 1992.
- H. Barbara Weinberg et al., *American Impressionism and Realism: The Painting of Modern Life, 1885–1915*, exh. cat., Metropolitan Museum of Art, New York, 1994.

DENNIS MILLER BUNKER
Born 1861, New York; died 1890, Boston

Bunker, a painter of landscapes, portraits, figure studies and still lifes, was one of the first American painters to experiment with Impressionism. In New York he studied at the National Academy of Design and Art Students' League. In 1882 he went to Paris for two years where he worked at the Académie Julian and the Ecole des Beaux Arts.

While Bunker may have been exposed to Impressionism in Paris, his real introduction to the style came through Sargent, whom he met in Boston after moving there in 1885 to teach at the Cowles Art School. Bunker and Sargent painted together in the summer of 1888 in Calcot Mill, Gloucestershire, creating Impressionist views. On returning to the United States, Bunker adapted Impressionism to the American landscape. Despite such experiments, his figural paintings remained academic, with strong contours and a darker palette. Bunker began to achieve artistic success but died at the age of twenty-nine. ER

- Charles B. Ferguson, *Dennis Miller Bunker Rediscovered*, exh. cat., New Britain Museum of American Art, Conn., 1978.
- R. H. Ives Gammell, *Dennis Miller Bunker*, New York, 1953.
- Erica E. Hirshler, *Dennis Miller Bunker: American Impressionist*, exh. cat., Museum of Fine Arts, Boston, 1994.

STANISLAS HENRI JEAN-CHARLES CAZIN
Born 1841, Samer, Pas-de-Calais; died 1901, Lavandou, near Toulon

After training as a draftsman, Cazin taught at the Ecole Spéciale d'Architecture in Paris in the mid-1860s. He exhibited oil sketches painted near Barbizon at the 1865 and 1866 Salons, and was appointed director of the Ecole de Dessin in Tours and curator of the Musée de Tours in 1868. During the Franco-Prussian War, he fled to England where he produced Asian-influenced ceramics. Before returning to France in

1875, he travelled to Italy and Holland in 1872. Cazin then devoted his efforts to painting, settling in Equihen, on the Channel coast.

Until about 1888, Cazin combined classical or religious themes with contemporary settings. In later canvases like *Farm Beside an Old Road* (cat. 9), Cazin turned to pure landscape, working in a naturalistic style that responded to Corot and drew on his memories of his native Normandy.

Cazin's paintings appealed to Barbizon and Impressionist collectors, as well as to contemporary critics. He successfully exhibited paintings and ceramics in Paris and made his American debut in New York in 1893. His willingness to travel to the United States and his fluency in English made him popular with American collectors, connoisseurs and artists. KM

- Léonce Bénédite, 'Jean-Charles Cazin', *Revue de l'art ancien et moderne*, 10 (August 1901), pp. 1–32, 73–104.
- *Catalogue de 31 Peintures par J.-Ch. Cazin*, exh. cat., Galerie Georges Petit, Paris, 1908.
- Gabriel Weisberg, 'Jean-Charles Cazin's Reception in America', *Apollo*, 149, no. 144 (February 1999), pp. 35–40.

ANTOINE CHINTREUIL
Born 1814, Point-de-Vaux, Ain;
died 1873, Septeuil, Seine-et-Oise

Chintreuil settled in Paris in 1838, but did not begin to paint until 1842. He studied briefly with Paul Delaroche before meeting Corot. Chintreuil would describe himself as Corot's pupil for the rest of his life. Around 1850, Chintreuil joined a small community of landscape painters at Igny in the Bièvre valley, southwest of Paris, where he befriended Daubigny. Soon after, Chintreuil moved permanently to the village of Septeuil, near Mantes, where he painted such works as *Last Rays of Sun on a Field of Sainfoin* (cat. 10), in which he focused on the unexpected and dramatic effects of light and weather upon panoramic sweeps of countryside.

After many rejections, Chintreuil's work was accepted by the Salon for the first time in 1847. During the 1850s, the French state bought several of his paintings. Rejected by the Salon again in 1863, Chintreuil showed three paintings at the Salon des Refusés. Following that exhibition, his reputation grew steadily and Bostonians such as Charles Goddard Weld added his works to their collections of French landscapes. KM

- Françoise Baudson, *Antoine Chintreuil: 1814–1873, Catalogue de l'exposition organisée par les villes de Bourg-en-Bresse et Pont-de-Vaux*, Bourg, 1973.
- *Brumes et rosées: Paysages d'Antoine Chintreuil, 1814–1873*, Réunion des musées nationaux, Paris and Monastère royal de Brou, Bourg-en-Bresse, 2002.

- Albert de la Fizelière, Jules Champfleury and Frédéric Henriet, *La Vie et l'oeuvre de Chintreuil*, Paris, 1874.

JOSEPH FOXCROFT COLE
Born 1837, Jay, Maine; died 1892, Winchester, Mass.

Cole, a landscape painter and etcher, was a key figure in the early appreciation of Barbizon and Impressionist painting in Boston. He studied in Paris with Barbizon artists Lambinet (cat. 26) and Charles Jacque. Cole's Barbizon style landscapes were popular in Boston, often among the same collectors whom he encouraged to buy French Barbizon pictures from the 1860s onwards. He also occasionally acted as an agent, purchasing Barbizon works on behalf of Bostonians in Paris, as well as for his own growing collection.

As early as 1874, Cole began interesting Bostonians in Impressionism – that year, he bought a Pissarro for Angell. Cole also acquired Impressionist paintings for himself, buying Monet's *Antibes Seen from the Plateau Notre-Dame* (cat. 38), for example, in 1890. As his career progressed, his own paintings changed from Barbizon to Impressionist in style. ER

- Wayne Craven, 'J. Foxcroft Cole (1837–1892): His Art, and the Introduction of French Painting to America', *American Art Journal*, 13, no. 2 (Spring 1981), pp. 51–71.
- Frank Robinson, *Living New England Artists*, Boston, 1888.
- Frederic P. Vinton, 'Joseph Foxcroft Cole', *Memorial Exhibition of the Works of J. Foxcroft Cole*, exh. cat., Museum of Fine Arts, Boston, 1893.

JEAN-BAPTISTE-CAMILLE COROT
Born 1796, Paris; died 1875, Ville d'Avray

Born to wealthy parents, Corot entered his family's business before being allowed to pursue his interest in art. At the age of twenty-six, he began studying with the classical landscape painters Achille-Etna Michallon and Jean-Victor Bertin. He won the Prix de Rome for landscape painting in 1825, which took him to Rome from 1826 to 1828.

Corot first travelled to Fontainebleau in 1822 and returned annually to paint and to visit the many friends who had followed him there, including Millet and Daubigny. An inveterate traveller, Corot sketched landscapes throughout Europe *en plein air* and returned to his studios in Paris and Ville d'Avray to compose finished paintings. Until the 1850s, he often included biblical or mythological subjects in his classically composed landscapes. Thereafter, his style softened and his subjects became more indeterminate, as in *Bathers in a Clearing* (cat. 13). Corot's paintings influenced many younger artists and

he counted among his pupils the landscape painters Chintreuil and François-Louis Français, as well as the Impressionists Pissarro, Sisley and Berthe Morisot.

Corot achieved great success during his lifetime, exhibiting annually in the Salons beginning in 1827 and winning the grand prize at the 1855 Exposition Universelle. His work was eagerly collected outside of France, particularly by Bostonians. KM

- Michael Pantazzi, Vincent Pomarède and Gary Tinterow, *Corot: 1796–1875*, exh. cat, Réunion des Musées Nationaux, Paris, Musée des beaux-arts du Canada, Ottawa and the Metropolitan Museum of Art, New York, 1996.
- Alfred Robaut and Etienne Moreau-Nélaton, *L'Oeuvre de Corot par Alfred Robaut: Catalogue raisonné et illustré précédé de l'histoire de Corot et de ses œuvres par Etienne Moreau-Nélaton ornée de dessins originaux et de croquis du maître*, 4 vols, Paris, 1905, reprinted Paris, 1965, 5 vols.
- Hélène Toussaint, Geneviève Monnier and Martine Servot, *Hommage à Corot: Peintures et dessins des collections françaises*, exh. cat., Paris, 1975.

CHARLES-FRANCOIS DAUBIGNY
Born 1817, Paris; died 1878, Paris

The son of a classical landscape painter, Daubigny first worked in the restoration studio at the Louvre and later as a graphic illustrator. He began painting near Fontainebleau in 1834 and eventually purchased a home in Barbizon. In 1838, he made his Salon debut with an etching and entered Paul Delaroche's atelier, where he studied for about six months.

In 1857, Daubigny launched his floating studio, a boat from which he recorded the landscape along the Seine, Marne and Oise rivers under varying atmospheric effects, as evident in *Ile-de-Vaux on the Oise near Auvers* (cat. 15). Despite some unfavourable contemporary critical responses to the rough and unfinished quality of his river scenes, Daubigny's light-filled canvases with bright colours and rapid brushstrokes won medals and were purchased by the French state.

Daubigny's success was assured by 1853 when he received a first class medal at the Salon. His dedication to painting *en plein air* influenced many younger artists, including the Impressionists, whose works he supported as a juror at the Salon of 1868. Justly associated with paintings in the Barbizon style, Daubigny's canvases were found in the collections of several Bostonians. KM

- Robert Hellebranth et al., *Charles-François Daubigny, 1817–1878*, Morges, 1976.
- Madeleine Fidell-Beaufort and Janine Bailly-Herzberg, *Daubigny*, translated by Judith Schub, Paris 1975.
- Etienne Moreau-Nélaton, *Daubigny raconté par lui-même*, 2 vols, Paris, 1925.

EDGAR DEGAS
Born 1834, Paris; died 1917, Paris

The son of affluent parents, Degas was encouraged to study art. In 1854, he entered the atelier of Louis Lamothe, a pupil of Ingres who emphasised drawing skills. Degas then studied briefly at the Ecole des Beaux-Arts. He soon left for an extended visit to Italy, where he copied ancient and Renaissance works, returning to Paris in 1859. Degas successfully exhibited portraits and historical scenes at the Salon from 1864 until 1870. He was increasingly attracted to Manet's avant-garde artistic and literary circle, and, after 1870, adopted their interest in contemporary subject matter, painting such motifs as ballet dancers (cat. 17), horse races (cat. 16) and bathing women.

Degas played an important role in organising the Impressionist exhibitions held between 1874 and 1886 and participated in all but one. Despite this affiliation, he did not share the Impressionist interest in spontaneity and painting *en plein air*, relying instead on memory and a body of preliminary studies for his carefully organised compositions. He worked in a variety of media, creating oil paintings, prints, sculptures, drawings, and, after the 1890s, photographs. Bostonians were quick to appreciate Degas's work, recognising its modernity of subject-matter and treatment, and the MFA was the first American museum to acquire one of his canvases. KM

• Jean Surherland Boggs, et al., *Degas*, exh. cat., Galeries nationales du Grand Palais, Paris, Metropolitan Museum of Art, New York, National Gallery of Canada, Ottawa, 1988.
• Henri Loyrette, *Degas*, Paris, 1991.
• Paul-André Lemoisne, *Degas et son oeuvre*, 4 vols, Paris, 1946–9.

NARCISSE-VIRGILE DIAZ DE LA PEÑA
Born 1808, Bordeaux; died 1876, Menton

Born into a family of political exiles from Spain, Diaz was orphaned as a child and raised in an abbey near Paris. He painted porcelain in a Sèvres factory before entering the Paris studio of François Souchon, a pupil of Jacques-Louis David, in 1828. Diaz copied paintings by Rembrandt and Correggio in the Louvre and studied eighteenth-century French works by Watteau and Boucher. He soon encountered the work of Eugène Delacroix and incorporated Romantic and orientalist themes into his own compositions.

Diaz first visited Barbizon in 1835, joining friends Théodore Rousseau and Daubigny, and, with Rousseau's encouragement, began to concentrate on painting realistic landscapes. He regularly returned to the Forest of Fontainebleau, which became the dominant subject of his compositions.

The first of the Barbizon group to achieve financial and popular success, Diaz exhibited regularly at the Salon from 1831. He was well regarded by younger French artists, including Monet, Renoir, Bazille and Sisley, and the American artists Hunt and Cole encouraged Bostonians such as Susan Cornelia Clarke Warren to buy works by Diaz. KM

• R. Ballu, 'Les Artistes contemporains – Diaz', *Gazette des Beaux-Arts*, 40 (1877), pp. 290 ff.
• Jules Claretie, *Exposition des oeuvres de N. Diaz de la Peña à l'Ecole Nationale des Beaux-Arts*, Paris 1877.
• *Narcisse Diaz de la Peña, 1807–1876*, Paris, 1968.

PHILIP LESLIE HALE
Born 1865, Boston; died 1931, Boston

A painter of portraits, landscapes and figural works, Hale, together with John Leslie Breck, was one of the first Americans to work with Monet in Giverny. The son of the prominent Boston clergyman Edward Everett Hale, he studied at the MFA School, the Art Students' League in New York, and at the Académie Julian and the Ecole des Beaux-Arts in Paris. In 1888, Hale began working under Monet's influence. While summering in Giverny during the early 1890s, he experimented with Impressionism, and also, unlike most Bostonians, with Divisionism.

Although Hale was a successful artist, he was most influential as a teacher. He taught at the MFA School from 1893 to 1931 and at the Pennsylvania Academy of the Fine Arts from 1913 to 1928. As the art critic of the *Boston Herald* and a contributor to other local papers, Hale promoted French and American Impressionism. He was a powerful local tastemaker, and his admiration for Impressionism encouraged Bostonians to buy and create pictures in that style. ER

• Frederick W. Coburn, 'Philip L. Hale: Artist and Critic', *World To-Day*, 14 (October 1907), pp. 59–67.
• Nancy Hale, *The Life in the Studio*, Boston, 1969.
• *Philip Leslie Hale, A.N.A., 1865–1931: Paintings and Drawings*, exh. cat., Vose Galleries, Boston, 1988.

CHILDE HASSAM
Born 1859, Dorchester, Mass.;
died 1935, East Hampton, NY

Hassam was one of the foremost American Impressionists. He studied at art schools in Boston, and in 1886 went to Paris to work at the Académie Julian. Whereas Hassam's early work was Barbizon-influenced and dark, in France his art was more affected by contemporary French paintings than by his formal training. His work came to include brilliantly lit paintings of modern life in the Impressionist manner.

Hassam continued exploring Impressionism after he returned to the United States in 1889. Although he settled in New York, he frequently travelled to New England, producing Impressionist views of Boston and the New Hampshire coast. Hassam was a member of the American Impressionist group The Ten American Painters, but he disliked the term Impressionism and refused to acknowledge his work's connection to the style. Nevertheless, he experimented more successfully with it than almost any other American artist. ER

• Warren Adelson, Jay E. Cantor and William H. Gerdts, *Childe Hassam: Impressionist*, New York, 1999.
• Ulrich W. Hiesinger, *Childe Hassam: American Impressionist*, Munich, 1994.
• H. Barbara Weinberg et al., *Childe Hassam: American Impressionist*, exh. cat., Metropolitan Museum of Art, New York, 2004.

WILLIAM MORRIS HUNT
Born 1824, Brattleboro, Vt;
died 1879, Appledore, Isles of Shoals, NH

A painter of portraits, figures, landscapes and murals, Hunt was instrumental in the early appreciation of Barbizon painting in Boston. While studying in Paris with Couture, he befriended J. F. Millet and experimented with his broad handling and rural subjects. He bought at least eight Millets (including cat. 29) and pictures by another friend, Diaz.

Back in Boston, Hunt became the city's leading artist, executing portraits and figure studies and later concentrating on exploring transient atmospheric effects in landscape. He was also an influential teacher of the painterly Barbizon style and inspired numerous Boston artists to study in France, many with his teacher, Couture. He encouraged Bostonians to collect Barbizon works as well, even selling them Millets from his own collection. As an 1893 biographical entry on Hunt concluded: 'The present admiration in this country for modern French art can be directly traced to his advocacy' (*National Cyclopeadia of American Biography*, 1893, pp. 18–19). ER

• Martha J. Hoppin and Henry Adams, *William Morris Hunt: A Memorial Exhibition*, exh. cat., Museum of Fine Arts, Boston, 1979.
• Helen M. Knowlton, *The Art-life of William Morris Hunt*, Boston, 1899.
• Sally Webster, *William Morris Hunt, 1824–1879*, Cambridge, 1991.

EMILE CHARLES LAMBINET
Born 1815, Versailles; died 1877, Bougival

Though Lambinet first studied with the history painters Michel-Martin Drolling and Emile Jean Horace Vernet, he was most influenced by the work of Corot and Daubigny. Lambinet himself was never a part of the group of painters working in the area around the Forest of Fontainebleau, but his sensitivity to rural subjects appealed to the same critics and collectors who supported the art of the Barbizon artists.

Lambinet lived most of his life in the area to the west of Paris, near Versailles, and made painting excursions to Ecouen, north of Paris. He painted with loose, airy brushstrokes that suggest the natural landscape rather than accurately transcribing each detail. In works such as *Village on the Sea* (cat. 26), Lambinet included local peasant figures, creating generalised scenes of the French countryside.

Highly regarded in the nineteenth century by both critics and collectors, Lambinet regularly exhibited paintings at the Salon between 1833 and 1878. After admiring paintings by Lambinet in Boston collections, Joseph Foxcroft Cole made his first visit to France in 1860 and studied with the artist. Upon returning to America, Cole promoted Lambinet's work to such collectors as Ernest Wadsworth Longfellow. KM

- *Catalogue de tableaux par Emile Lambinet*, Paris, 1878.
- C. H. Stranahan, *A History of French Painting*, New York, 1888, p. 250.

ERNEST LEE MAJOR
Born 1864, Washington, DC; died 1950, Boston

Major, a painter and pastelist of portraits, figures and still lifes, was an early experimenter with and advocate of Impressionism. He first studied art in Washington, DC at the Corcoran Gallery of Art and in 1882 went to New York to work at the Art Students' League. A talented student, he won the Hallgarten Prize at the National Academy of Design in New York in 1884 and then travelled to Europe to study at the Académie Julian. While in Paris, Major became interested in Impressionism and explored its possibilities in views of the French countryside.

Major moved to Boston in 1888 and became influential as a teacher, first at the Cowles Art School, where he worked from 1888 to 1894 (replacing Bunker), and then at the Massachusetts Normal School, from 1896 to 1942. He encouraged his students to experiment with Impressionism, contributing to the early acceptance of the style in Boston. Major's own work was successful – he exhibited it nationally, winning many prizes. ER

- M. F. B., 'Mr. Major's Paintings', *Boston Evening Transcript*, 24 February 1920.
- *Ernest Lee Major, 1864–1950*, exh. cat., Vose Galleries, Boston, 1995.
- Erica E. Hirshler, 'Artists' Biographies', in Trevor J. Fairbrother, *The Bostonians: Painters of an Elegant Age, 1870–1930*, exh. cat., Museum of Fine Arts, Boston, 1986.

EDOUARD MANET
Born 1832, Paris; died 1883, Paris

Manet's father, a wealthy magistrate, first resisted his son's desire to paint. In 1850, Manet entered the atelier of Thomas Couture, where he spent six years. Manet supplemented his training by studying the old masters and Velásquez, whose influence can be seen in the sober palette and lone figure of *Street Singer* (cat. 28).

Manet's unconventional flatness, bright tones and contemporary subjects shocked a public accustomed to the smooth surfaces and classical motifs of academic painting. The jury rejected his first Salon entry in 1859, but awarded him an honourable mention in 1861. In 1863, all of his entries were rejected and exhibited instead at the Salon des Refusés. Manet showed his work frequently and earned success at later Salons and in private galleries. Though admired by younger artists, including Monet, Manet never exhibited with the Impressionists. In the 1870s, he introduced Impressionist colour and brushwork to his work. He made his Boston debut in 1880 with the exhibition of *The Execution of Maximilian* (1868–69; Städtische Kunsthalle, Mannheim). The adventurous Boston collector Sarah Sears bought Manet's *Street Singer* in 1895, probably through the recommendation of Mary Cassatt, the artist and friend of Degas, who admired Manet's modernity. KM

- Françoise Cachin and Charles S. Moffett, *Manet 1832–1883*, exh. cat, Metropolitan Museum of Art, New York 1983.
- Eric Darragon, *Manet*, Paris, 1991.
- Dennis Rouart and Daniel Wildenstein, *Edouard Manet: Catalogue raisonné*, 2 vols, Lausanne and Paris, 1975.

JEAN-FRANÇOIS MILLET
Born 1814, Gruchy; died 1875, Barbizon

Millet created paintings, prints and drawings of people and places in his native Normandy, in Barbizon, and in places he visited. Born to a prosperous peasant family in the small village of Gruchy, Millet first studied portrait and history painting in nearby Cherbourg. Supported by a stipend from the town of Cherbourg, he entered the Paris studio of Paul Delaroche in 1837. Millet soon abandoned his academic training and lost his funding.

Through the 1840s, Millet painted portraits and genre scenes in Normandy and Paris. In 1849, he settled in Barbizon, joining Théodore Rousseau, Constant Troyon and Diaz. There Millet recorded the activities of local farmers and shepherds and explored the effects of light on the countryside, evident in *Three Men Shearing Sheep in a Barn* (cat. 29).

Millet exhibited regularly at the Salon beginning in 1840 and participated in the Expositions Universelles of 1855 and 1867. His American debut occurred in 1854 at the Boston Athenaeum. The most popular Barbizon artist with Boston collectors, Millet was enthusiastically promoted by his close friend, William Morris Hunt, who himself purchased at least eight paintings by Millet. KM

- Robert L. Herbert, *Jean-François Millet*, exh. cat., Grand Palais, Paris, 1975.
- Etienne Moreau-Nélaton, *Millet raconté par lui-même*, 3 vols, Paris, 1921.
- Alfred Sensier and Paul Mantz, *La Vie et l'oeuvre de J.-F. Millet*, Paris, 1881.

CLAUDE MONET
Born 1840, Paris; died 1926, Giverny

Monet enrolled at the Académie Suisse in Paris in 1859. He served a year of military duty, then returned to Paris in 1862 and entered the atelier of Charles Gleyre, there befriending Renoir and Sisley. In 1870–1, Monet was in exile in London, returning to France after a four-month sojourn in Holland. He first lived in Argenteuil, on the River Seine downstream from Paris, and subsequently moved to Vétheuil in 1878 before settling permanently at Giverny in 1883.

Monet travelled increasingly widely after 1879. In his records of the scenes he observed, he sought to convey the ephemeral effects of light and atmosphere, caught at a particular moment, using expressive colour and short, distinct brushstrokes. After about 1889 he embarked upon a more systematic rendering of specific subjects, creating series of subjects caught under different conditions.

Monet's early victories at the Salon ended in 1869, when his work was rejected. In 1874, he helped to organise the first exhibition of the group that subsequently became known as the Impressionists. He maintained strong ties with those artists, exhibiting with them in 1876, 1877, 1879 and 1882. The subject of considerable admiration amongst younger American artists, Monet was visited by many Boston artists, and his work was appreciated by Boston collectors. Bostonians developed an early appreciation of Monet's work, and the MFA hosted his first American museum retrospective. KM

- Charles F. Stuckey, *Claude Monet: 1840–1926*, exh. cat., Art Institute of Chicago, New York, 1995.
- Paul Hayes Tucker, *Claude Monet: Life and Art*, New Haven and London, 1995.
- Daniel Wildenstein, *Claude Monet: Biographie et catalogue raisonné*, 5 vols, Lausanne, 1974–91, reprinted in 4 vols, Paris, 1997.

LILLA CABOT PERRY
Born 1848, Boston; died 1933, Hancock, NH

A painter of landscapes, figure studies and portraits, Perry was an influential early advocate of Impressionism in the United States. She studied with Bunker, amongst others, in Boston and in Munich and Paris. In 1889 she spent the first of nine summers working with Monet in Giverny, where they became close friends. Monet gave her advice on her painting, while Perry experimented with Impressionism's brilliant colour and broken brushwork. However, like many academically trained Americans, she never fully allowed the atmosphere to dissolve the form, and continued to render figures with a sense of solid mass.

Perry brought a painting by Monet back to Boston in 1889, and through articles and lectures encouraged Bostonians' interest in his work. She influenced such collectors as her brother, Arthur Cabot, for whom she bought Monet's *Meadow with Haystacks near Giverny* (cat. 36) in 1899. ER

- Erica E. Hirshler, *A Studio of Her Own: Women Artists in Boston 1870–1940*, exh. cat., Museum of Fine Arts, Boston, 2001.
- Meredith Martindale et al., *Lilla Cabot Perry: An American Impressionist*, exh. cat., National Museum of Women in the Arts, Washington, DC, 1990.
- Eleanor Tufts, *American Women Artists, 1830–1930*, exh. cat., National Museum of Women in the Arts, Washington, DC, 1987.

CAMILLE PISSARRO
Born 1830, Charlotte Amalie, Danish West Indies; died 1903, Paris

Born in the West Indies, Pissarro attended boarding school near Paris, returning home in 1847 to work in his father's store. He travelled to Venezuela before moving permanently to France in 1855. Here he admired paintings by Corot and Delacroix and enrolled in the Ecole des Beaux-Arts and the Académie Suisse, befriending Monet and Paul Cézanne. An informal student of Corot's, Pissarro used a silvery palette and soft touch in his own early landscapes.

Pissarro first exhibited at the Salon in 1859, but received little critical comment until 1866, when Emile Zola praised his work. That year, Pissarro moved to Pontoise, on the River Oise, northwest of Paris. He painted landscapes of the town and surrounding countryside, often emphasising its rapid industrialisation. Paul Cézanne joined Pissarro in Pontoise in 1874; the two artists worked together for two years, influencing each others' painting styles. Pissarro continued to spend time in Paris, participating in all eight Impressionist exhibitions. In the 1880s, he moved to the rural village of Eragny and explored the Divisionist techniques of Georges Seurat, but later returned to a modified form of Impressionism. KM

- *Camille Pissarro, 1830–1903*, exh cat., Arts Council of Great Britain, London, Museum of Fine Arts, Boston, 1980.
- Raymond Cogniat, *Pissarro*, Paris, 1974.
- Ludovic Rodolphe Pissarro and Lionello Venturi, *Camille Pissarro: Son art – son oeuvre*, 2 vols, Paris, 1939.

PIERRE-AUGUSTE RENOIR
Born 1841, Limoges; died 1919, Cagnes

Renoir was apprenticed to a porcelain painter in Paris at the age of thirteen and in 1858 began to work for a manufacturer of window blinds and decorative objects. He started to copy paintings in the Louvre in 1860, then entered the Ecole des Beaux-Arts and the studio of Charles Gleyre. There he befriended fellow students Monet, Sisley and Frédéric Bazille, working with them in Paris and the countryside.

Renoir made his Salon debut in 1864, achieving intermittent success there in subsequent years. He exhibited in the first three Impressionist exhibitions, then returned to the Salon in 1879. In the 1880s he travelled to North Africa and Italy, painting landscapes and figures in the places he visited. It was Monet, with whom he worked in the 1870s, who taught Renoir to capture the essence of a moment while painting *en plein air*. Later, Paul Cézanne encouraged Renoir to concentrate on the structure and solidity of his subjects. Renoir was primarily a figure painter. He turned increasingly to images of the nude, in search of greater timelessness of subject, as well as to portraits. Parisian dealer Paul Durand-Ruel introduced Renoir's work to many Americans, including several Bostonians. KM

- François Daulte, *Auguste Renoir: Catalogue raisonné de l'oeuvre peint*, Lausanne, 1971.
- John House and Anne Distel, *Renoir*, exh. cat., Arts Council of Great Britain, London, 1985.
- Barbara Ehrlich White, *Renoir: His Life, Art and Letters*, New York, 1984.

JOHN SINGER SARGENT
Born 1856, Florence; died 1925, London

Sargent worked in oil, watercolour and charcoal, creating portraits, landscapes, subject pictures and murals. He was one of the first Americans to experiment with Impressionism. Born in Italy to expatriate parents, he studied art in Florence and Paris and achieved early success at the Paris Salon. His scandalous *Madame X* (Metropolitan Museum of Art, New York), shown at the 1884 Salon, brought a temporary decline in his portrait commissions. It was then that he experimented most extensively with Impressionism, working with his friend Monet at Giverny. Sargent acquired four Monet oils and continued to paint loose, light-filled landscapes for the rest of his career.

In 1887–8, on a visit to Boston, the American city with which he is most associated, Sargent introduced such friends as Bunker and Vinton to Impressionism. Greatly admired as a portraitist, Sargent was an influential tastemaker in Boston and promoted both French and American Impressionism there. ER

- Trevor J. Fairbrother, *John Singer Sargent*, New York, 1994.
- Elaine Kilmurray and Richard Ormond (eds), *John Singer Sargent*, exh. cat., Tate Gallery, London, 1998.
- Marc Simpson et al., *Uncanny Spectacle: The Public Career of the Young John Singer Sargent*, exh. cat., Sterling and Francine Clark Art Institute, Williamstown, Mass., 1997.

ALFRED SISLEY
Born 1839, Paris; died 1899, Moret-sur-Loing

Born to British expatriate parents, Sisley entered Charles Gleyre's atelier in 1860. There he befriended Renoir, Monet, Pissarro and Frédéric Bazille, with whom he made frequent visits to Fontainebleau. Sisley's compositions from those trips incorporate the muted palette and careful pictorial organisation of landscapes by Corot and other Barbizon painters.

Sisley eschewed the urban environment of Paris, preferring the small rural villages nearby. Characteristically Impressionist, his paintings of the 1870s and 1880s, such as *Waterworks at Marly* (cat. 52), explore the momentary effects of light and atmosphere on a landscape. They also often juxtapose modern industry with a more traditional pastoral environment.

Sisley exhibited works at the Salons of 1866, 1868 and 1870 before participating in four of the Impressionist exhibitions. His American debut occurred in Boston in an 1883 exhibition organised by Paris art dealer Paul Durand-Ruel. Despite his associations with successful French painters and such

American friends as Joseph Foxcroft Cole, Sisley attracted far less attention and sold far fewer paintings in both Europe and the United States than many of his fellow Impressionists. Following Sisley's death in 1899, interest in his work increased dramatically among French and American collectors. KM

- François Daulte, *Alfred Sisley: Catalogue raisonné de l'oeuvre peint*, Lausanne, 1959.
- Richard Shone, *Sisley*, London, 1992.
- MaryAnne Stevens et al., *Alfred Sisley*, exh. cat., Royal Academy, London, 1992.
- MaryAnne Stevens et al., *Alfred Sisley*, exh. cat., Musée des Beaux-Arts, Lyon, 2002.

EDMUND CHARLES TARBELL
Born 1862, West Groton, Mass.;
died 1938, New Castle, NH

Tarbell was the leading artist of the Boston School, the city's distinctive variant of Impressionism. A painter of figures, landscapes, portraits and still lifes, he studied at the School of the Museum of Fine Arts and in Paris. After returning home in 1886, he began experimenting with Impressionism, executing *plein-air* figure studies that combine Impressionist landscapes with more solidly modelled figures reflecting his academic training. Tarbell was a founding member of the American Impressionist group The Ten American Painters.

In his later work Tarbell retained an Impressionist's interest in light but moved his figures indoors, working with careful craftsmanship in emulation of seventeenth-century Dutch painters. Such pictures became trademarks of the Boston School. Tarbell taught at the MFA School from 1889 to 1912 and introduced generations of art students to Impressionism. A leader of Boston's artistic community, he influenced local collectors and the MFA, which often solicited his opinion. ER

- Laurene Buckley, *Edmund C. Tarbell: Poet of Domesticity*, New York, 2001.
- Frederick W. Coburn, 'Edmund C. Tarbell', *International Studio*, 32, no. 127 (September 1907), pp. lxxv–lxxxvii.
- Susan Strickler et al., *Impressionism Transformed: The Paintings of Edmund C. Tarbell*, exh. cat., Currier Gallery of Art, Manchester, 2001.

JOHAN FREDERIK (FRITS) THAULOW
Born 1847, Oslo, Norway;
died 1906, Vollendam, Holland

After studying painting in Oslo, Copenhagen and Karlsruhe, Thaulow visited Paris in 1874. He travelled to the 1876 Philadelphia Centennial Exhibition, and he exhibited at the Paris Salon from 1877. He first achieved success in Oslo, where he exhibited landscapes of that distinctive city and its environs. He played a leading role in the city's art community, championing younger Norwegian artists. He continued to visit Norway, but in 1892 moved permanently to France. He was elected to the international fine arts jury of the 1889 Exposition Universelle in Paris. His own winter landscapes were favourably received there and the French state purchased one of his canvases. In 1890, he was involved with the foundation of the Salon de la Société Nationale (Salon du Champ de Mars), a more liberal alternative to the official Salon.

Like his friend Monet, Thaulow was well-received in the United States. In 1898, Andrew Carnegie invited him to serve as a juror for the Carnegie Institute's International Art Exhibition. Thaulow took the opportunity to travel to New York, Boston and Washington, DC, and he painted several American landscapes. KM

- *Frits Thaulow*, exh. cat., Hirschl and Adler Galleries, New York, 1985.
- Claudie Judrin, *Frits Thaulow, un norvégien français*, exh. cat., Oslo, 1994.
- Vidar Poulsson, *Frits Thaulow: 1847–1906*, Oslo, 1992.

FREDERIC PORTER VINTON
Born 1846, Bangor, Maine; died 1911, Boston

Vinton painted portraits, landscapes, and genre pictures and was an early proponent of Impressionism in Boston. In 1875, after several years of study and with Hunt's encouragement, he travelled to France where he studied with Léon Bonnat and Jean-Paul Laurens. Back in Boston, he became a leading American portraitist, specialising in male sitters. His portraits are typically dark and direct, demonstrating his admiration for Diego Velásquez.

Vinton was probably introduced to Impressionism by his friend Sargent whom he met in Boston in 1887 or 1888. In France in 1889, Vinton met Boudin, the Impressionist whose work most interested him (he eventually owned several Boudins) and began experimenting with Impressionist landscape. Vinton became an advocate for the style in Boston, inspiring his patrons to buy Impressionist paintings. Although he exhibited them, his own experiments with Impressionism remained relatively little known until after his death. ER

- Arlo Bates, *Memorial Exhibition of the Works of Frederic Porter Vinton*, Museum of Fine Arts, Boston, 1911.
- William Howe Downes, 'The Vinton Memorial Exhibition', *Art and Progress*, 3, no. 4 (February 1912), pp. 474–77.
- Louis Earle Rowe, 'Boudin, Vinton and Sargent', *Bulletin of the Rhode Island School of Design*, 25 (January 1937), pp. 1–5.

THEODORE M. WENDEL
Born 1859, Midway, Ohio; died 1932, Ipswich, Mass.

A painter, pastellist and etcher of landscapes, figures and still lifes, Wendel was one of the first Americans to work with Monet. The son of German immigrants, he studied art at the University of Cincinnati and Munich Academy with Frank Duveneck. Although none of Wendel's early works survive, they were apparently in a dark, realist mode.

In about 1885, Wendel enrolled at the Académie Julian, but by 1886, he was working with Monet in Giverny. He rapidly adopted his mentor's bright colours, painterly handling and decorative compositions. By 1892, Wendel had moved to Boston, where he taught art at Wellesley College and the Cowles Art School. In 1898 he settled in Ipswich, Massachusetts, but he exhibited regularly in Boston galleries until disabled by disease in 1917. Although Wendel never gained a national reputation, Monet reportedly commented in the late 1880s that 'Wendel is the only American painter whose work interests me' (Agnes B. Wendel to MFA, 15 September 1952, MFA artist files). ER

- John I. H. Baur, 'Introducing Theodore Wendel', *Art in America*, 64, no. 6 (November–December 1976), pp. 102–5.
- John I. H. Baur, *Theodore Wendel: An American Impressionist, 1859–1932*, exh. cat., Whitney Museum of American Art, 1976.
- Erica E. Hirshler, 'Artists' Biographies', in Trevor J. Fairbrother (ed.), *The Bostonians: Painters of an Elegant Age, 1870–1930*, exh. cat., Museum of Fine Arts, Boston, 1986, p. 229.

Opposite: Detail of cat. 54

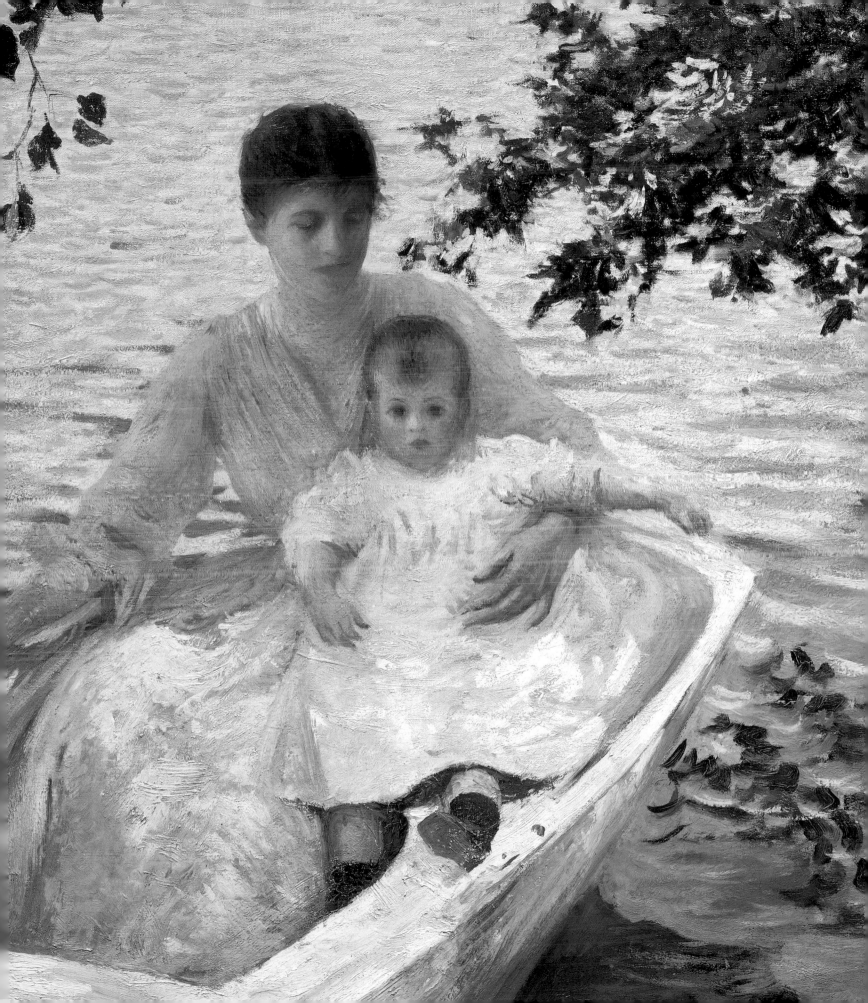

SELECT BIBLIOGRAPHY

Arlo Bates, *Memorial Exhibition of the Works of Frederic Porter Vinton*, exh. cat., Museum of Fine Arts, Boston, 1911.

Jean Sutherland Boggs et al., *Degas*, exh. cat., Galeries nationales du Grand Palais, Paris; Metropolitan Museum of Art, New York; National Gallery of Canada, Ottawa, 1988.

Françoise Cachin and Charles S. Moffett, *Manet: 1832–1883*, exh. cat., The Metropolitan Museum of Art, New York, 1983.

Camille Pissarro, 1830–1903, exh. cat., Arts Council of Great Britain, London; Museum of Fine Arts, Boston, 1980.

Catalogue of Paintings by the Impressionists of Paris, exh. cat., Chase's Gallery, Boston, 1891.

Theodore Child, 'Some Modern French Painters', *Harper's New Monthly Magazine*, 80, no. 480 (May 1890), p. 828.

Frederick W. Coburn, 'Philip L. Hale: Artist and Critic', *World To-Day*, 14 (October 1907), pp. 59–67.

The Collector, 6, no. 7 (1 February 1895), p. 114.

Wayne Craven, 'J. Foxcroft Cole (1837–1892): His Art, and the Introduction of French Painting to America', *American Art Journal*, 13, no. 2 (Spring 1981), pp. 51–71.

William Howe Downes, 'Boston Painters and Paintings, No. VI, Private Collections', *Atlantic Monthly*, 62 (December 1888), pp. 777–86.

William H. Downes, 'The Vinton Memorial Exhibition', *Art and Progress*, 3, no. 4 (February 1912), pp. 474–7.

Trevor J. Fairbrother, *The Bostonians: Painters of an Elegant Age, 1870–1930*, exh. cat., Museum of Fine Arts, Boston, 1986.

Trevor J. Fairbrother, *John Singer Sargent*, New York, 1994.

Desmond Fitzgerald, 'Claude Monet', *Loan Collection of Paintings by Claude Monet*, exh. cat., Copley Society, Boston, 1905.

Richard Wrightman Fox and T. J. Jackson Lears (eds), *The Culture of Consumption: Critical Essays in American History, 1880–1900*, New York, 1983.

Hamlin Garland, *Roadside Meetings*, New York, 1930.

William H. Gerdts, *Lasting Impressions: American Painters in France, 1865–1915*, exh. cat., Terra Foundation for the Arts, Evanston, Ill., 1992.

William H. Gerdts, *Monet's Giverny: An Impressionist Colony*, New York, 1993.

Greta, 'Art in Boston: The Wave of Impressionism', *Art Amateur*, 24 (May 1891), p. 141.

Greta, 'Boston Art and Artists', *Art Amateur*, 17 (17 October 1887), p. 93.

Ulrich W. Hiesinger, *Impressionism in America: The Ten American Painters*, exh. cat., Jordan-Volpe Gallery, New York, 1991.

Erica E. Hirshler, 'The Fine Art of Sarah Choate Sears', *Antiques*, 160, no. 3 (September 2001), pp. 320–9.

Erica E. Hirshler, 'Helping "Fine Things Across the Atlantic": Mary Cassatt and Art Collecting in the United States', in *Mary Cassatt: Modern Woman*, Judith A. Barter, exh. cat., The Art Institute of Chicago; Museum of Fine Arts, Boston; National Gallery of Art, Washington, DC; Chicago, 2001.

Erica E. Hirshler, *A Studio of Her Own: Women Artists in Boston 1870–1940*, exh. cat., Museum of Fine Arts, Boston, 2001.

Martha Hoppin, 'William Morris Hunt and His Critics', *American Art Review*, 2 (1975), pp. 79–91.

Hans Huth, 'Impressionism Comes to America', *Gazette des Beaux-Arts*, 29 (April 1946), pp. 225–52.

Henry James, 'Art in Boston', *Atlantic Monthly*, 29 (March 1872), pp. 372–4.

Robert Jensen, *Marketing Modernism in Fin-de-Siècle Europe*, Princeton, 1994.

King's Hand-Book of Boston, Cambridge, Mass., 1881.

Helen M. Knowlton, *The Art-Life of William Morris Hunt*, Boston, 1899.

Marchal E. Landgren, *American Pupils of Thomas Couture*, exh. cat., University of Maryland Art Gallery, College Park, 1970.

L. Lejeune, 'The Impressionist School of Painting', *Lippincott's Magazine*, 24 (December 1879), pp. 720–7.

Ernest Wadsworth Longfellow, *Random Memories*, Boston and New York, 1922.

'The Midwinter Exhibition at the St. Botolph Club', *Boston Evening Transcript*, 28 January 1890, p. 6.

Alexandra R. Murphy, *Jean-François Millet*, exh. cat., Museum of Fine Arts, Boston, 1984.

Emily Ballew Neff and George T. M. Shackleforth, *American Painters in the Age of Impressionism*, exh. cat., Museum of Fine Arts, Houston, 1994.

Richard Ormond and Elaine Kilmurray, *The Complete Paintings of John Singer Sargent*, 3 vols, New Haven and London, 1998–2003.

Marian Lawrence Peabody, *To Be Young Was Very Heaven*, Boston, 1967.

Philippe Piguet, *Monet et Venise*, Paris, 1986.

Anne L. Poulet and Alexandra R. Murphy, *Corot to Braque: French Paintings from the Museum of Fine Arts, Boston*, exh. cat., Museum of Fine Arts, Boston, 1979.

Frank Robinson, *Living New England Artists*, Boston, 1888.

Daniel Rosenfeld (ed.), *European Painting and Sculpture, c. 1770–1937*, Museum of Art, Rhode Island School of Design, Providence, 1991.

Louis Earle Rowe, 'Boudin, Vinton and Sargent', *Bulletin of the Rhode Island School of Design*, 25 (January 1937), pp. 1–5.

George T. M. Shackelford and Fronia E. Wissman, *Impressions of Light: The French Landscape from Corot to Monet*, exh. cat., Museum of Fine Arts, Boston, 2002.

Douglass Shand-Tucci, *The Art of Scandal: The Life and Times of Isabella Stewart Gardner*, New York, 1997.

Martha A. S. Shannon, *Boston Days of William Morris Hunt*, Boston, 1923.

Charles F. Stuckey, *Claude Monet 1840–1926*, exh. cat., Art Institute of Chicago; New York, 1995.

Carol Troyen and Pamela S. Tabbaa, *The Great Boston Collectors: Paintings from the Museum of Fine Arts*, Museum of Fine Arts, Boston, 1984.

Paul Hayes Tucker, *Claude Monet: Life and Art*, New Haven and London, 1995.

Eleanor Tufts, *American Women Artists, 1830–1930*, exh. cat., National Museum of Women in the Arts, Washington, DC, 1987.

Frederic P. Vinton, 'Joseph Foxcroft Cole', *Memorial Exhibition of the Works of J. Foxcroft Cole*, exh. cat., Museum of Fine Arts, Boston, 1893.

Cecilia Waern, 'Some Notes on French Impressionism', *Atlantic Monthly*, 69 (April 1892), pp. 535–41.

Sally Webster, *William Morris Hunt, 1824–1879*, Cambridge, 1991.

H. Barbara Weinberg et al., *American Impressionism and Realism, The Painting of Modern Life, 1885–1915*, exh. cat., Metropolitan Museum of Art, New York, 1994.

Gabriel Weisberg, 'Jean-Charles Cazin's Reception in America', *Apollo*, 149, no. 444 (February 1999), pp. 35–40.

Frances Weitzenhoffer, *The Havemeyers: Impressionism Comes to America*, New York, 1986.

Daniel Wildenstein, *Claude Monet: Biographie et catalogue raisonné*, 5 vols, Lausanne, 1974–91; reprinted in 4 vols, Paris, 1997.

Daniel Wildenstein, *Monet or The Triumph of Impressionism*, 4 vols, Paris, 1996.

LENDERS TO THE EXHIBITION

BOSTON
Museum of Fine Arts

CHICAGO
Terra Museum of American Art

LONDON
Tate

SAN ANTONIO
San Antonio Museum of Art

and a private collector who wishes to remain anonymous

PHOTOGRAPHIC ACKNOWLEDGEMENTS

COPYRIGHT OF WORKS ILLUSTRATED
All efforts have been made to trace the estates
of the following artists:
Frank Weston Benson, cats 1, 2
Childe Hassam, cats 21, 22, 23
Ernest Lee Major, cat. 27
Edmund Charles Tarbell, cat. 54

PHOTOGRAPHIC CREDITS
All works of art are reproduced by kind permission
of the lender. Specific acknowledgments for providing
photographs are as follows:

Courtesy Adelson Galleries, Inc., New York: p. 126

Courtesy Boston Athenaeum: p. 131 (middle column)

Boston, © 2005, Museum of Fine Arts: cats 1, 2, 3, 4, 5, 7,
8, 9, 10, 11, 12, 13, 14, 15, 16, 17 18, 19, 20, 21, 22, 23, 24, 25,
26, 27, 28, 29, 30, 31, 32, 33, 34, 35, 36, 37, 38, 39, 40 41, 42,
43, 45, 46, 47, 50, 51, 52, 53, 54, 55, 56, 57

Bridgeman Art Library: figs 8, 12;
p. 128 (bottom, middle column)

Chicago, Terra Foundation for the Arts: cat. 48

Ursula Edelmann, ARTOTHEK: fig. 13

Houston, © The Museum of Fine Arts, Houston:
p. 130 (top, right column)

London, © Tate, London 2004: cat. 49

Courtesy Peabody Essex Museum:
p. 131 (right-hand column)

Rhode Island School of Design © Del Bogart: fig. 11

San Antonio, courtesy of the San Antonio Museum of Art:
cat. 44

Mrs Jonathan Hindle
Robin Heller Moss
Russell and Gundula Hoban
Anne Holmes-Drewry
Sir Joseph Hotung
Mrs Sue Howes and Mr Greg Dyke
Mr and Mrs Allan Hughes
Mrs Pauline Hyde
Simone Hyman
S Isern-Feliu
Sir Martin and Lady Jacomb
Heather Angelien James
Mrs Ian Jay
Harold and Valerie Joels
Joseph Strong Frazer Trust
Mr D H Killick
Mr and Mrs James Kirkman
Mrs Ella Krasner
Joan H Lavender
Mr George Lengvari and Mrs Inez
 Lengvari
Lady Lever
Colette and Peter Levy
The Peter and Susan Lewis Foundation
Mr and Mrs Kenneth Lieberman
Sir Sidney Lipworth QC and Lady
 Lipworth
Miss R Lomax-Simpson
London's Museums, Archives and
 Libraries Fund
Mr and Mrs Mark Loveday
Mr and Mrs Henry Lumley
Sally and Donald Main
Mr and Mrs Eskandar Maleki
Mr and Mrs Michael (RA) and José Manser
Mr Curt Marcus
Mr M Margulies
Mr David Marks and Ms Nada Chelhot
Marsh Christian Trust
Mr and Mrs Stephen Mather
Miss Jane McAusland
Christopher and Clare McCann
Gillian McIntosh
Mr and Mrs Andrew McKinna
Sir Kit and Lady McMahon
Lakshman Menon and Darren Richards
The Mercers' Company
Norma Miller and Jeremy Levison
The Millichope Foundation
James Moores
Mr and Mrs Alan Morgan
Mr and Mrs Carl Anton Muller
R John Mullis
North Street Trust
N Peal Cashmere
Mrs Elin Odfjell
Mr and Mrs Simon Oliver
Mrs Lale Orge
Mr Michael Palin
Mr and Mrs Vincenzo Palladino
John H Pattisson
The Pennycress Trust
Mr and Mrs A Perloff
Philip S Perry
R John Mullis
Mr D B E Pike
Mr Godfrey Pilkington
Mr and Mrs Anthony Pitt-Rivers
Mr and Mrs William A Plapinger
John Porter Charitable Trust
Victoria Provis and Dick van der Broek
The Quercus Trust
John and Anne Raisman
Sir David and Lady Ramsbotham
Mr and Mrs Graham Reddish
Mr T H Reitman
Mrs Estefania Renaud
The Family Rich Charities Trust
The Roland Group of Companies plc
Mr and Mrs Ian Rosenberg
Sarah and Alastair Ross-Goobey
Paul and Jill Ruddock

Mrs Jean Sainsbury
Lady (Robert) Sainsbury
Mr and Mrs Bryan Sanderson
Mr and Mrs Hugh Sassoon
Mr Schaefer and Ms Ma
The Schneer Foundation Inc
Carol Sellars
Mr and Mrs Marcus Setchell
Dr and Mrs Augustin Sevilla
Dr Lewis Sevitt
The Countess of Shaftesbury
Mrs Stella Shawzin
Alan and Marianna Simpson
George Sivewright
Mr and Mrs Mark Franklin Slaughter
Brian D Smith
The Peter Storrs Trust
Summers Art Gallery, Dorking
Mrs D Susman
The Swan Trust
John Tackaberry
Mrs Mark Tapley
The Tavolozza Foundation
Mr and Mrs John D Taylor
Miss M L Ulfane
Visa Lloyds Bank Monte Carlo
Mrs Catherine Vlasto
Sir John and Lady Waite
Bruno Wang
Mr John B Watton
Edna and Willard Weiss
Mr and Mrs Anthony Williams
Jeremy Willoughby OBE
Iwan and Manuela Wirth
The Rt Hon Lord and Lady Young
 of Graffham
and others who wish to remain anonymous

Benjamin West Group Donors
Chairman
Lady Judge

Gold Patrons
Mrs Deborah L Brice
Sir Paul and Lady Judge
Jack and Linda Keenan
Riggs Bank Europe

Silver Patrons
Lady Campbell Adamson
Ms Ruth Anderson
Susan Ansley Johnson
Megan Barnett
Mrs Adrian Bowden
Jeffrey E Brummette and Donna M Lancia
Mr and Mrs Paul Collins
Mr and Mrs Bruce McLaren
Lady Purves
Frank and Anne Sixt
Ms Tara Stack
Frederick and Kathryn Uhde

Bronze Patrons
Sir Rudolph and Lady Agnew
Michael and Barbara Anderson
Mrs Alan Artus
Mr Oren Beeri and Mrs Michal Berkner
Thomas and Diane Berger
Mr and Mrs Mark Booth
Wendy M Brooks and Tim Medland
Jeremy Brown
Mrs Melanie Brown
Mrs Susanne Childs
Paolo Cicchiné and Marcelle Joseph
Mr Ed Cohen
Mrs Joan Curci
Linda and Ronald F Daitz
Ann Dell Prevost
Mr and Mrs Peter Dicks
Virginia H Drabbe-Seeman
Mr and Mrs Alan Jenkins, Chairman,
 Eversheds LLP

Arthur Fabricant
Mr Joseph A Field
Mr and Mrs Robert L Forbes
Cyril and Christine Freeman
Mr and Mrs Edward Greene
Madeleine Hodgkin
Suzanne and Michael Johnson
Mr and Mrs Richard Kaufman
Lorna Klimt
Mr Scott Lanphere
Mr Charles G Lubar
Mr and Mrs Michael Mackenzie
Mike and Martha Pedersen
Ken and Dimity Rubie
Carole Turner Record
Mr and Mrs Philip Renaud
Mr and Mrs Justus Roele
Mrs Sylvia B Scheuer
Mr and Mrs Thomas Schoch
Carl Stewart
John and Sheila Stoller
Mr and Mrs Julian Treger
Michael and Yvonne Uva
Mr and Mrs Jeffrey M Weingarten
Mr and Mrs John D Winter
and others who wish to remain anonymous

Schools Patrons Group
Chairman
Mrs Alison Myners

Gold Patrons
Arts and Humanities Research Board
The Brown Foundation Inc, Houston
The Ernest Cook Trust
The Gilbert & Eileen Edgar Foundation
The Eranda Foundation
Mr and Mrs Jack Goldhill
Fiona Johnstone
The David Lean Foundation
The Leverhulme Trust
The Henry Moore Foundation
Paul and Alison Myners CBE
Newby Trust Limited
Edith and Ferdinand Porjes Charitable Trust
The Rose Foundation
Paul Smith and Pauline Denyer-Smith
The South Square Trust
The Starr Foundation
Sir Siegmund Warburg's Voluntary
 Settlement
The Harold Hyam Wingate Foundation

Silver Patrons
The Lord Aldington
The Headley Trust
The Stanley Picker Trust
The Radcliffe Trust
The Celia Walker Art Foundation

Bronze Patrons
The Charlotte Bonham-Carter Charitable
 Trust
Mr and Mrs Stephen Boyd
The Selina Chenevière Foundation
May Cristea Award
Keith and Pam Dawson
The Delfont Foundation
Mr Alexander Duma
Hirsh London
Mrs Juliette Hopkins
Professor Ken RA and Mrs Dora Howard
The Lark Trust
Mrs Peter Low
Martineau Family Charity
N Peal Cashmere
Mr and Mrs Carlo Nicolai
Pickett
Peter Rice Esq
Anthony and Sally Salz
Mr and Mrs Robert Lee Sterling Jr
The Peter Storrs Trust

Mr and Mrs Denis Tinsley
Miss Hazel M Wood's Charitable Settlement
The Worshipful Company of Painter-
 Stainers
and others who wish to remain anonymous

Contemporary Patrons Group
Susan and John Burns
Debbie Carslaw
Claire Livingstone
Roxanne Rosoman
and others who wish to remain anonymous

American Associates of the Royal Academy Trust

Burlington House Trust
Mr Walter Fitch III
Mr and Mrs Donald P Kahn
Ms Nancy B Negley
Ms Louisa Stude Sarofim
Mr and Mrs James C Slaughter

Benjamin West Society
Mrs Walter H Annenberg
Mr Francis Finlay

Benefactors
Mrs Deborah Loeb Brice
Mrs Edmond J Safra
Mr and Mrs Frederick B Whittemore

Sponsors
Mr and Mrs Herbert S Adler
Ms Britt Allcroft
Mrs Jan Cowles
Mrs Marianne Diwik
Mrs Katherine D Findlay
Mrs Henry J Heinz II
Mr David Hockney RA
Mr Hamish Maxwell
Mrs Lucy F McGrath
Mr and Mrs John R Robinson
Mr Arthur O Sulzberger
 and Ms Allison S Cowles
Mr and Mrs Vernon Taylor Jr

Patrons
Mr and Mrs Steven Ausnit
Mr and Mrs F William Aylward
Mr Donald A Best
Mr and Mrs Henry W Breyer III
Mrs Mildred C Brinn
Dr and Mrs Robert Carroll
Mr and Mrs Benjamin Coates
Mrs Catherine G Curran
Anne S Davidson
Ms Zita Davisson
Mr Claude du Pont
Mrs June Dyson
Mr and Mrs Jonathan D Farkas
Mrs A Barlow Ferguson
Mr Richard E Ford
Ms Barbara Fox-Bordiga
Mr and Mrs Lawrence S Friedland
Baron and Baroness of Fulwood
Mr and Mrs Eugene Goldberg
Mrs Lee M Granger
Mrs Rachel K Grody
Mr and Mrs Irving Harris
Dr Bruce C Horten
Mr Robert J Irwin
Mr William W Karatz
Mrs Stephen M Kellen
Mr and Mrs Gary A Kraut
Mrs Katherine K Lawrence
Mr and Mrs William M Lese
Mr Arthur L Loeb
Mr and Mrs Robert Menschel
Ms Barbara T Missett
Mr Allen Model

Ms Diane A Nixon
Mr and Mrs Wilson Nolen
Ms Barbara G Pine
Ms Louisa Stude Sarofim
Mrs Frances G Scaife
Ms Jan B Scholes
Mr and Mrs Stanley De Forest Scott
Mr and Mrs Morton I Sosland
Mrs Frederick M Stafford
Mr and Mrs Stephen Stamas
Ms Brenda Neubauer Straus
Ms Elizabeth F Stribling
 and Mr Guy Robinson
Mr Martin J Sullivan
Mr Royce Deane Tate
Ms Britt Tidelius
Mr and Mrs Lewis Townsend
Mr Richard B Tullis
Mrs William M Weaver Jr
Mr and Mrs George White
Dr and Mrs Robert D Wickham
Mr Robert W Wilson

Corporate Benefactor
The Brown Foundation
The Starr Foundation

Corporate Sponsor
Citigroup

Corporate Donors
General Atlantic Partners
Sony

Corporate Membership of the Royal Academy of Arts

Launched in 1988, the Royal Academy's Corporate Membership Scheme has proved highly successful. Corporate Membership offers company benefits to staff, clients and community partners and access to the Academy's facilities and resources. The outstanding support we receive from companies via the scheme is vital to the continuing success of the Academy and we thank all members for their valuable support and continued enthusiasm.

Corporate Patrons
Bloomberg LP
Deutsche Bank AG
Ernst & Young LLP
GlaxoSmithKline plc
Hay Group
ITV plc
John Lewis Partnership
Radisson Edwardian Hotels
Standard Chartered Bank

Corporate Members
Apax Partners Ltd
Arcadia Group plc
AON
Atos Origin
Bear, Stearns International Ltd
Bibendum
BNP Paribas
The Boston Consulting Group
Bovis Lend Lease Limited
The British Land Company plc
Bunzl
Calyon
Cantor Fitzgerald
Capital International Limited
CB Richard Ellis
Christie's
Chubb Insurance Company of Europe

Citigroup
CJA (Management Recruitment
 Consultants) Limited
Clifford Chance
Concordia Advisors
De Beers
Diageo plc
Doll
Epson (UK) Ltd
Eversheds
F & C Management Ltd
Fleming Family & Partners
GAM
Goldman Sachs International
Heidrick & Struggles
H J Heinz Company Limited
HSBC plc
King Sturge
KPMG
Lazard
LECG
Linklaters
Man Group plc
Mayer Brown Rowe & Maw
Mizuho International
Momart Limited
Morgan Stanley
Norton Rose
Peninsular and Oriental Steam
The Navigation Company
Pentland Group plc
PriceWaterhouseCoopers LLP
Raytheon Systems Ltd
Richards Butler
The Royal Bank of Scotland
The Royal Society of Chemistry
Schroders & Co
Sea Containers Ltd
SG
The Smith & Williamson Group
Trowers & Hamlins
UBS Wealth Management
Unilever UK Limited
Veredus Executive Resourcing
Watson Wyatt
Weil, Gotschal & Manges
Whitehead Mann
Yakult UK Ltd

Honorary Corporate Members

All Nippon Airways
A T Kearney
AXA IM
Aygaz
Carlsberg UK Ltd
Corus
Danske Bank
Farrow & Ball
Garanti Bank
London First
Novo Nordisk

SUPPORTERS OF PAST EXHIBITIONS
The President and Council of the Royal
Academy would like to thank the following
sponsors and benefactors for their generous
support of major exhibitions during the
last ten years:

ABN AMRO
 Masterpieces from Dresden, 2003
Akkök Group of Companies
 *Turks: A Journey of a Thousand Years,
 600–1600*, 2005
Allied Trust Bank
 Africa: The Art of a Continent, 1995*
American Associates of the Royal Academy
Trust
 Illuminating the Renaissance:

*The Triumph of Flemish Manuscript
 Painting in Europe*, 2003
 The Art of Philip Guston (1913–1980),
 2004
American Express
 Giorgio Armani: A Retrospective, 2003
Anglo American Corporation of South Africa
 Africa: The Art of a Continent, 1995*
A.T. Kearney
 231st Summer Exhibition, 1999
 232nd Summer Exhibition, 2000
 233rd Summer Exhibition, 2001
 234th Summer Exhibition, 2002
 235th Summer Exhibition, 2003
 236th Summer Exhibition, 2004
Aygaz
 *Turks: A Journey of a Thousand Years,
 600–1600*, 2005
Barclays
 *Ingres to Matisse. Masterpieces of French
 Painting*, 2001
BBC Radio 3
 Paris: Capital of the Arts 1900–1968, 2001
BMW (GB) Limited
 *Georges Rouault: The Early Years,
 1903–1920*, 1993
 David Hockney: A Drawing Retrospective,
 1995*
British Airways Plc
 Africa: The Art of a Continent, 1995
British American Tobacco
 Aztecs, 2002
Carlsberg UK Ltd
 *Ancient Art to Post-Impressionism:
 Masterpieces from the Ny Carlsberg
 Glyptotek, Copenhagen*, 2004
Cantor Fitzgerald
 *From Manet to Gauguin: Masterpieces
 from Swiss Private Collections*, 1995
 1900: Art at the Crossroads, 2000
Chase Fleming Asset Management
 The Scottish Colourists 1900–1930,
 2000
Chilstone Garden Ornaments
 *The Palladian Revival: Lord Burlington
 and His House and Garden at Chiswick*,
 1995
Christie's
 Frederic Leighton 1830–1896, 1996
 *Sensation: Young British Artists from
 The Saatchi Collection*, 1997
 *Pre-Raphaelite and Other Masters: The
 Andrew Lloyd Webber Collection*, 2003
Classic FM
 *Goya: Truth and Fantasy,
 The Small Paintings*, 1994
 *The Glory of Venice:
 Art in the Eighteenth Century*, 1994
 *Masters of Colour: Derain to Kandinsky.
 Masterpieces from The Merzbacher
 Collection*, 2002
 Masterpieces from Dresden, 2003
 *Pre-Raphaelite and Other Masters:
 The Andrew Lloyd Webber Collection*,
 2003
Corporation of London
 Living Bridges, 1996
Corus
 *Turks: A Journey of a Thousand Years,
 600–1600*, 2005
Country Life
 *John Soane, Architect: Master of Space
 and Light*, 1999
Credit Suisse First Boston
 The Genius of Rome 1592–1623, 2000
The Daily Telegraph
 American Art in the 20th Century, 1993
 1900: Art at the Crossroads, 2000
Danske Bank
 *Ancient Art to Post-Impressionism:
 Masterpieces from the Ny Carlsberg
 Glyptotek, Copenhagen*, 2004

De Beers
 Africa: The Art of a Continent, 1995
Debenhams Retail plc
 Premiums and RA Schools Show, 1999
 Premiums and RA Schools Show, 2000
 Premiums and RA Schools Show, 2001
 Premiums and RA Schools Show, 2002
Deutsche Morgan Grenfell
 Africa: The Art of a Continent, 1995
Diageo plc
 230th Summer Exhibition, 1998
The Drue Heinz Trust
 *The Palladian Revival: Lord Burlington
 and His House and Garden at Chiswick*,
 1995
 Denys Lasdun, 1997
 Tadao Ando: Master of Minimalism,
 1998
The Dupont Company
 American Art in the 20th Century, 1993
Ernst & Young
 Monet in the 20th Century, 1999
Eyestorm
 *Apocalypse: Beauty and Horror
 in Contemporary Art*, 2000
Farrow & Ball
 *Matisse, His Art and His Textiles:
 The Fabric of Dreams*, 2005
Fidelity Foundation
 *The Dawn of the Floating World
 (1650–1765). Early Ukiyo-e Treasures
 from the Museum of Fine Arts, Boston*,
 2001
Friends of the Royal Academy
 Victorian Fairy Painting, 1997
Game International Limited
 *Forty Years in Print: The Curwen Studio
 and Royal Academicians*, 2001
The Jacqueline and Michael Gee Charitable
Trust
 *LIFE? or THEATRE?
 The Work of Charlotte Salomon*, 1999
Garanti Bank
 *Turks: A Journey of a Thousand Years,
 600–1600*, 2005
Générale des Eaux Group
 Living Bridges, 1996
Glaxo Wellcome plc
 The Unknown Modigliani, 1994
Goldman Sachs International
 Alberto Giacometti, 1901–1966, 1996
 Picasso: Painter and Sculptor in Clay,
 1998
The Guardian
 The Unknown Modigliani, 1994
Guinness PLC (see Diageo plc)
 225th Summer Exhibition, 1993
 226th Summer Exhibition, 1994
 227th Summer Exhibition, 1995
 228th Summer Exhibition, 1996
 229th Summer Exhibition, 1997
Harpers & Queen
 *Georges Rouault: The Early Years,
 1903–1920*, 1993
 Sandra Blow, 1994
 David Hockney: A Drawing Retrospective,
 1995*
 Roger de Grey, 1996
The Headley Trust
 Denys Lasdun, 1997
The Henry Moore Foundation
 Africa: The Art of a Continent, 1995
Ibstock Building Products Ltd
 *John Soane, Architect: Master of Space
 and Light*, 1999
The Independent
 Living Bridges, 1996
 *Apocalypse: Beauty and Horror
 in Contemporary Art*, 2000
International Asset Management
 *Frank Auerbach, Paintings and Drawings
 1954–2001*, 2001

Donald and Jeanne Kahn
 John Hoyland, 1999
Land Securities PLC
 Denys Lasdun, 1997
Lassa Tyres
 *Turks: A Journey of a Thousand Years,
 600–1600*, 2005
The Mail on Sunday
 Royal Academy Summer Season, 1993
Mercedes-Benz
 Giorgio Armani: A Retrospective, 2003
Merrill Lynch
 American Art in the 20th Century, 1993*
 Paris: Capital of the Arts 1900–1968, 2001
Mexico Tourism Board
 Aztecs, 2002
Midland Bank plc
 RA Outreach Programme, 1993–1996
 Lessons in Life, 1994
Minorco
 Africa: The Art of a Continent, 1995
Natwest Group
 Nicolas Poussin 1594–1665, 1995
The Nippon Foundation
 *Hiroshige: Images of Mist, Rain, Moon
 and Snow*, 1997
Novo Nordisk
 *Ancient Art to Post-Impressionism:
 Masterpieces from the Ny Carlsberg
 Glyptotek, Copenhagen*, 2004
Pemex
 Aztecs, 2002
Peterborough United Football Club
 *Art Treasures of England:
 The Regional Collections*, 1997
Premiercare (National Westminster Insurance
Services)
 Roger de Grey, 1996*
RA Exhibition Patrons Group
 Chagall: Love and the Stage, 1998
 Kandinsky, 1999
 Chardin 1699–1779, 2000
 *Botticelli's Dante: The Drawings for
 Dante's Divine Comedy*, 2001
 *Return of the Buddha:
 The Qingzhou Discoveries*, 2002
 *Ernst Ludwig Kirchner:
 The Dresden and Berlin Years*, 2003
 *Vuillard: From Post-Impressionist to
 Modern Master*, 2004
 The Art of William Nicholson, 2004
Reed Elsevier plc
 Van Dyck 1599–1641, 1999
 Rembrandt's Women, 2001
Virginia and Simon Robertson
 Aztecs, 2002
 *Illuminating the Renaissance:
 The Triumph of Flemish Manuscript
 Painting in Europe*, 2003
The Royal Bank of Scotland
 Braque: The Late Works, 1997*
 Premiums, 1997
 Premiums, 1998
 Premiums, 1999
 Royal Academy Schools Final Year Show,
 1996
 Royal Academy Schools Final Year Show,
 1997
 Royal Academy Schools Final Year Show,
 1998
The Sara Lee Foundation
 Odilon Redon: Dreams and Visions,
 1995
Silhouette Eyewear
 Sandra Blow, 1994
 Africa: The Art of a Continent, 1995
Société Générale, UK
 *Gustave Caillebotte:
 The Unknown Impressionist*, 1996*
Thames Water Plc
 *Thames Water Habitable Bridge
 Competition*, 1996

Time Out
 *Sensation: Young British Artists from
 The Saatchi Collection*, 1997
 *Apocalypse: Beauty and Horror
 in Contemporary Art*, 2000
The Times
 Drawings from the J Paul Getty Museum,
 1993
 *Goya: Truth and Fantasy, The Small
 Paintings*, 1994
 Africa: The Art of a Continent, 1995
UBS Wealth Management
 *Pre-Raphaelite and Other Masters:
 The Andrew Lloyd Webber Collection*,
 2003
Walker Morris
 Premiums, 2003
 Royal Academy Schools Final Year Show,
 2003
Yakult UK Ltd
 RA Outreach Programme, 1997–2002
 *alive: Life Drawings from the Royal
 Academy of Arts & Yakult Outreach
 Programme*

* Recipients of a Pairing Scheme Award,
managed by Arts + Business. Arts + Business
is funded by the Arts Council of England and
the Department for Culture, Media and Sport

OTHER SPONSORS
Sponsors of events, publications and other
items in the past five years:

A.T. Kearney
Carlisle Group plc
Country Life
Derwent Valley Holdings plc
Dresdner Kleinwort Wasserstein
Fidelity Foundation
Foster and Partners
Goldman Sachs International
Gome International
Gucci Group
Rob van Helden
IBJ International plc
John Doyle Construction
Martin Krajewski
Marks & Spencer
Michael Hopkins & Partners
Morgan Stanley Dean Witter
Prada
Radisson Edwardian Hotels
Richard and Ruth Rogers
Strutt & Parker